NORMAN ROCKWELL'S
Happy Holidays

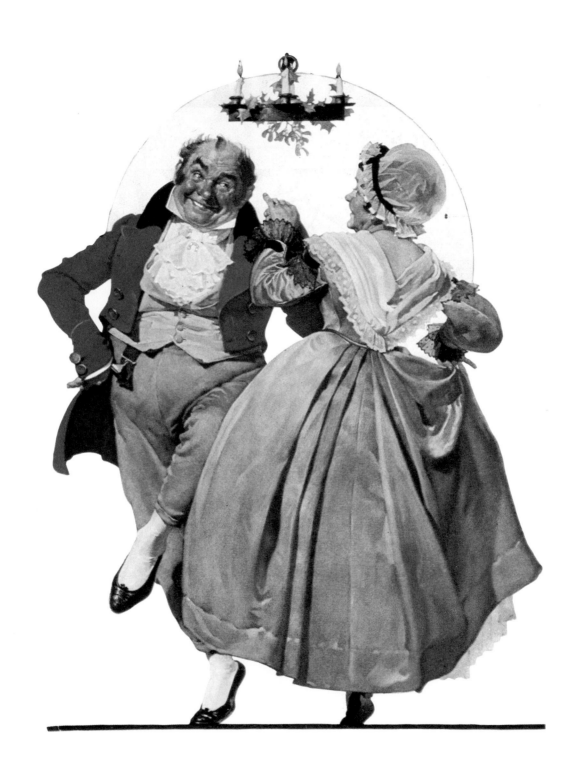

NORMAN ROCKWELL'S
HAPPY HOLIDAYS

GEORGE MENDOZA

G. P. PUTNAM'S SONS
New York

Library of Congress Cataloging in Publication Data

Main entry under title:

Norman Rockwell's happy holidays.

1. Rockwell, Norman, 1894–1978. 2. Holidays in art.
3. Holidays. I. Rockwell, Norman, 1894–1978.
II. Mendoza, George.
ND237.R68N68 1983 759.13 83-11036
ISBN 0-399-12838-7

Book Design by Bernard Schleifer

Printed in the United States of America

For kind permission to reprint copyrighted material, grateful acknowl-
edgement is made to the following sources. Any oversight is inadvertent
and will be corrected on notification in writing to the Publisher.

Brandt & Brandt Literary Agents, Inc., for "Abraham Lincoln" from
A Book Of Americans by Rosemary and Stephen Vincent Benet, copy-
right 1933 by Rosemary and Stephen Vincent Benet, copyright renewed
© 1961 by Rosemary Carr Benet. Published by Holt, Rhinehart and
Winston, Inc.

Michael Demarest/*Time Magazine* for "In Praise of Gardening" by
Michael Demarest.

Doubleday & Company, Inc., for "A Skinny Kid" and "As Though I
Were a Thief With Time" from *The Mist Men* by George Mendoza,
copyright © 1970 by George Mendoza.

Mrs. Norma Millay Ellis for "The Unexplorer" by Edna St. Vincent
Millay from *Collected Poems*, copyright 1922, 1950 by Edna St. Vincent
Millay, published by Harper & Row.

Ms. Mari Fransson for Maine Perch Soup recipe.

Harcourt Brace Jovanovich, Inc., for "A Miserable Merry Christmas"
from *The Autobiography of Lincoln Steffens*, copyright 1931 by Har-
court Brace Jovanovich, Inc., renewed 1959 by Peter Steffens.

Harcourt Brace Jovanovich, Inc., and Granada Publishing Ltd., for "i
carry your heart with me" from *Complete Poems 1913–1962* by e. e.
cummings, copyright 1952 by e. e. cummings.

Harper & Row, Publishers, Inc., for "The Innocents Abroad" by
Mark Twain, and "All About American Holidays" by Maymie Krythe,
copyright © 1962 by Maymie R. Krythe.

William Heinemann Ltd., for *Some Damnable Errors About
Christmas* from *A Christmas Garland* by Max Beerbohm/G. K.
CH*ST*RT*N.

Indiana University Press for "Fireworks" by Babette Deutsch.

Alfred A. Knopf, Inc., for "Dreams" from *The Dream Keeper &
Other Poems* by Langston Hughes, copyright 1932 by Alfred A. Knopf,
Inc., and renewed 1960 by Langston Hughes.

Little, Brown and Company for *Blue Highways* by William Least

Heat Moon, copyright © 1982 by William Least Heat Moon.

Little Brown and Company and William Collins Sons & Company for
A Traveller's Life by Eric Newby, copyright © 1982 by Eric Newby.

Little, Brown and Company and Curtis Brown, Ltd., for "Always
Marry an April Girl" from *Verse From 1929 On* by Ogden Nash, copy-
right © 1943 by Ogden Nash; first appeared in *Cosmopolitan*.

Liveright Publishing Corporation and Granada Publishing Ltd., for
"little tree" and "Paris; this April sunset completely utters" from *Tulips
and Chimneys* by E. E. Cummings, copyright © 1923, 1925, and re-
newed 1951, 1953 by E. E. Cummings, copyright © 1973, 1976 by the
Trustees for the E. E. Cummings Trust, copyright © 1973, 1976 by
George James Firmage.

Macmillan Publishing Company, Inc., for "Ah, Spring . . .," "There's
No Ending," "The Fish That Got Away," "As Though I Were a Thief
With Time," and "Fishing the Morning Lonely," all from *The Secret
Places of Trout Fishermen* by George Mendoza, copyright © 1977 by
George Mendoza.

New Century Publishers, Piscataway, New Jersey 08854, for *Cele-
brations* by Becky Stevens Cordell, copyright © 1977 by Butterick
Publishing, A Division of American Can Company.

The New York Times for "On the Beach," July 9, 1979 ("*Ob-
server*") and "Two Weeks in Mare's Nest," June 29, 1965, both by
Russell Baker, copyright © 1965/79 by The New York Times Com-
pany.

Oxford University Press for *Abroad* by Paul Fussell, copyright ©
1980 by Paul Fussell.

G. P. Putnam's Sons for "Leisure Will Kill You" from *Laid Back in
Washington* by Art Buchwald, copyright © 1978, 1979, 1980, 1981 by
Art Buchwald, © 1981 by Los Angeles Times Syndicate for columns
first published in 1981.

Mr. Tom Sydorick for "Heroic Luggage" by Tom Sydorick.

ACKNOWLEDGMENTS

MY DEEPEST THANKS and appreciation is extended to all those who helped make this book of a wanderer's dreams come true: Richard N. Barkle, Director, Public Relations, *Pan American World Airways;* Tom Rockwell; Judy Rowcliffe and Tom Talamini, vice presidents, *Daily & Associates,* San Francisco; Mike J. Damiano, *New Zealand Government Tourist Office;* Rex Forrester, Hunting and Fishing Officer, *New Zealand Government Tourist Bureau;* Carol J. Nelson, Public Affairs Manager, *Air New Zealand* (North America); *Spanish National Tourist Office; Iberia Airlines;* Vinnie Modugno, vice president, *American Airlines;* D. Perry Moran, vice president, *Delta Queen Steamboat Company;* James Nassikas, President, *The Stanford Court Hotel;* Ralph S. Goodman, Marketing Director, *The Stanford Court Hotel;* Ed Safdie, owner, *Sonoma Mission Inn & Spa;* Nicole Sekora-Mendoza, Creative Consultant; Nancy J. Perlman, editor, *The Putnam Publishing Group;* Mari Fransson, *Pan American World Airways;* Herman Wiener, General Manager, *Fairmont Hotel,* San Francisco; S. C. Kaufmann, Publicity Director, *The Cloister,* Sea Island, Georgia; Alice Marshall, Manager, Public Relations, *Cunard Line;* Antonio R. Alonso, President, *Marketing Ahead;* Audrey E. Cusson, *The Putnam Publishing Group;* Bogdan Cujic, Assistant Director, *Yugoslav National Tourist Office.* All artwork provided courtesy of the Norman Rockwell Museum at the Old Corner House, Stockbridge, Massachusetts, with the assistance of Laurie Norton Moffatt, Curator.

THIS BOOK IS DEDICATED TO
my friend Stephen A. Ollendorff,
who is not only the most sagacious
and patient lawyer in the world but also an
indefatigable tennis opponent.

To many a youth, and many a maid,
Dancing in the chequered shade.
And young and old come forth to play
On a sunshine holiday.

<div align="right">—JOHN MILTON</div>

SOME YEARS AGO I received a letter from *Town & Country* magazine that read: "This is to introduce Mr. George Mendoza, who has been assigned to do an article on trout fishing around the world for T&C. As part of this article, Mr. Mendoza will recount personal experiences in Chile and New Zealand. He would also like to include an experience on the Test and Itchen Rivers in England. In this regard, we would appreciate any assistance you might provide him."

Though I did not realize it at the time, that letter was to become one of the most important documents of my life. For in the years that followed, that short note opened my life to many delicious trout fishing experiences. You might say the letter provided golden happy holidays on and off the stream.

True, I went around the world four times on the coattails of that letter, and yes, I must have fished every trout and salmon river in the world wherever sweetwater spilled from mountain peaks or gorges. I became a wanderer seeking rivers, as simple as that.

Trouble was, I never wanted my assignment to end. I never wanted to write that story or to cap it because then it would have been done, all over, the adventure of following rivers remembered only in a graveyard of words.

So I never finished the piece for *Town & Country*, and I doubt that I ever will. I'm still working at it. And I hope I always will keep working on another trip, one more trout fishing adventure. Even in the furious face of my editor's wild protests—"Enough! How many more streams must you fish before you write this story?"—I must confess trout streams are endless and seeking them more so. You just can't say, "It's done!" There is still that rainbow trout in Argentina, that elusive brown monster you lost in Yugoslavia, one more sentimental trip to the Battenkill River in Vermont, a place of Green Mountain rivers you knew as a boy.

I've been accused of living one long holiday and that someday I'll have to make up for the whole business of not working like an ordinary man who faces up to responsibilities. Hogwash. I'm free and I've lived my life on my terms and that beats living your life with someone else's ideas clogging up your dreams. I do believe in the magic of dreams and in the wings of poems and tunes that stir the leaves of your mind.

If you have the gaze of the child in your eyes, come on, I'll take you wandering. On the Big Horn through the mountains of lost arrows.

—*GEORGE MENDOZA*

NORMAN ROCKWELL'S
Happy Holidays

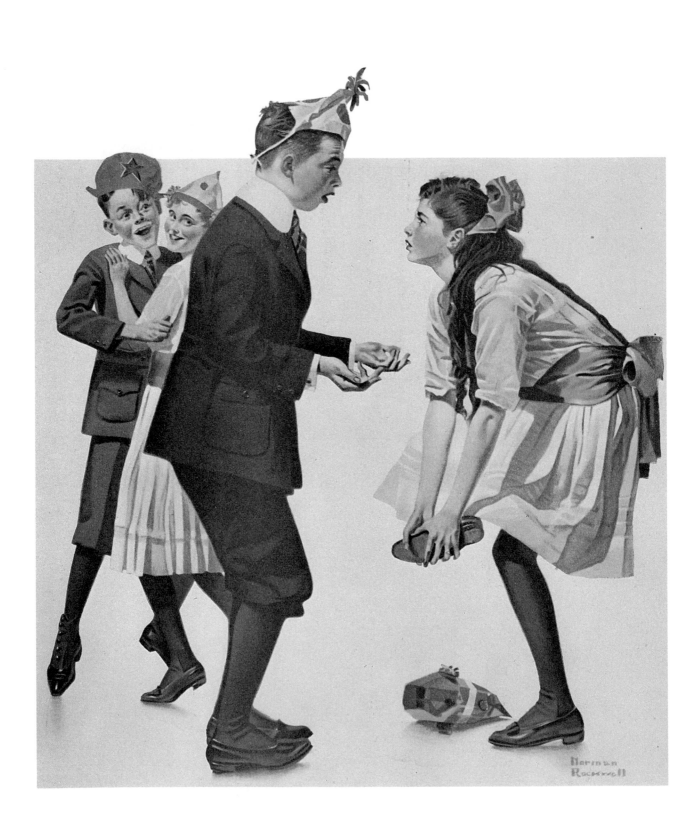

What better wish can be given you than that in the coming year you may never lose an old friend, but gain many new; that you may never do an unkindness, for which you would be sorry; that while God's sunshine is upon you, then will not be forgotten the blessing of it; that when clouds arrive, you will think with joy of the possibility of sunshine; and that on the gay opening day of the year, you will remember

"If all the year were playing holidays,
To sport would be as tedious as to work."

—"A New Year's Wish,"
The Delineator, 1882

ONCE'T ther' was a 'ittle boy—
 What maked some resolushuns,
On New Year's Day—'at he would stop
 A-bein' sech a "Noo-sanse."
He sed, he'd start in takin' bafs
 Without no drivin' to it;
He sed, he'd go to bed at night
 Soon as he's telled to do it.
An' after this he'd stick to trufe,
 An' never tell a fib;
He never more'd put a frog
 In baby sister's crib;
He'd never take the cookie box
 When Cook had jus' fresh filled it;
He'd alway say: 'at it was *him*
 Took Muvver's c'lone, an' spilled it.
He'd let the poor cat live in peace,
No more fill Gran'dad's pipe wif grease:

He'd quit a-teasin' 'ittle girls
Wif catty-pillers in their curls.
When Sister's best beau comes to call
He'd never hide—an' tell—*a-tall;*
He'd never climb on kitchen roofs
To hide his Granny-ma's false toofs;
He'd never take Aunt Belle's gold puffs,
An' stuff 'em in her new beau's cuffs.
Green apples? No, he'd never steal,
Nor monkey wif Big Bruvver's wheel:
He'd clean his teef, an' scrub his neck,
An' never sulk the leastes' speck,
When comp'ny comes an' he's helped last.
Folks'll forget his naughty past.
These resolushuns, when he maked em'
He meaned to keep—but oh, he breaked 'em!
So now he says: "Folks, do not fear!
I'll make a bran' new set—Nex' Year."

—*MARGARET G. HAYES*
"Resolushuns"
The Delineator, 1913

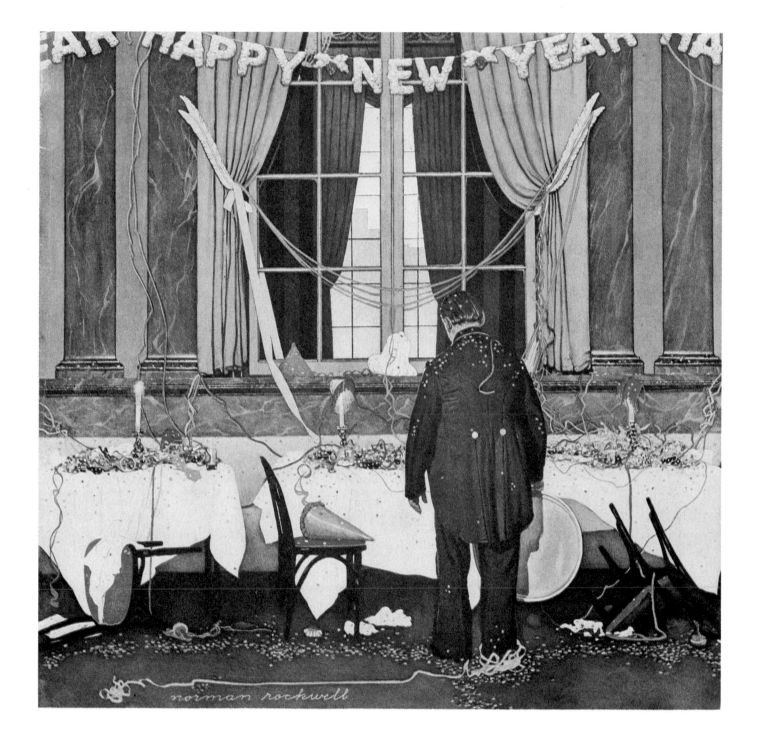

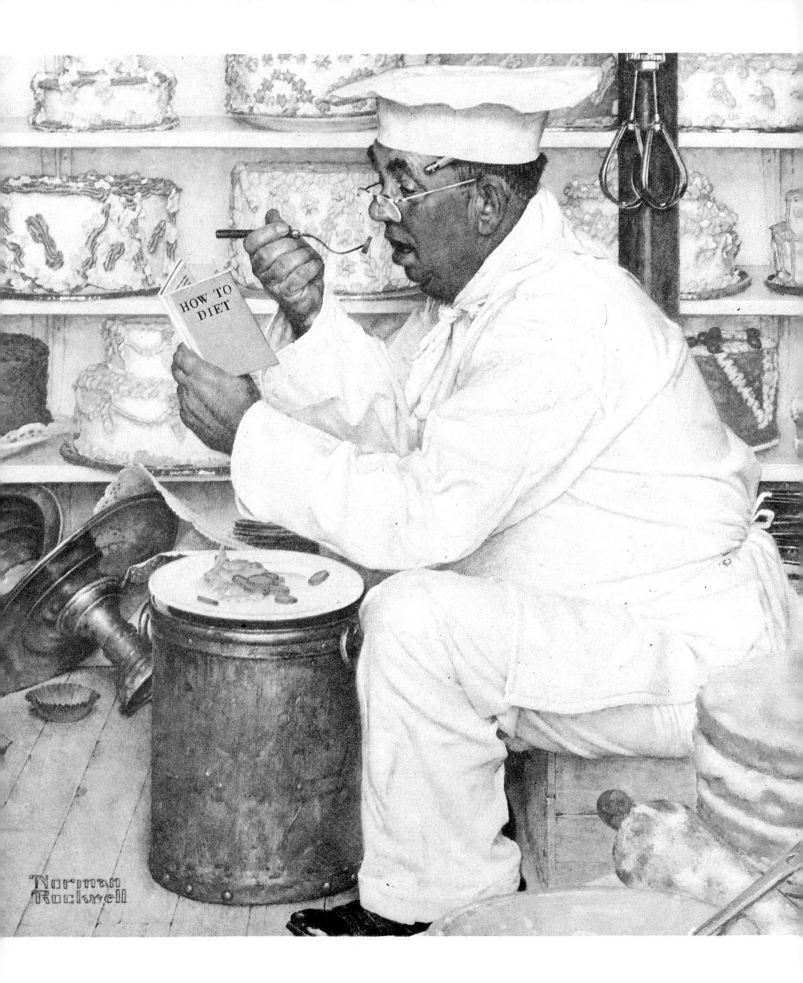

RECIPES FOR RECOVERY FROM THE HOLIDAYS

BRAN MUFFINS

2 oz. butter
½ cup dark brown sugar
3 T. molasses (blackstrap)
2 eggs
1 cup sour milk or buttermilk
2 cups bran, soaked in ½ cup water (hot)
1 cup raisins
1 cup stone-ground whole wheat flour
1 T. soy flour
¾ tsp. baking soda
½ tsp. salt

Cream together butter and sugar and molasses. Add eggs and beat until well combined. Add milk, bran mixture, and raisins. Stir to combine. Sift together the dry ingredients and add to other mixture to form a batter. Use ¼ cup batter for each muffin. Bake in greased muffin tins at 375° for 18 minutes.

Calories per muffin: 125

STUFFED ZUCCHINI

Yield: 8 servings
12 zucchini (scoop out pulp with melon scoop after cutting ends off)
1 T. butter
1 lb. onion chopped
zucchini pulp, chopped
1 medium red pepper, minced
12 oz. spinach, cooked and chopped
3 cloves garlic, minced
white pepper to taste
Vege-sal (found in the health food store)
2 fertile eggs
½ cup ricotta cheese (part skim)

Cook off onions and garlic in butter. Add pulp, mushrooms, red pepper, and spinach. Cook slowly several minutes and season. Combine eggs and ricotta cheese. Mix cheese with vegetable mixture. Pipe into zucchini shells and steam whole zucchini until just tender. Just before serving, slice zucchini and fan out onto plate.

SAUCE FOR ZUCCHINI

Yield: 30 2 oz. servings
1 onion
4 medium tomatoes
6 medium-sized carrots
3 small garlic cloves, minced
1 cup canned tomato juice
1 cup canned tomatoes
½ cup chicken stock

Cook off onion in 1 teaspoon butter till soft, add the rest of ingredients, and allow to simmer for 1½ hours. Puree and put through strainer. Pour 2 oz. sauce over each serving and then garnish dish with 1 teaspoon Asiago cheese, grated. A dollop of yogurt can be added for decoration. Use a feathering technique.

Calories per serving: 208

BOUDIN AUX FRUIT DE MERS

Yield: 10 4 oz. servings
- ½ lb. shrimp
- ½ lb. salmon (this is for Cuisinart mixture or mousse)
- ½ lb. scallops
- ½ lb. salmon (diced)
- 3 egg whites
- 1 T. butter
- 3–4 cups chopped spinach
- 1 bunch chopped watercress
- 4 T. milk
- 1 T. fresh chopped chives, tarragon, parsley, basil (4 T. in all)
- ¼ cup minced shallots
- pinch of salt, white pepper, nutmeg

Puree salmon and scallops with egg whites in Cuisinart for 3 minutes. Take out and place in a bowl over crushed ice. Add milk and mix well. Add diced scallops and salmon, stirring lightly. Season with Vege-sal or salt, white pepper, and nutmeg. Set aside.

Sweat the shallots in butter. Add chopped spinach and watercress. Simmer lightly 2 minutes. Transfer to bowl and chill till very cold in the fridge. When cold, add herbs and then combine with first mixture.

Cut foil squares. Rub very lightly with butter or oil. Place them in simmering fish stock (or herb broth). Simmer for 8 minutes. Garnish with cucumber slices or tomato chopped finely. Use herb Buerreblanc or Dijon mustard as a sauce.

Calories per serving: 137

POPPY SEED BREAD

Yield: 16 slices
1¼ cups stone-ground whole wheat flour
½ cup raw sesame seeds
2 T. non-fat dry milk
2 tsp. poppy seeds
1½ tsp. baking powder
½ tsp. salt
2 eggs, lightly beaten
¼ cup unheated honey
¼ cup fresh orange juice
2 T. unsalted sweet butter, melted
2 T. cold-pressed vegetable oil (almond)
¼ tsp. cinnamon (optional)

Heat oven to 350°. Combine flour, sesame seeds, dry milk, poppy seeds, baking powder, salt, and cinnamon in a medium-sized bowl. Mix other ingredients in a small bowl and stir egg mixture into flour mixture just until mixed. Spoon mixture into a Teflon-coated loaf pan. Bake on center oven rack until wooden pick inserted in center is withdrawn clean, approximately 35–40 minutes. Cool in pan on wire rack 15 minutes. Then remove from pan and cool on rack 10 minutes.

Calories per slice: 124

This bread is wonderful cut into small pieces and used as an hors d'oeuvre with orange-flavored low-fat cream cheese or tofu-peanut butter spread.

STUFFED CHICKEN BREAST

Yield: 8 servings
8 3 oz. chicken breasts (skin off and butterflied out)
8 tsp. minced shallots
8 oz. poppy seed bread
8 oz. fresh wild Chantrelle mushrooms (chopped rough)
3 T. skim milk
1 T. sweet butter
 Vege-sal
 white pepper
2 carrots
2 sticks celery, chopped medium-fine
1 large onion
3 cups chicken stock
1 large ripe tomato (chopped)

Have a butcher butterfly the chicken breasts for you. Lay them skin-side down on a tray and they are now ready to be stuffed.

Sweat the shallots in butter in a Teflon pan for 3 minutes. Then add mushrooms and cook 3 more minutes. Add crumbled poppy seed bread, skim milk, and pinch of Vege-sal and white pepper. Place in refrigerator; when cooled, add 1 whole egg. Place mixture evenly inside each breast. Roll them up tucking in the ends. Place chopped vegetables and chicken stock in a low-sided pot large enough to accommodate the chicken breasts. Bake at 375° for 18 minutes. Remove chicken to a platter. Keep warm. Bring the chicken juices to a boil (reserve 1 cup), pour over chicken breasts. Garnish with 2 oz. of favorite seasonal vegetable.

—SONOMA MISSION INN

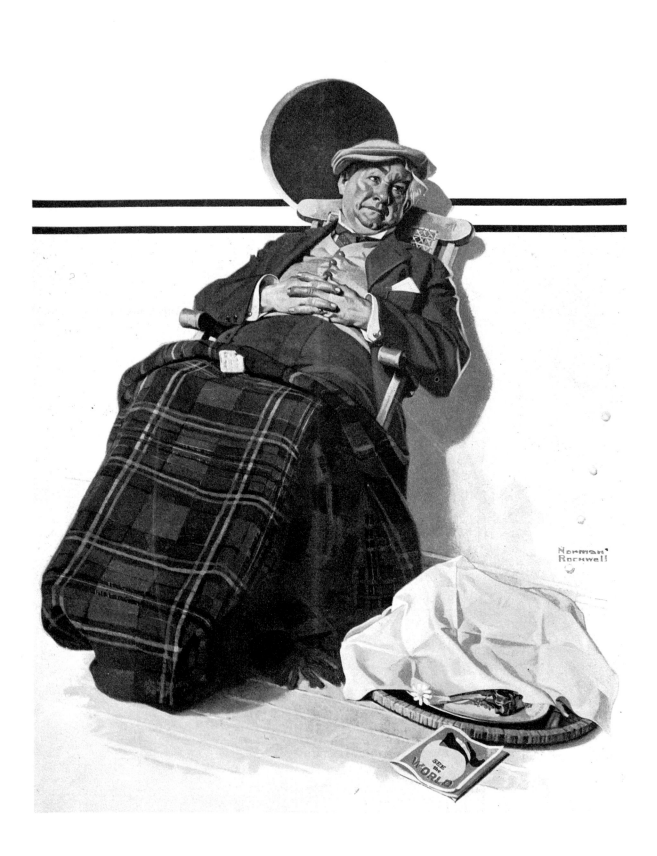

THE INNOCENTS ABROAD

It reminds me of the journal I opened with the New Year once, when I was a boy and a confiding and a willing prey to those impossible schemes of reform which well-meaning old maids and grandmothers set for the feet of unwary youths at that season of the year—setting oversized tasks for them, which necessarily failing, as infallibly weaken the boy's strength of will, diminish his confidence in himself, and injure his chances of success in life. Please accept of an extract:

Monday—Got up, washed, went to bed.
Tuesday—Got up, washed, went to bed.
Wednesday—Got up, washed, went to bed.
Thursday—Got up, washed, went to bed.
Friday—Got up, washed, went to bed.
Next Friday—Got up, washed, went to bed.
Friday fortnight—Got up, washed, went to bed.
Following month—Got up, washed, went to bed.

I stopped then, discouraged. Startling events appeared to be too rare in my career to render a diary necessary. I still reflect with pride, however, that even at that early age I washed when I got up. That journal finished me. I never have had the nerve to keep one since. My loss of confidence in myself in that line was permanent.

The ship had to stay a week or more at Gibraltar to take in coal for the home voyage.

—*MARK TWAIN*

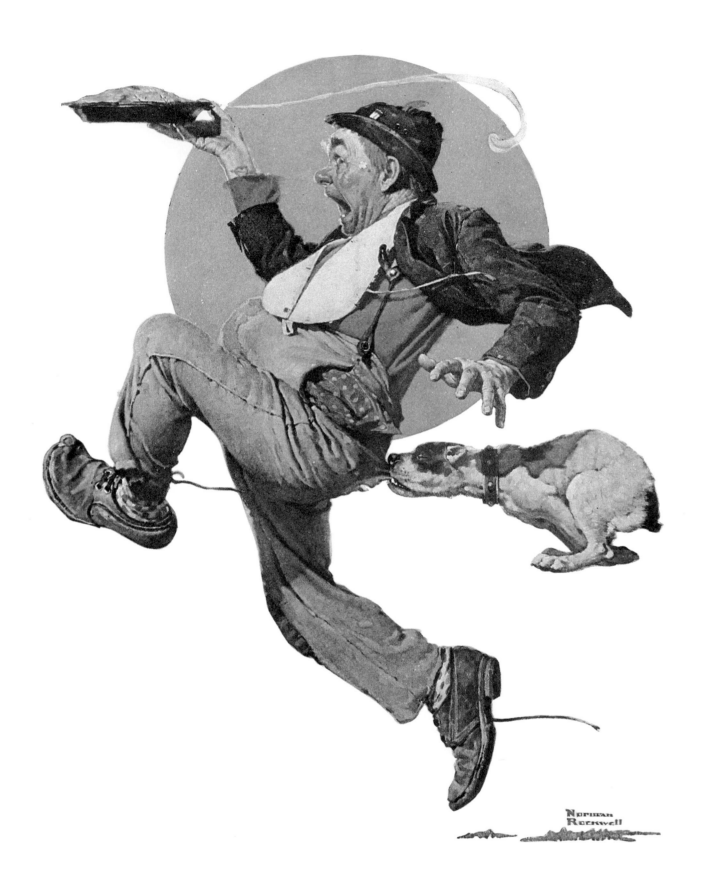

NEW YEAR'S EVE

LE DINER DU NOUVEL AN

Les Fines Huîtres Royale
ou
Le Parfait de Foie Gras Strasbourgoise
ou
La Coupe de Crevettes de Morecambe
ou
Le Caviar Beluga Frappé

*

La Crème Germiny en Tasse
Les Croutons au Beurre
ou
La Tortue en Tasse au Sherry
Les Paillettes au Chester

*

Les Mousselines de Sole au Champagne

*

Le Petits Tournedos Perigourdine

*

Les Fonds d'Artichaut Forestière
Les Haricots Verts au Beurre
Les Pommes Amandine

*

La Poire Camice Nesselrode
Le Parfait Glacé au Chartreuse

*

Les Friandises de St. Sylvestre

*

Le Café

—*CLARIDGE'S*

Should auld acquaintance be forgot,
 And never brought to mind?
Should auld acquaintance be forgot
 And days of auld lang syne.

For auld lang syne, my dear,
 For auld lang syne.
We'll tak' a cup o' kindness yet,
 For auld lang syne.

 —"Auld Lang Syne"

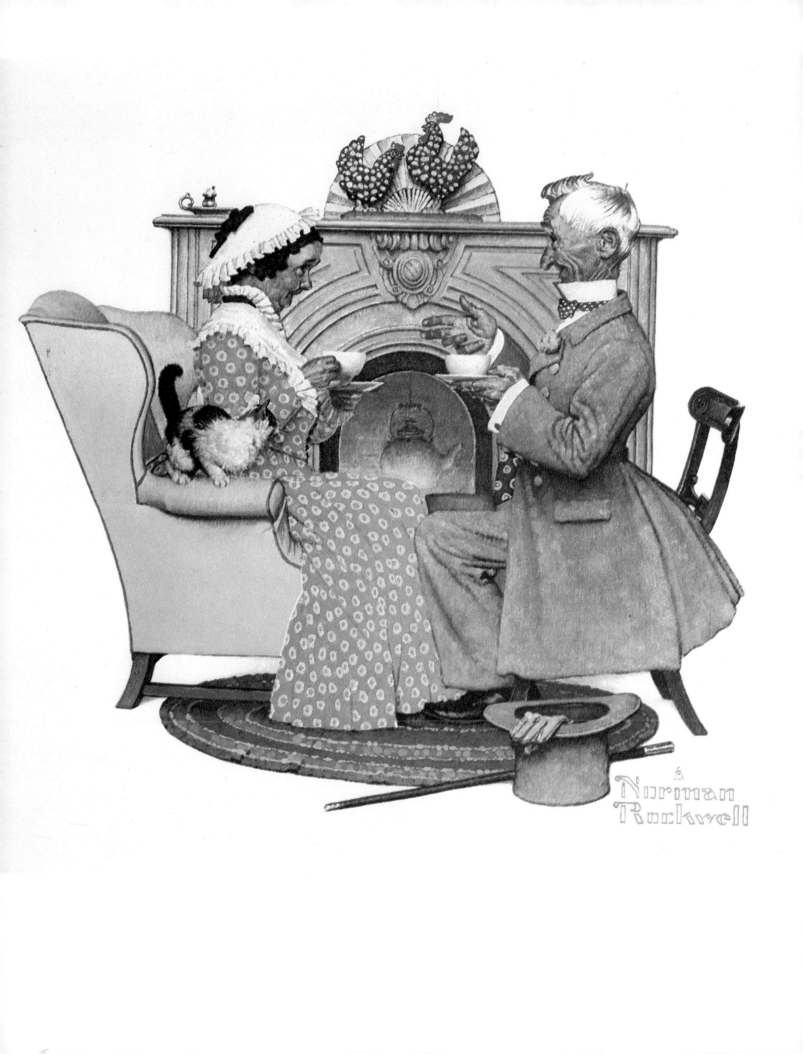

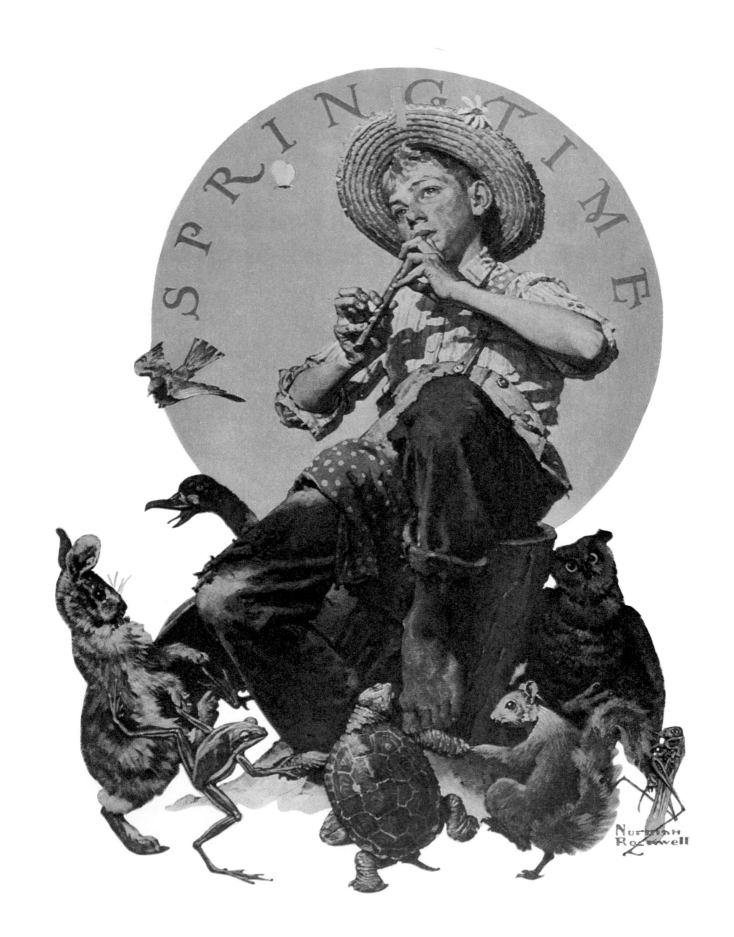

GROUNDHOG DAY is connected with a traditional weather superstition brought to the United States by English and German settlers, who called the day Candlemas. It is thought that various hibernating animals come to the surface of the ground on this day to observe the condition of the weather. If the groundhog, hedgehog, or badger sees the sun, he becomes frightened by his shadow and crawls back into his hole to sleep for six more weeks. In this event, the farmer expects cold weather for the next six weeks and a poor crop for the year. If the skies are cloudy, however, the groundhog stays above ground and this is a harbinger of an early spring. This is a rare instance in which sunshine is a bad omen.

Pennsylvania has become the home of groundhog fables and many groundhog clubs have been organized to observe the movements of the groundhog and predict the weather. After stalking the groundhog at sunrise, these clubs fill the day with merriment and celebration, all with a slight touch of self-mockery.

We believe in the wisdom of the groundhog,
We declare his intelligence to be of a
higher order than that of any other animal . . .
We rejoice that he can, and does, foretell
with absolute accuracy the weather conditions
for the six weeks following each second day of
 February . . .

—Creed of the Slumbering Groundhog Lodge,
Quarryville, Pennsylvania

(*To the tune of "John Brown's Body"*)

Let the scientific fakirs gnash their teeth and
 stamp with rage—
Let astrologers with crystals wipe such nonsense
 from the page—
We hail the King of Prophets, who's the world's
 outstanding Sage—

TODAY THE GROUNDHOG COMES!

Glory! Glory! to the Groundhog,
Glory! Glory! to the Groundhog,
Glory! Glory! to the Groundhog,

TODAY THE PROPHET COMES!

—Club Song of the
Slumbering Groundhog Lodge,
Quarryville, Pennsylvania

THE FIRST St. Valentine greeting appeared in London, October 25, 1684:

> Good morrow Vallentine,
> God send you ever
> To keep your promise and
> bee constant ever.

> *—EDWARD SANGON,*
> Tower Hill,
> London

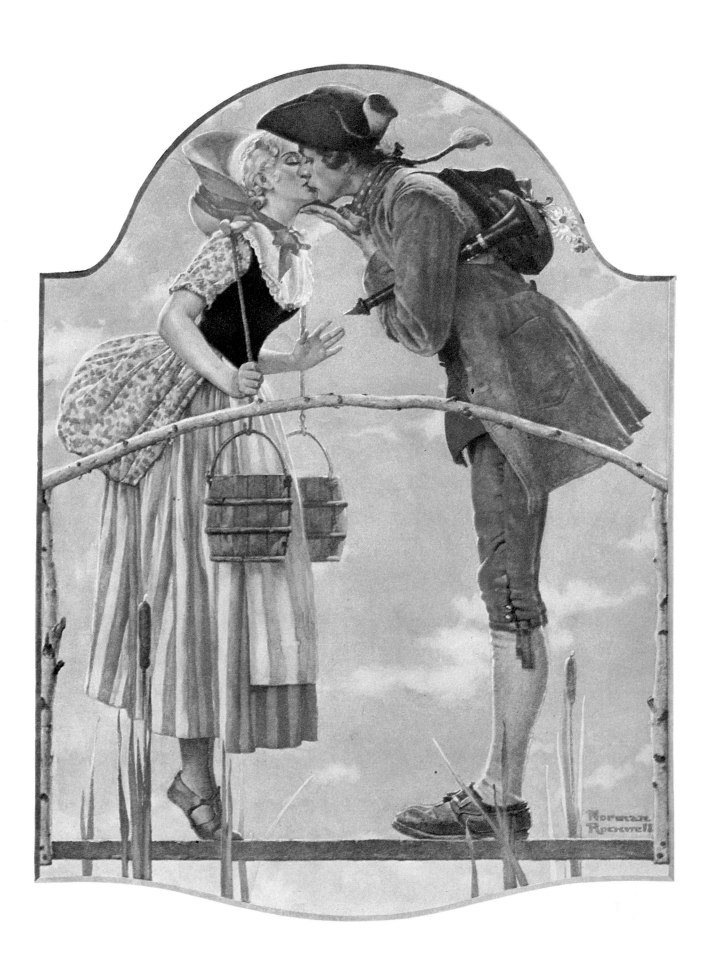

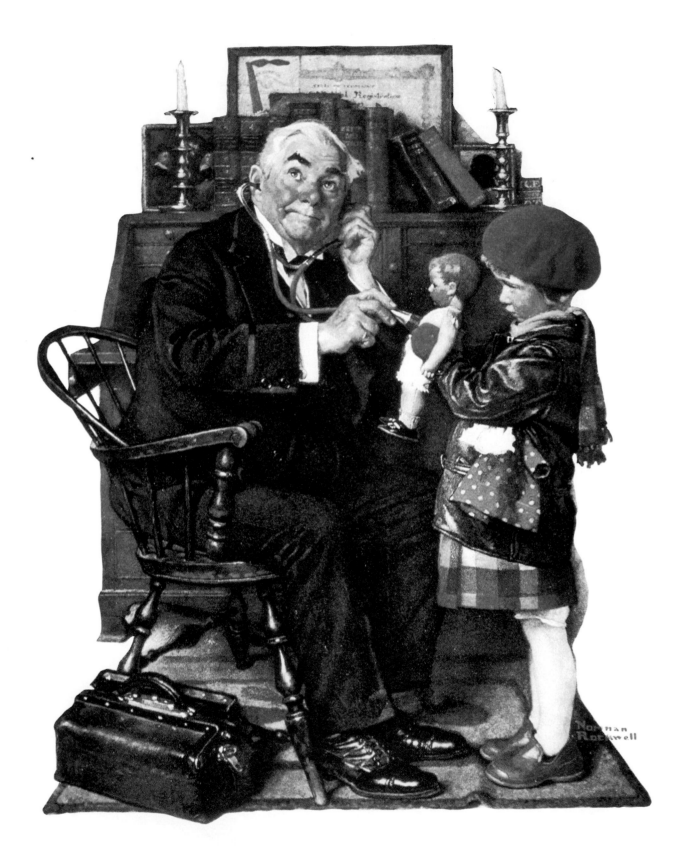

February the fourteenth day
It's valentine they say
I choose you from among the rest
The reason was I loved you best
Sure as the grape grows on the vine
So sure you are my valentine
The rose is red the violet blue
Lilies are fair and so are you.
Round is the ring that has no end,
so is my love for you my friend.
Again take this in good part
Along with it you have my heart.
But if you do the same refuse
Pray burn this paper and me excuse.

—From a handmade cutout valentine,
c. 1790, New England

I've often thought that I would send,
A valentine to some dear friend,
Now, though I've many friends, 'tis true,
My preference is all for you,
For if the truth must be confess'd,
Believe me, I like you the best.

—*AMANDA SNOWBALL*,
"Manchester, Feby 1849."

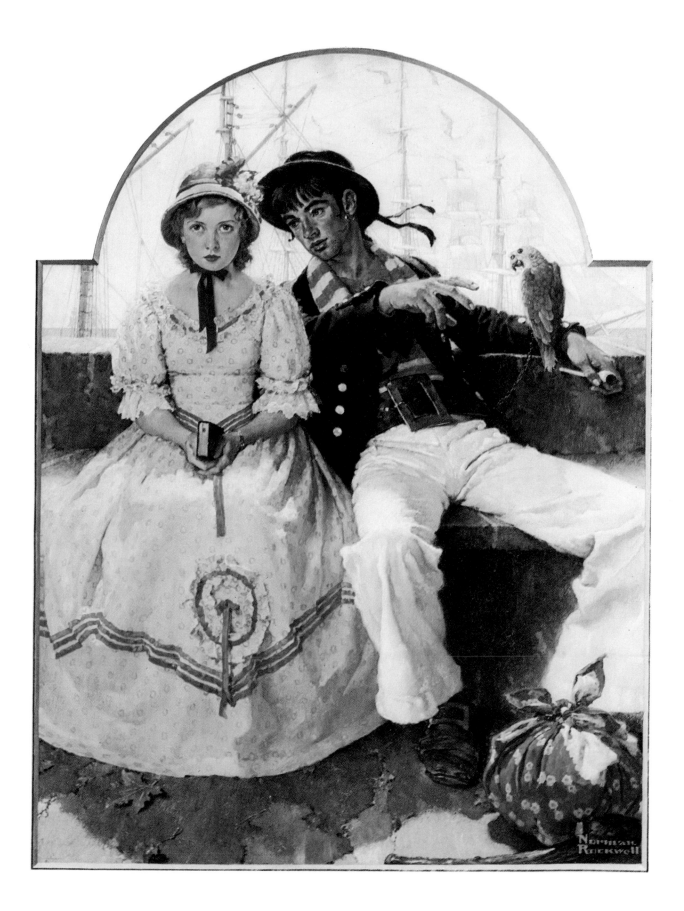

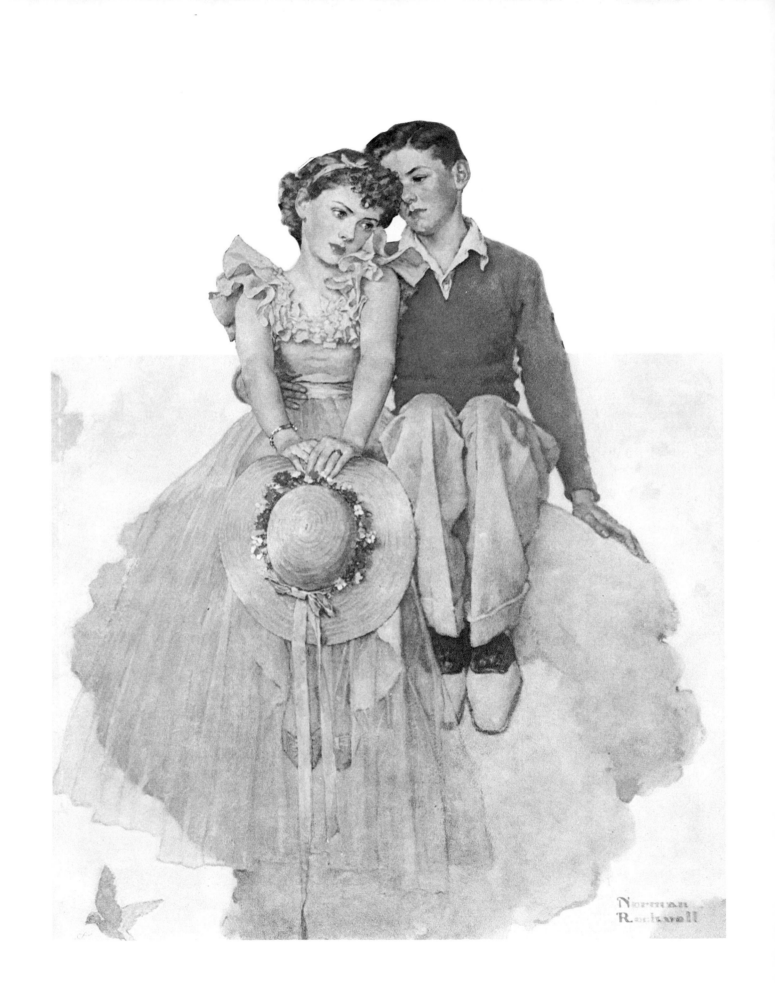

If thou must love me, let it be for nought
Except for love's sake only.

—*ELIZABETH BARRETT BROWNING*
"Sonnet XIV"

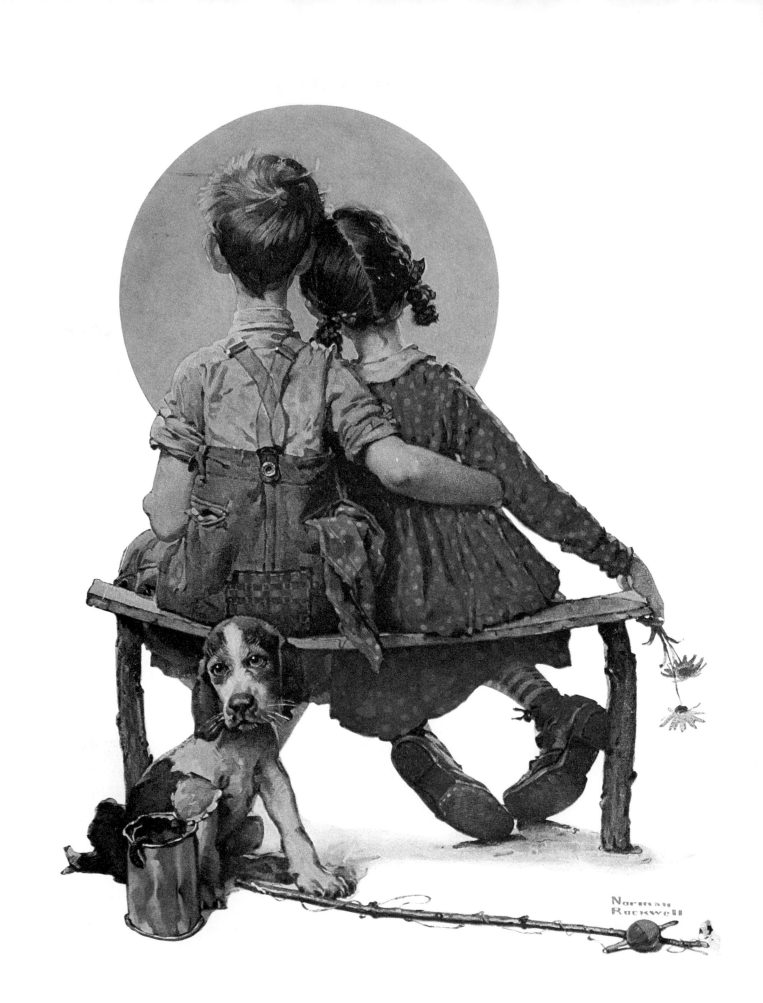

My love is like a red red rose
 That's newly sprung in June:
My love is like the melody
 That's sweetly play'd in tune.

As fair art thou, my bonnie lass,
 So deep in love am I:
And I will love thee still, my dear,
 Till a' the seas gang dry.

Till a' the seas gang dry, my dear,
 And the rocks melt wi' the sun:
And I will love thee still, my dear,
 While the sands o' life shall run.

And fare thee weel, my only love,
 And fare thee weel a while!
And I will come again, my love,
 Tho' it were ten thousand mile.

 —ROBERT BURNS
 "My Love Is Like a Red Red Rose"

I carry your heart with me(i carry it in
my heart)i am never without it(anywhere
i go you go,my dear;and whatever is done
by only me is your doing,mydarling)
 i fear
no fate(for you are my fate,my sweet)i want
no world(for beautiful you are my world,my true)
and it's you are whatever a moon has always meant
and whatever a sun will always sing is you

here is the deepest secret nobody knows
(here is the root of the root and the bud of the bud
and the sky of the sky of a tree called life;which grows
higher than soul can hope or mind can hide)
and this is the wonder that's keeping the stars apart

i carry your heart(i carry it in my heart)

—E. E. CUMMINGS

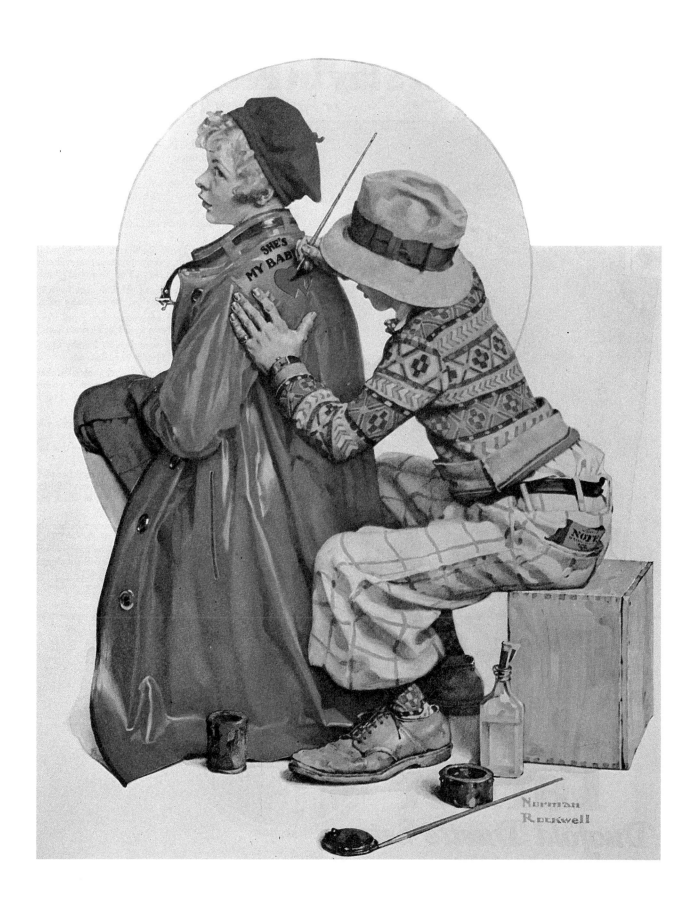

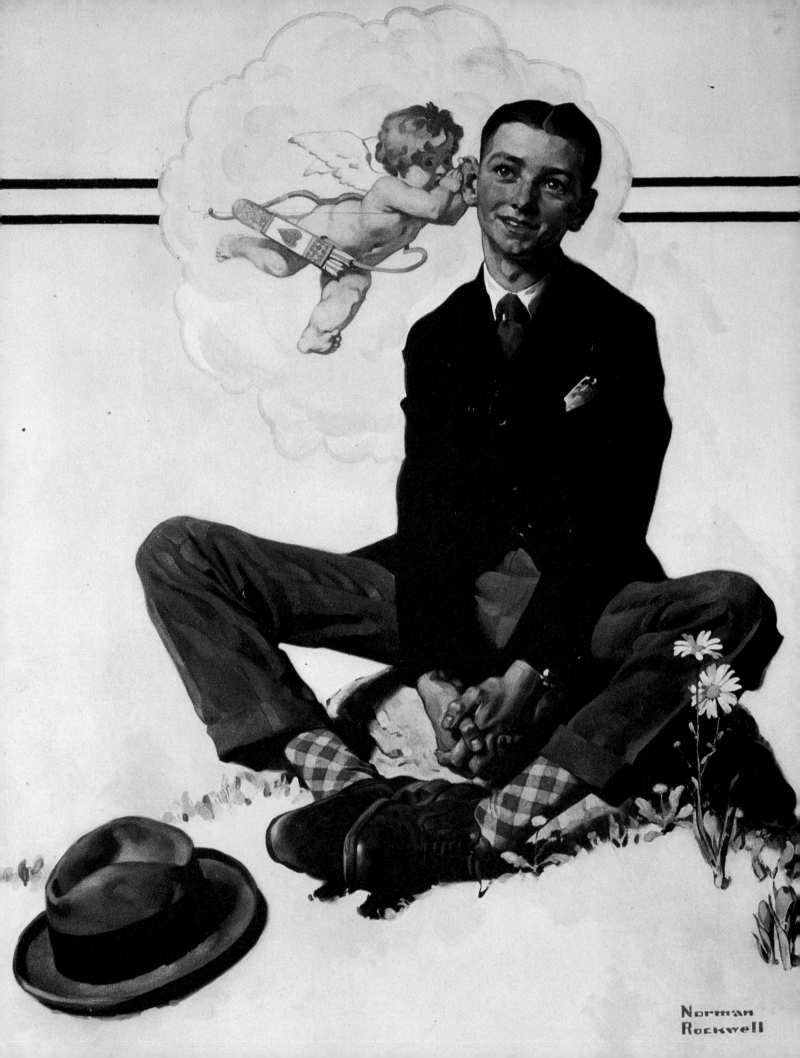

No popular respect will I omit
To do the honor on this happy day,
When every loyal lover tasks his wit
His simple truth in studious rhymes to pay,
And to his mistress dear his hopes convey.
Rather thou knowest I would still outrun
All calendars with Love's, — whose date alway
Thy bright eyes govern better than the sun, —
For with thy favor was my life begun ;
And still I reckon on from the smiles to smiles,
And not by summers, for I thrive on none
But those thy cheerful countenance compiles :
O! if it be to choose and call thee mine,
Love, thou art every day my Valentine.

—THOMAS HOOD
"For the fourteenth of February"

VALENTINE'S DAY DELIGHT

PRALINE ICE CREAM PIE

Yield: 8 servings
½ cup packed brown sugar
½ cup whipping cream
2 T. butter or margarine
1 cup chopped pecans
1 tsp. vanilla
1½ quarts vanilla ice cream
1 baked 9-inch pastry shell
3 egg whites
½ tsp. vanilla
¼ tsp. cream of tartar
⅓ cup granulated sugar
Rum Sauce

In medium skillet heat and stir brown sugar over medium-low heat just till sugar melts, about 10 to 12 minutes. Gradually blend in cream; cook 2 to 3 minutes more, or till smooth. Remove from heat; stir in butter, pecans, and the 1 teaspoon vanilla. Cool.

Stir ice cream just to soften. Quickly fold in praline mixture. Turn into pastry shell. Freeze. Just before serving, beat egg whites, the ½ teaspoon vanilla, and the cream of tartar to soft peaks. Gradually add granulated sugar, beating to stiff peaks. Spread meringue atop ice cream, seal-ing to edge. Bake in 475° oven for 4 to 5 minutes, or till lightly browned. Serve immediately with Rum Sauce.

RUM SAUCE:

In small saucepan combine 2 beaten egg yolks, ½ teaspoon grated lemon peel, ¼ cup lemon juice, ¼ cup sugar, and 4 tablespoons butter or margarine. Cook and stir till thickened. Stir in 3 tablespoons light rum. Makes about 1 cup.

—THE STANFORD COURT HOTEL

Lincoln was a long man.
He liked out of doors.
He liked the wind blowing
And the talk in country stores.

He liked telling stories,
He liked telling jokes.
"Abe's quite a character,"
Said quite a lot of folks.

Lots of folks in Springfield
Saw him every day,
Walking down the street
In his gaunt, long way.

Shawl around his shoulders,
Letters in his hat.
"That's Abe Lincoln."
They thought no more than that.

Knew that he was honest,
Guessed that he was odd,
Knew he had a cross wife
Though she was a Todd.

Knew he had three little boys
Who liked to shout and play,
Knew he had a lot of debts
It took him years to pay.

Knew his clothes and knew his house.
"That's his office, here.
Blame good lawyer, on the whole,
Though he's sort of queer.

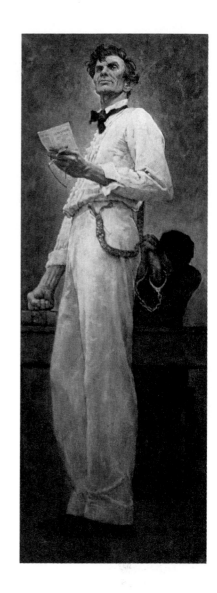

"Sure, he went to Congress, once,
But he didn't stay.
Can't expect us all to be
Smart as Henry Clay.

"Need a man for troubled times?
Well, I guess we do.
Wonder who we'll ever find?
Yes—I wonder who."

That is how they met and talked,
Knowing and unknowing.
Lincoln was the green pine.
Lincoln kept on growing.

—*STEPHEN VINCENT BENÉT*
"Abraham Lincoln, 1809–1865"

PRESIDENT'S BIRTHDAY DINNER

Tomato Soup

Bread Sticks

Pork Chop and Potato Casserole

Little Corn Pones Green Salad

Mincemeat Pielets

Coffee

MINCEMEAT PIELETS

Yield: 6 pielets
6 T. mincemeat
6 tsp. applesauce
1 double crust pie shell
1 egg, beaten

Cut pie crust into twelve 3-inch circles. Spread half of the circles with 1 tsp. applesauce each, leaving a ¼-inch rim clear. Over the applesauce spread 1 T. mincemeat. Moisten the edges with beaten egg and cover with the remaining pastry circles, making a few slits. Press and crimp the edges together and bake at 375° for 15–20 minutes or until well browned.

—*The Delineator*, 1928

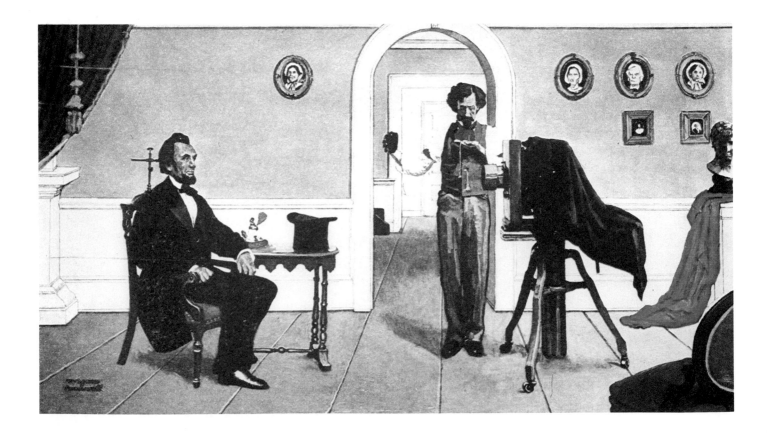

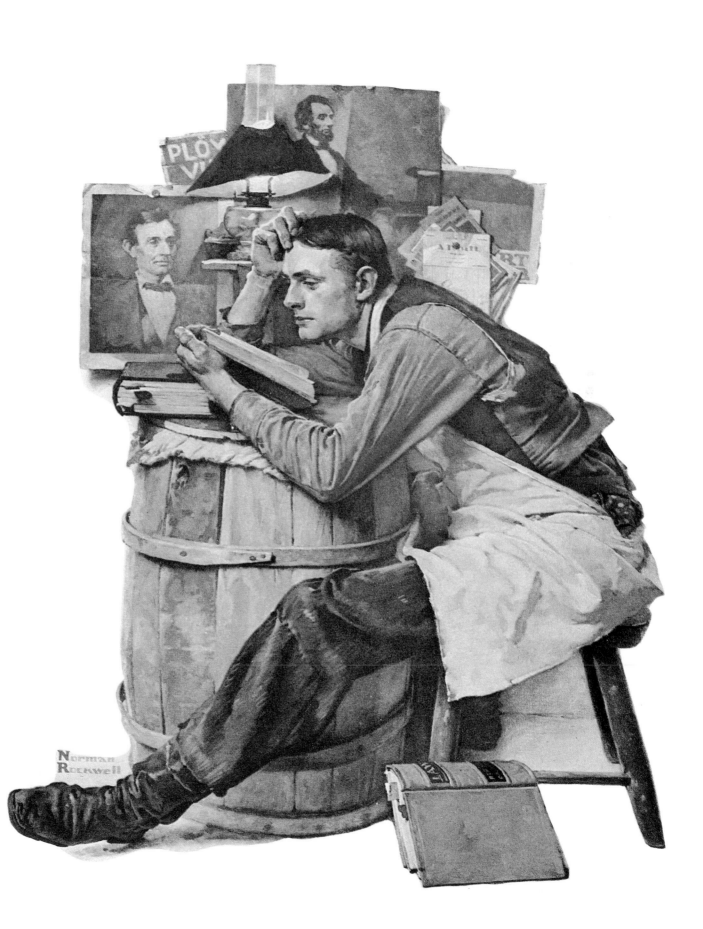

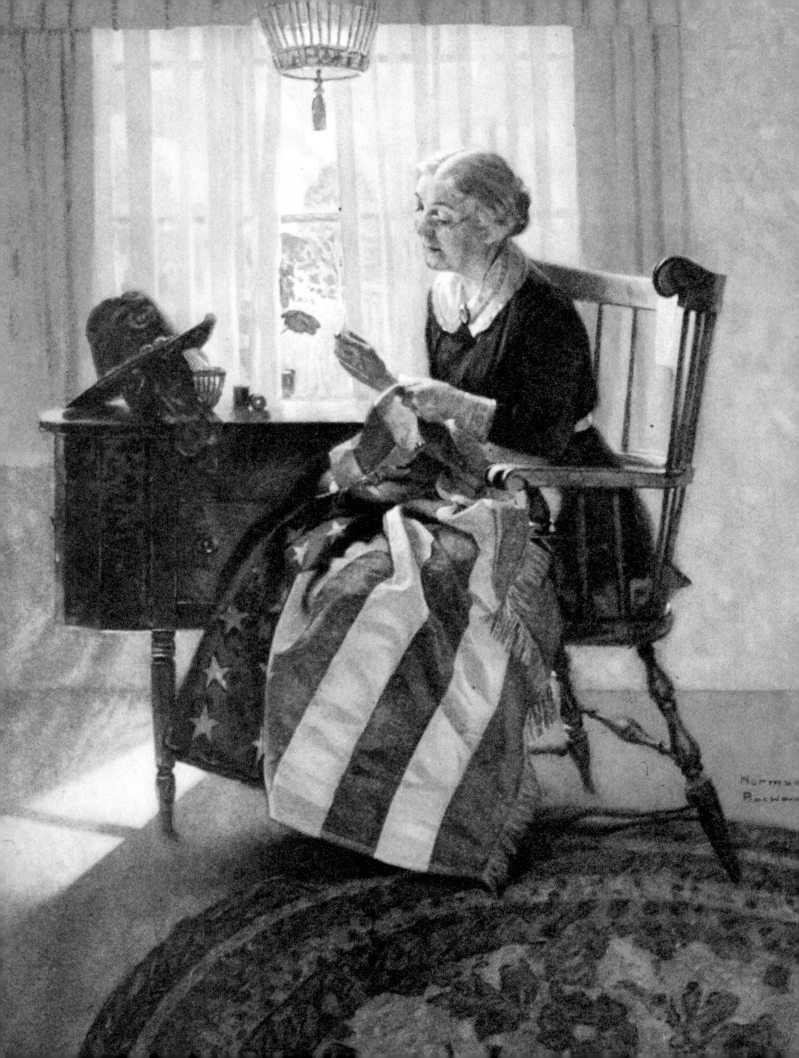

GEORGE WASHINGTON'S OLD-FASHIONED CHERRY PIE

Pastry for 9-inch two-crust pie
 3 cups canned water-pack sour red pitted cherries, drained
¾ cups sugar
 4 T. flour
⅛ tsp. salt
½ cup cherry liquid
½ tsp. almond extract
 few drops red food coloring
 1 T. butter *or* margarine

Heat oven to 425° (hot).

Roll out half the pastry and line a 9-inch plate. Drain cherries and reserve ½ cup of the juice. Mix together sugar, flour, and salt in a saucepan. Gradually add the ½ cup cherry juice; mix until smooth. Cook over moderate heat, stirring constantly, until smooth and thickened. Remove from heat and stir in almond extract and red food coloring. Pour sauce over cherries and mix gently.

Pour into lined pie plate; dot top with butter. Roll out rest of pastry and place over cherries. Trim and flute edge. Bake 35 to 40 minutes until crust is brown.

For a shiny crust, brush top with milk, cream, ice water, or slightly beaten egg yolk before baking; for a sparkling top, sprinkle with granulated sugar.

THE RIVER RAT

WHERE DOES A TROUT fisherman go during the icy month of February?

To New Zealand, of course, where there are rivers that have *never* been fished before!

I was fishing the Hunter, one of Prince Charles's favorite rivers, when I found myself snagged up on the river bottom. Another good muddler, I thought, gone! But then my line began to move, slowly at first, and then suddenly it was moving deep and hard and I knew I had hooked a tremendous fish.

For more than a half hour the fish fought; with all his strength he tried to make his break to freedom. He sounded, he charged, he jumped, he tore line from my reel, he made me slip and fall into the river. But I held him and took him in until he lay, all eight pounds, on the sandy bank, his huge toothy jaws held fiercely open.

"Forgive me, trout," I said aloud and struck him all at once stone dead.

Wet and cold, arm aching, trembling with my unexpected victory, I sat beside my beautiful scarlet-streaked rainbow trout talking to myself like an idiot, shouting my joy to the snowy peaks of the Southern Alps, for surely I was reeling with my conquest.

I told myself that all a fisherman had to do was make a catch like that, one rare catch, and the day belonged to him, for God had smiled upon him.

When I opened the trout, I discovered an eight-inch freshly swallowed river rat entombed in its pearly belly. I had never seen a rat in a trout's stomach before, only beetles and grasshoppers and minnows. The sight of the rat dis-

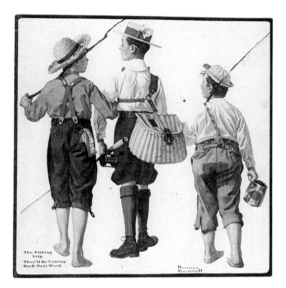

The Fishing
Trip
They'll Be Coming
Back Next Week

Norman
Rockwell

turbed me and I heaved it back into the river, feeling almost sorry I had killed this fish because he must have been a savage and brave hunter.

Later that evening, when I returned to my lakeside hotel with my trophy trout in hand, there were two elderly and very refined American ladies from Greenwich, Connecticut, who, greatly admiring my fish, asked if I might share him for dinner.

"Don't you want a picture of your fish?" one of the silver-haired ladies asked.

"Never cared for pictures of dead fish," I said.

"You should have had him mounted," ventured the other. "Why, he's as big as the ones mounted in the bar."

After dinner, I thought, Mendoza, why don't you go over to the Connecticut ladies and inform them that they have just eaten a trout that had an eight-inch river rat in its stomach. Go on, tell them, and watch their faces turn all red and confused. Dare you, Mendoza, do it, tell them.

But I didn't. I don't know why I didn't tell them because it's something that I would have done, perverse being that I sometimes am.

Now the trout was part of me forever and, I suppose, so was the river rat too. As for the ladies from Connecticut, they departed early the following morning, leaving behind a gift for me—a rare and very expensive bottle of New Zealand's best Pinot Chardonnay.

If I had told them about the river rat, I might have been drinking beer.

—GEORGE MENDOZA

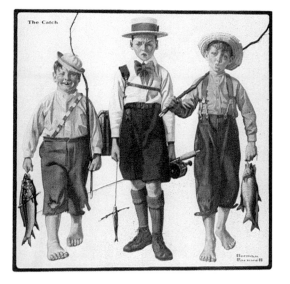
The Catch

I like nothing better than to go out in the country and bloviate.

—*WARREN GAMALIEL HARDING*
May 1920

The Cock is crowing,
The stream is flowing,
The small birds twitter,
The lake doth glitter,
The green field sleeps in the sun;
The oldest and youngest
Are at work with the strongest;
The cattle are grazing,
Their heads never raising;
There are forty feeding like one!
Like an army defeated
The snow hath retreated,
And now doth fare ill
On the top of the bare hill;
The ploughboy is whooping—anon—anon:
There's joy in the mountains;
There's life in the fountains;
Small clouds are sailing,
Blue sky prevailing;
The rain is over and gone!

—WILLIAM WORDSWORTH
"Written in March"

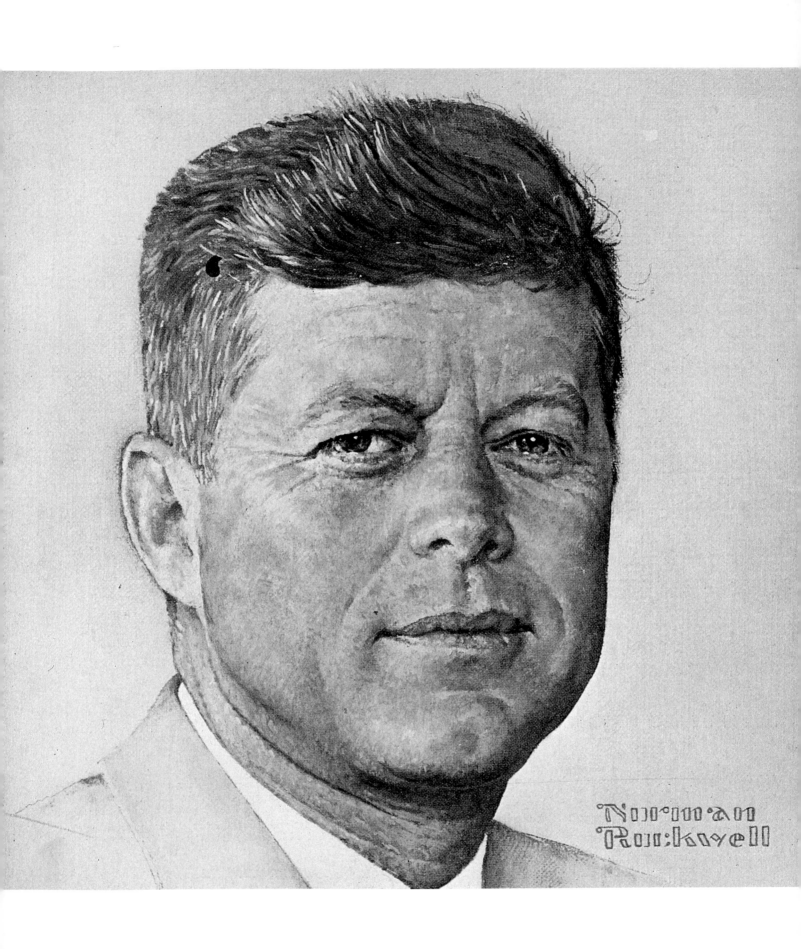

O Ireland, isn't it grand you look—
Like a bride in her rich adornin'?
And with all the pent-up love of my heart
I bid you the top o' the mornin'!

—*JOHN LOCKE*

THE EXACT DATE of Saint Patrick's birth, somewhere in Scotland, is unverified. His name at birth, however, was Maewyn and the time was between A.D. 373 and 395. Whatever facts are known regarding his life are obtained from his *Confession*, an explanation of his actions to his religious superiors. At the age of sixteen, he was captured by Irish marauders and sent to Ireland, where he spent six years in captivity tending sheep. It was during this period that he had the first of frequent visions which were to guide his life and which, at this time, assisted his escape.

For the next eighteen years, he remained on the Continent, studying at the monastery of Saint Martin of Tours in France. Later he entered the priesthood and ultimately became a bishop. Subsequently, Pope Celestine I named him Patrick and sent him to Ireland as a missionary.

It was during his campaign to convert the inhabitants from Druidism to Christianity that the legends regarding Saint Patrick arose. The shamrock was used by Saint Patrick to explain the concept of the Trinity, that one unity can have three equal components. The three leaves joined at the stem symbolized this idea. It is interesting to note, however, that the shamrock was also used in ancient Celtic fertility rites.

On his missionary travels, Saint Patrick was preceded by a drummer to announce his arrival. And, according to legend, it was with drumming that he banished all the snakes from Ireland. He had to dupe the last snake by luring him into a box, which he then hurled into the sea.

The first United States observance of Saint Patrick's death occurred in Boston in 1737 and was sponsored by the Charitable Irish Society of Boston. In Philadelphia in 1780, the Friendly Sons of St. Patrick began celebrating the day in that city, and its branch in New York began celebrating in 1784. These societies were fostered to a great extent by the Irish veterans of the American Revolution.

WHAT GOOD IS AN Irish drink without a toast? Here are a couple of tips on how to toast:

Toast with the glass in your right hand.
Raise glass straight out from your shoulder, in case you are concealing a sword or dagger.
Clink glasses after the toast is said and before drinking. The noise frightens evil spirits!

Those are the rules, now here is a sampling of Irish toasts.

Slainte (pronounced slawn'che), which means "health" in Gaelic and is the Irish equivalent of "cheers" "skol."

Here's a good wish for the farmer:

"May the frost never afflict your
 spuds.
May the outside leaves of your cabbage
 always be free from worms.
May the crows never pick your
 haystack,
and may your donkey always be in foal."

For your St. Patrick's Day dinner party:

"May the roof above us
 never fall in
and may we friends gathered below
 never fall out."

For your birthday:

"May you die in bed at 95 years,
shot by a jealous husband (wife)."

A couple of general ones:

"May the grass grow long
on the road to hell
for the want of use."

"Here's a health
to your enemies' enemies."

Finally, here's a toast for the man himself:

St. Patrick was a gentleman
who through strategy and
stealth
drove all the snakes from
Ireland.
Here's toasting to his health—
but not too many toastings
lest you lose yourself and then
forget the good St. Patrick
and see all those snakes again.

BEWARE THOUGHTS that come in the night. They aren't turned properly; they come in askew, free of sense and restriction, deriving from the most remote of sources. Take the idea of February 17, a day of canceled expectations, the day I learned my job teaching English was finished because of declining enrollment at the college, the day I called my wife from whom I'd been separated for nine months to give her the news, the day she let slip about her "friend"—Rick or Dick or Chick. Something like that.

That morning, before all the news started hitting the fan, Eddie Short Leaf, who worked a bottomland section of the Missouri River and plowed snow off campus sidewalks, told me if the deep cold didn't break soon the trees would freeze straight through and explode. Indeed.

That night, as I lay wondering whether I would get sleep or explosion, I got the idea instead. A man who couldn't make things go right could at least go. He could quit trying to get out of the way of life. Chuck routine. Live the real jeopardy of circumstance. It was a question of dignity.

The result: on March 19, the last night of winter, I again lay awake in the tangled bed, this time doubting the madness of just walking out on things, doubting the whole plan that would begin at daybreak—to set out on a long (equivalent to half the circumference of the earth), circular trip over the back roads of the United States. Following a circle would give a purpose—to come around again—where taking a straight line would not. And I was going to do it by living out of the back end of a truck. But how to begin a beginning?

A strange sound interrupted my tossing. I went to the window, the cold air against my eyes. At first I saw only starlight. Then they were there. Up in the March blackness, two entwined skeins of snow and blue geese honking north, undulating W-shaped configuration across the deep sky, white bellies glowing eerily with the reflected light from town, necks stretched northward. Then another flock pulled by who knows what out of the south to breed and remake itself. A new season. Answer: begin by following spring as they did—darkly, with the neck stuck out.

The vernal equinox came on gray and quiet, a curiously still morning not winter and not spring, as if the cycle paused. Because things go their own way, my daybreak departure turned to a morning departure, then to an afternoon departure. Finally, I climbed into the van, rolled down the window, looked a last time at the rented apartment. From a dead elm sparrow hawks used each year came a high *whee* as the nestlings squealed for more grub. I started the engine. When I returned a season from now—if I did return—those squabs would be gone from the nest.

Accompanied only by a small, gray spider crawling the dashboard (kill a spider and it will rain), I drove into the street, around the corner, through the intersection, over the bridge, onto the highway. I was heading toward those little towns that get on the map—if they get on at all—only because some cartographer has a blank space to fill: Remote, Oregon; Simplicity, Virginia; New Freedom, Pennsylvania; New Hope, Tennessee; Why, Arizona; Whynot, Mississippi. Igo, California (just down the road from Ono), here I come.

—WILLIAM LEAST HEAT MOON
(WILLIAM TROGDON)
Blue Highways

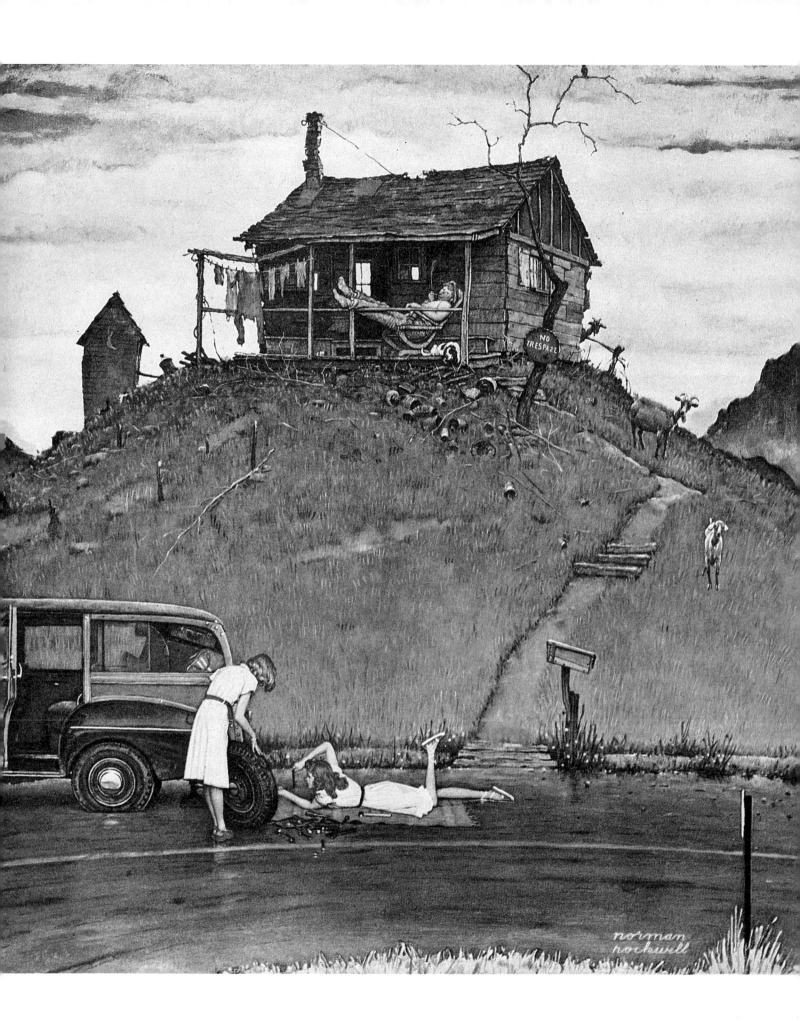

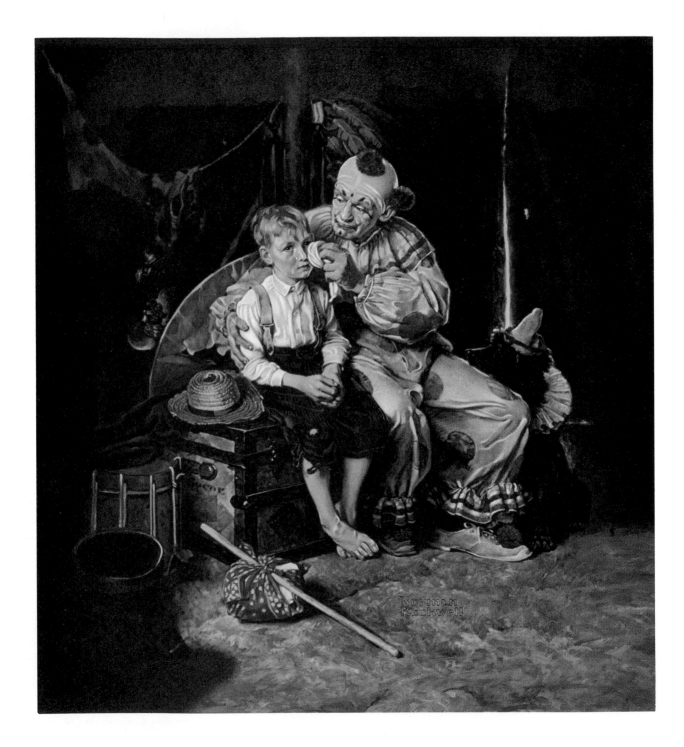

Things come inside a man
understand . . . ?
to be on a road, any road.
A road between fields,
a road between hills,
a road between clouds,
a road between roads,
sometimes I feel it come inside me
strong,
like the weight of a star.
And a voice buckets from my soul . . .
take the road between the snowy moons,
take the road between the first morning and the
 last night,
take the road between the pinch of lights
in the doryman's village,
but never take the road between your dreams.

—GEORGE MENDOZA

There was a road ran past our house
Too lovely to explore.
I asked my mother once—she said
That if you followed where it had led
It brought you to the milk-man's door.
(That's why I have not traveled more.)

—EDNA ST. VINCENT MILLAY
"The Unexplorer"

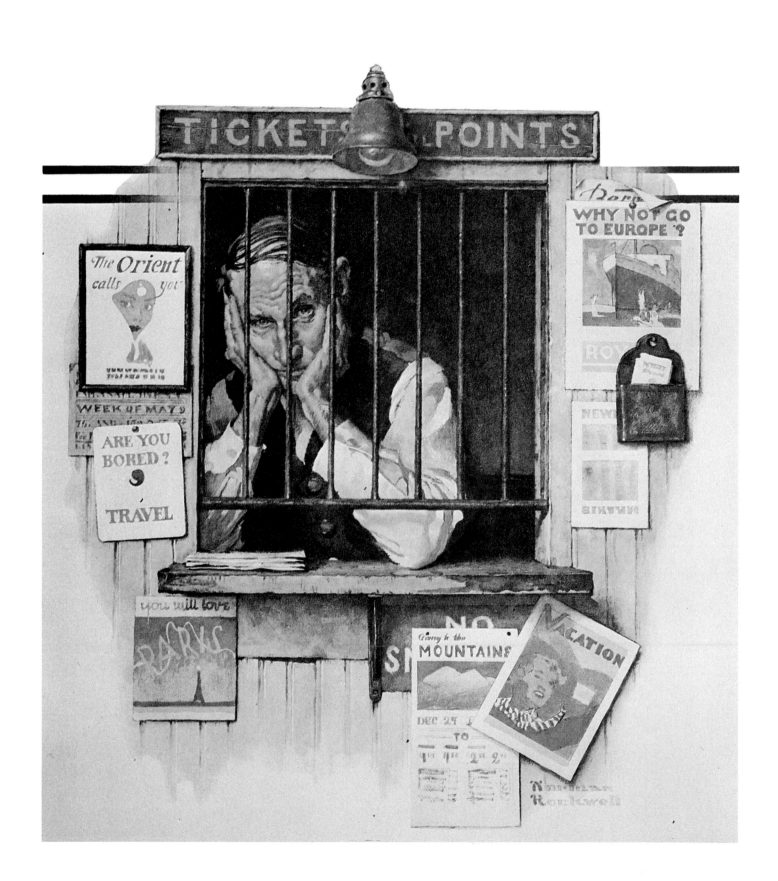

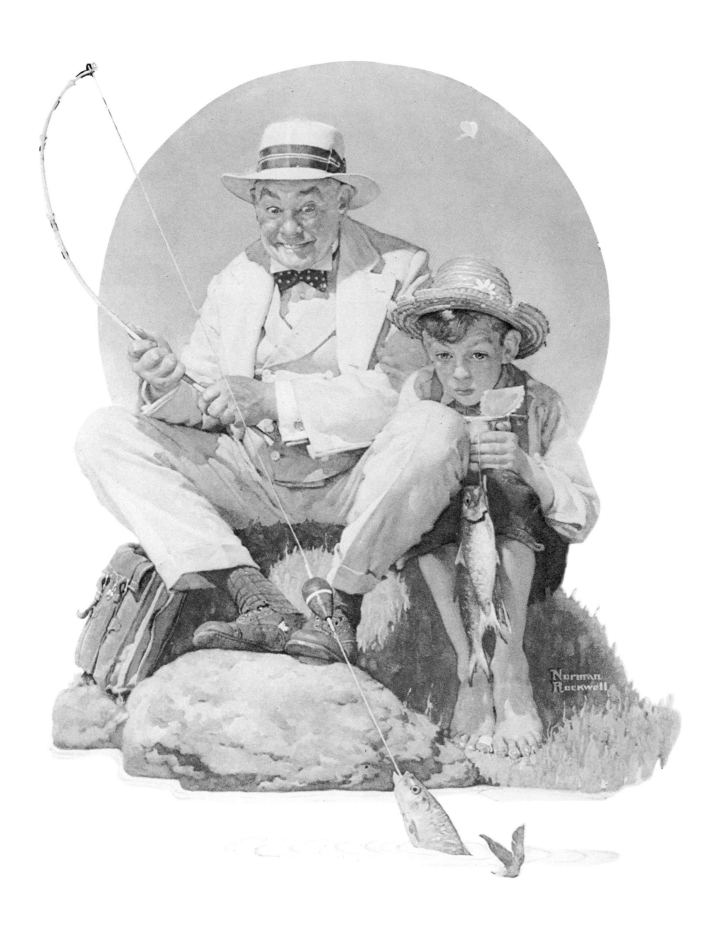

AH, SPRING! YOU'VE GOT ME BY THE HAND

SPRING IS THE TIME for lovers and flowers and trout fishermen. Since I am all three, I must prepare early, for the sounds of the river are near and the trout are waiting.

Winter ices in most fishermen, a time turned to memories of seasons past, a time for tying up rare feathers of birds and the fur of animals to make flies, trout flies and salmon flies, a time for reading more books about the fishing life, a waiting time for spring to come again.

Ah, spring! You've got me by the hand. My canvas trout creel that has waded rivers around the world is out once more. I can see that it's beginning to have a classic, worn look like a vintage car or a fine old wine. I like things that grow old, that touch places and time, marked by memories.

My trout rods are bamboo, not the new graphite that is becoming more fashionable. I take the gleaming sticks out of their leather cases as though I were opening the graves of their mastermakers: Garrison, Payne, and Leonard. All gone now. But not the life they left in the wood.

I know it's still too early; the season has not opened yet. There are no rivers below my terrace where a line may float the current. I must appear a fool to my neighbors across the way. *What is that man doing casting line from a piece of wood?*

Ah, spring! You are the wood and I your line. How good it feels to flick the bamboo again even though it be from my terrace overlooking leafless, dusty gardens. Now as I test the wood with my hand cocked firm, I am dreaming I am on my Battenkill in Vermont, casting to the tongues of water below the dam. Trout are rising in the chilling air. I am working a Quill Gordon (Iron Fraudator)* in the heavy currents, and a trout suddenly strikes, a fighter of two pounds, slashing out leader and line, my first trout of the new year.

How soon will it come—opening day? I know of fishermen who drive hundreds of miles to be with their rivers on opening day. It is usually raining and the wind is cold and the water freezing. Many know they will not catch a fish, not one trout will come to their fly. It doesn't matter, nothing matters on opening day except being there by your river. It is a madness that has saved many stark souls.

Meanwhile, there are days and nights still to go: reels must be oiled and played with, lines are greased and new leaders are knotted and fly boxes come open for the feathers will soon be in flight.

As for me, one fisher of the trouts, I am a dreamer from the terrace. If you see my line whipping past your window, I have not come to hook your flowerpots, only time and more dreams.

—GEORGE MENDOZA

* According to Art Flick, my friend and trout-fisherman extraordinaire, the Quill Gordon is the "first mayfly of consequence to emerge, coming rather early in the season, often appearing when the air is so cold that few of the flies are able to leave the water, being numbed and unable to fly."

Spring, the sweet Spring, is the year's
 pleasant king;
Then blooms each thing, then maids dance in
 a ring,
Cold doth not sting, the pretty birds do
 sing—
 Cuckoo, jug-jug, pu-we, to-witta-woo!

The palm and may make country houses gay,
Lambs frisk and play, the shepherds pipe all
 day,
And we hear aye birds tune this merry lay—
 Cuckoo, jug-jug, pu-we, to-witta-woo!

The fields breathe sweet, the daisies kiss our
 feet,
Young lovers meet, old wives a-sunning sit,
In every street these tunes our ears do greet—
 Cuckoo, jug-jug, pu-we, to-witta-woo!
 Spring, the sweet Spring!

 —THOMAS NASHE
 "Spring"

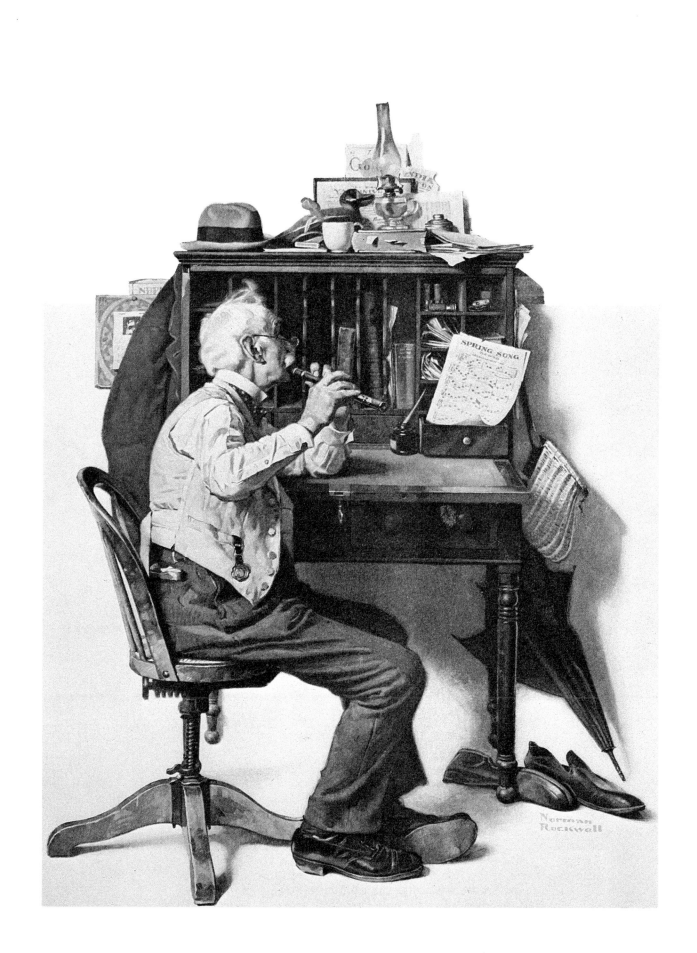

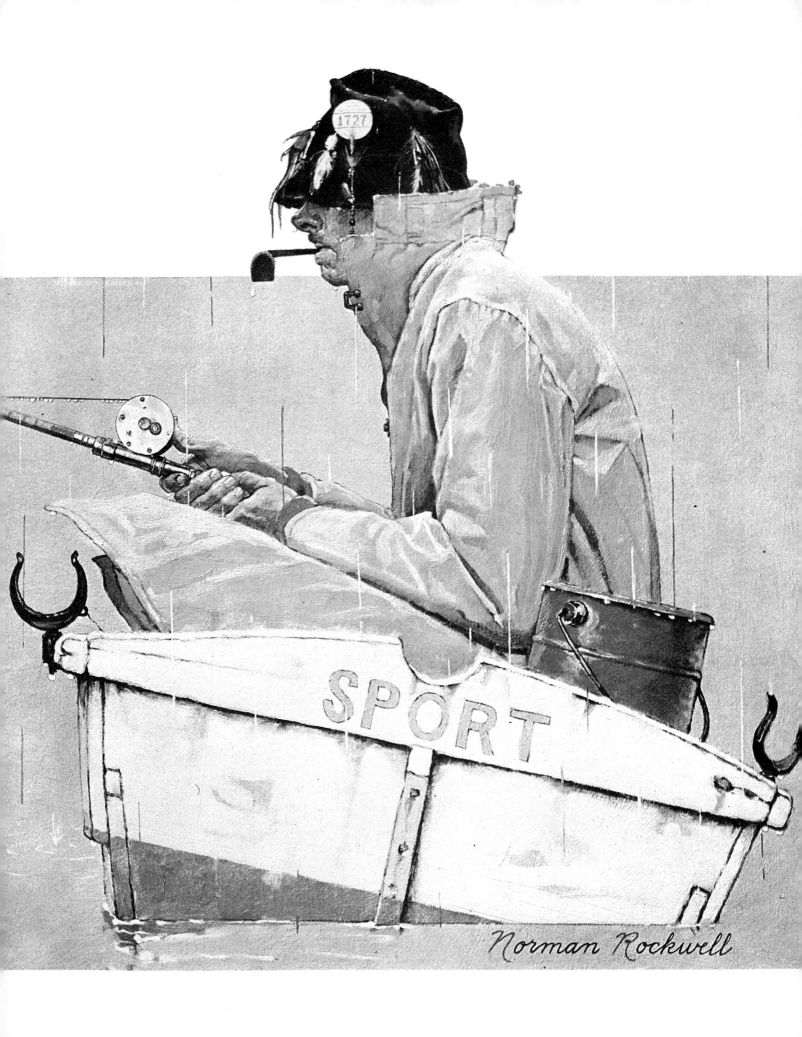

Norman Rockwell

FISHING THE MORNING LONELY

WHEN I WADE into a river fishing for trouts I feel as though I am entering another part of my soul. And as I watch the early lights flower in the shadows, I know I have come to the river seeking more, much more than the catching of the trouts.

How can I describe this to you—you who have fished the morning lonely and you who were never there?

I must relate an experience I had while picking my way among the stones downstream. The morning was glorious, coming up creamy colored mayflies.

It was a day to follow a brook, to drift every thought in your head out into the currents, to walk with the water, to glide upon it like a cloud.

Reflections of trees and flowers floated on the surface of the brook in a million images of flashing loveliness. *Truly*, I thought, *here is the face of God, in all this and not beyond this.*

Under the trees on the opposite bank it was dark, full of lost whispers, and there were trouts coming up, ripples of big and little trouts in pools scattered like wild flowers, unaware of a stalk of man sticking out of the river.

I was very quiet. I said to the river:

I have no name, no place have I come from and nowhere do I go, yet I am with you like one of your own rocks and I have come to take one of your fish.

Water swirled round the pilings of my boots, pressing hard against my legs. I felt like a boy again, adventuring along my first Vermont brook. It was the kind of day that I hoped would last forever, a day of wine and fruit and song.

Across the river I saw a huge dorsal fin slash the surface of a pool, and I could feel my chest suddenly expand with excitement.

I wanted to play that fish. A careful cast placed above him and the bamboo would soon be bending and my reel singing out.

I tied on a sulphur parachute, waxed it lightly with my fingers, then let it drop on the water so that I could evaluate its float. The wings of the parachute shot straight up, a natural fly, none better to take the trout.

I started to cast upstream, quartering my line across and up, mending the line quickly left to avoid the deadly, sudden drag.

It was all working, rod and line a ballet, every cast coming closer to the trout. Now I could see the fly sailing over his pool, and I could feel that fish as though my heart were at the end of the line. I told myself he was ready to leap for my delicate fly.

But he didn't leap for anything. That fly was perfect, I reassured myself and, picking up my line, I cast above him again. This time I would give the fly a tiny jiggle, make it look alive.

Suddenly a wave of laughter filled the air. And the fish struck at the precise moment of my distraction! He was there and I wasn't and now he had my beautiful parachute and a memory of fine tippet flowing from his lip.

I cursed and on top of that I cursed again. I knew my fish was down and gone. I could almost see him brooding beneath a ledge of darkened stone. He would not come up for a long time.

The laughter rose again stronger round the bend of the pool, and I made my way toward the sounds that had ruined my morning catch.

When we looked at each other across the river none of us could believe the truth absurd. Hadn't we traveled far and long enough to avoid human company?

But there we were, a fisherman fishing the morning lonely, and a boy and girl in the nest of a rubber raft spinning waves of love in the hiding place of a dark brook cove.

What could we say and if we knew what to say—how then to say it?

I looked up into the sky, full of the memory of those lovely open legs.

—GEORGE MENDOZA

Praise the spells and bless the charms,
I found April in my arms.
April golden, April cloudy.
Gracious, cruel, tender, rowdy;
April soft in flowered languor
April cold with sudden anger,
Ever changing, ever true—
I love April. I love you.

<div style="text-align:right">

—*OGDEN NASH*
"Always Marry an April Girl"

</div>

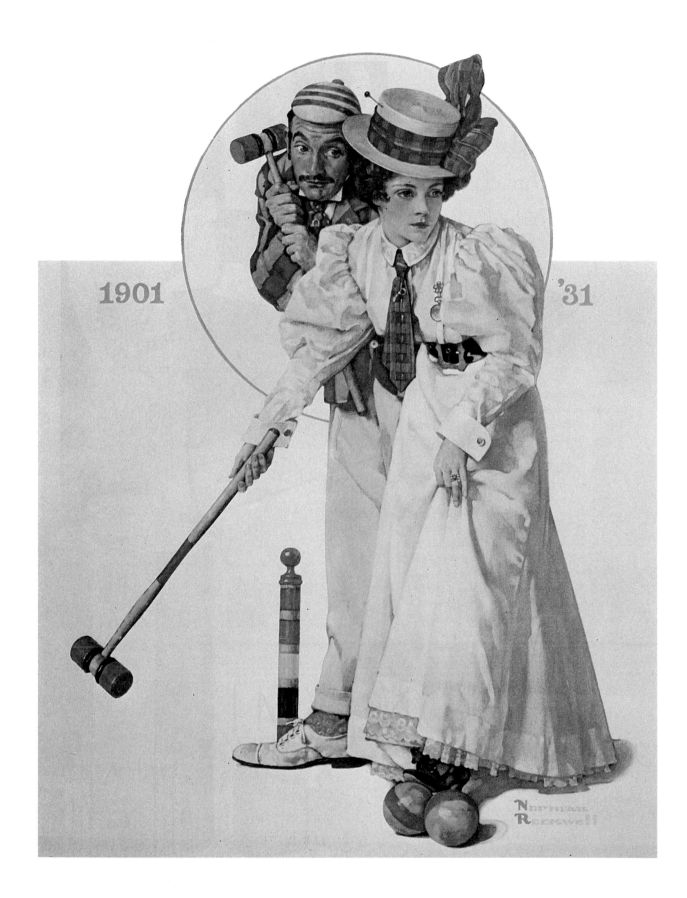

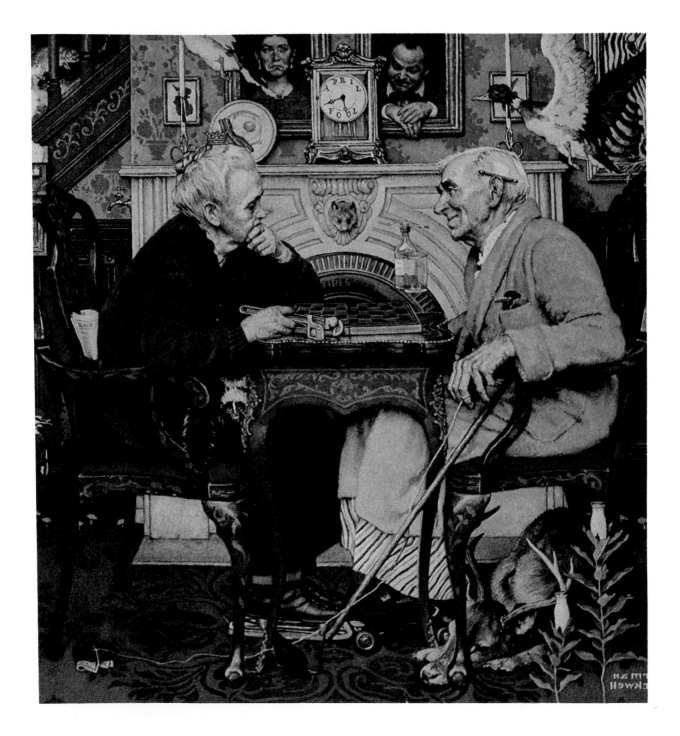

THERE ARE MANY EXPLANATIONS of the origin of April Fools' Day, none of which has been satisfactorily authenticated. The day most probably relates to an ancient New Year's festival held on the vernal equinox, March 21, the beginning of the new year according to the pre-Gregorian calendar. In France, the custom of April fooling developed after the implementation of the Gregorian calendar by Charles IX in 1564 moved the beginning of the new year to January 1. Prior to the change, it had been customary to exchange New Year's gifts on April 1. When the date was changed, people began to send mock gifts on April 1. It was only sometime later that the custom made its way to England and Scotland. In Scotland, one of the favorite pranks is to send someone off to hunt a *gowk* ("cuckoo"). The word *gowk* is derived from *geck*, which means "someone who is easily imposed upon." The prank was so common that in Scotland the day is known as April's Gowk Day.

The first of April, some do say,
Is set apart for All Fools' Day,
But why the people call it so
Nor I, nor they themselves do know.
But on the day are people sent
On purpose for pure merriment.

—*Poor Robin's Almanac,* 1760

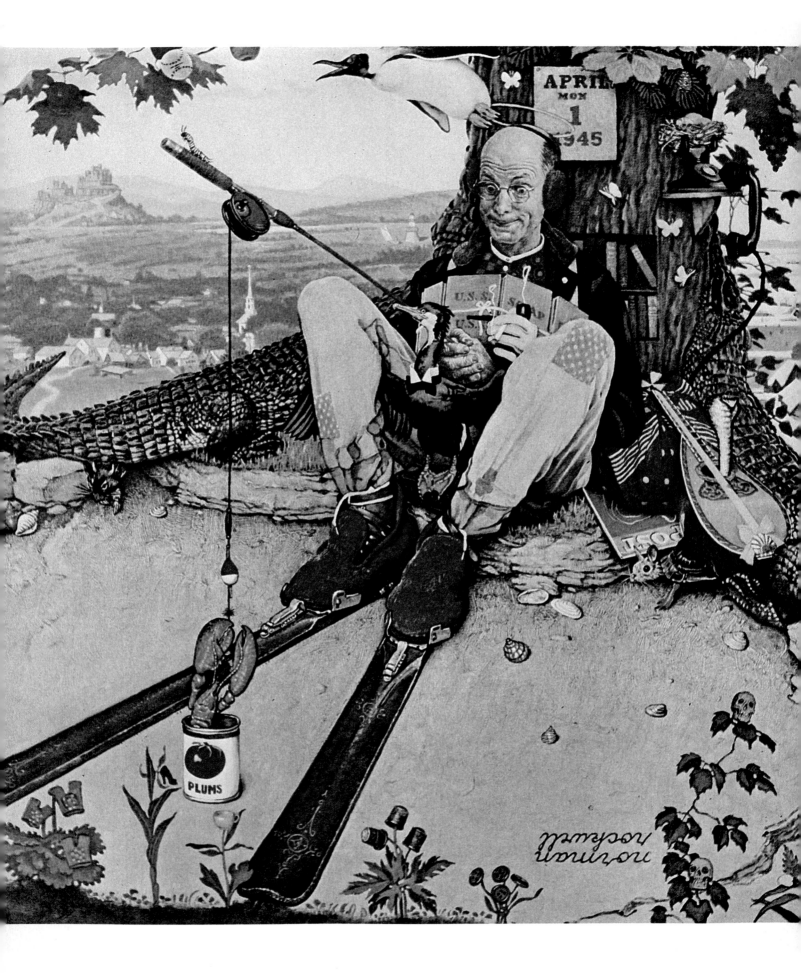

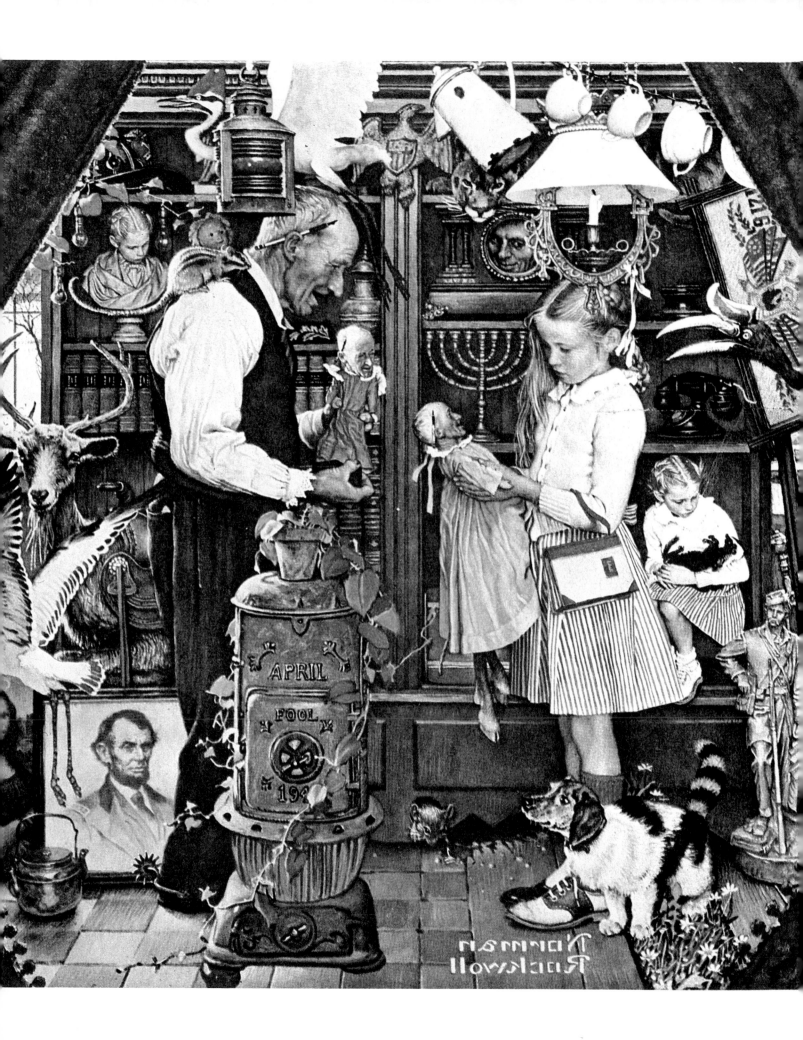

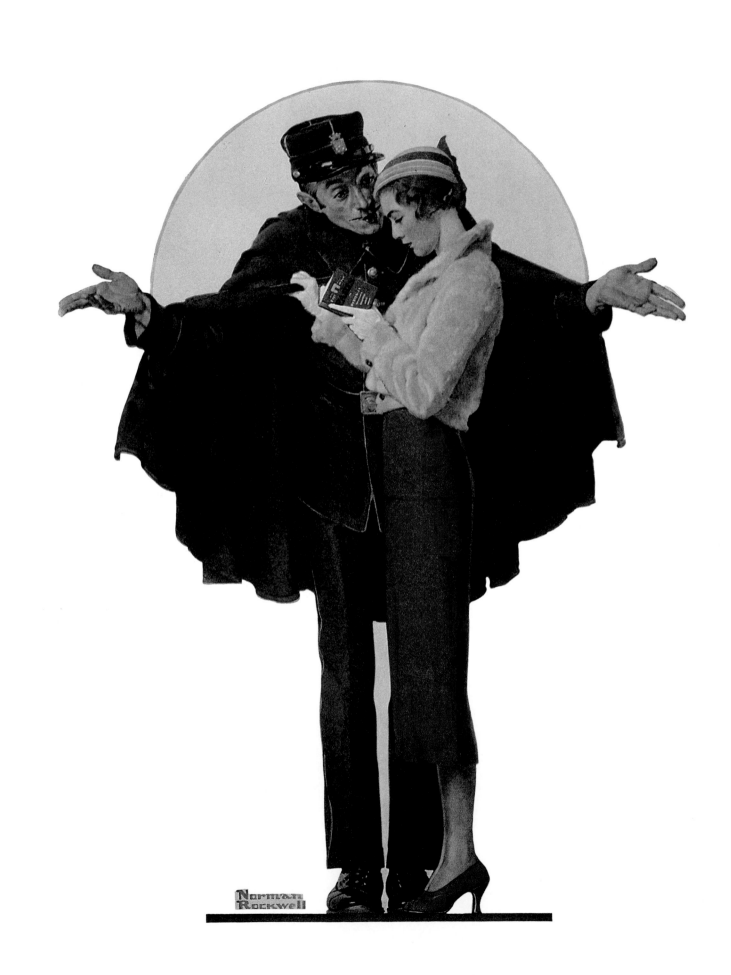

ONE WHO HAS hotel reservations and speaks no French is a tourist. Anthropologists are fond of defining him, although in their earnestness they tend to miss the essence. Thus Valene L. Smith in *Hosts and Guests: The Anthropology of Tourism:* "A tourist is a temporarily leisured person who voluntarily visits a place away from home for the purpose of experiencing a change." But that pretty well defines a traveler too. What distinguishes the tourist is the motives, few of which are ever openly revealed: to raise social status at home and to allay social anxiety; to realize fantasies of erotic freedom; and most important, to derive secret pleasure from posing momentarily as a member of a social class superior to one's own, to play the role of a "shopper" and spender whose life becomes significant and exciting only when one is exercising power by choosing what to buy. Cant as the tourist may of the Taj Mahal and Mt. Etna at sunset, his real target today is the immense Ocean Terminal at Hong Kong, with its miles of identical horrible camera and tape-recorder shops. The fact that the tourist is best defined as a fantasist equipped temporarily with unaccustomed power is better known to the tourist industry than to anthropology.

—*PAUL FUSSELL*
Abroad

Paris; this April sunset completely utters
utters serenely silently a cathedral

before whose upward lean magnificent face
the streets turn young with rain,
spiral acres of bloated rose
coiled within cobalt miles of sky
yield to and heed
the mauve
 of twilight (who slenderly descends,
daintily carrying in her eyes the dangerous first stars)
people move love hurry in a gently

arriving gloom and
see!(the new moon
fills abruptly with sudden silver
these torn pockets of lame and begging colour)while
there and here the lithe indolent prostitute
Night,argues

with certain houses

—*E. E. CUMMINGS*

My favorite city in all the world is Paris, because I've had such wonderful moments in that city and it has always seemed to be a friend when I return to her parks and bridges and cafés.

People remember a face in Paris. "Bonjour, monsieur, yes it's good to see you again too!"

I know Paris is Hemingway and chestnut trees and beautiful girls and it makes your heart say, "I want to stay in this city forever even if it means I'm going to be poor . . ." But it's something more and my heart has never divulged that secret.

—*GEORGE MENDOZA*

GOOD FRIDAY HOT CROSS BUNS

The Good Friday custom of eating hot cross buns has continued to the present. In ancient times, the sign of the cross on the bun made it a Christian cake. Often the housewife used to make the cross on a loaf of bread to prevent the devil from interfering with her baking—and since Good Friday was supposed to be the most unlucky day of the year, she naturally took every precaution to guard against evil influences and make her baking a success.

 3 cups scalded milk
 2 pkg. dry yeast
 1 cup flour (approximate)

Scald milk. When lukewarm, add yeast and enough flour to make a thick batter. Beat well; cover and place in a warm place overnight to form a sponge.

Next morning add:

 1 cup sugar
 ½ cup melted lukewarm butter
 ½ tsp. nutmeg
 1½ tsp. salt
 4–5 cups flour to form a soft dough

Knead well and let rise for 5 hours. Punch down and roll out to ½-inch thickness. Cut into 2-inch rounds. Place on buttered cookie sheets and let rise in a warm place ½ hour. Lightly make cross on each bun with sharp knife or razor blade. Bake at 350° for 20 minutes or until lightly brown. When done, brush with egg white mixed with a little sugar or glaze with a little molasses and milk. If desired, form white sugar crosses by drizzling the following glaze over warm buns: 1 cup confectioners' sugar, sifted, mixed with 1½ T. milk and ¼ tsp. vanilla. Makes 2½ dozen buns.

—The Delineator, 1895

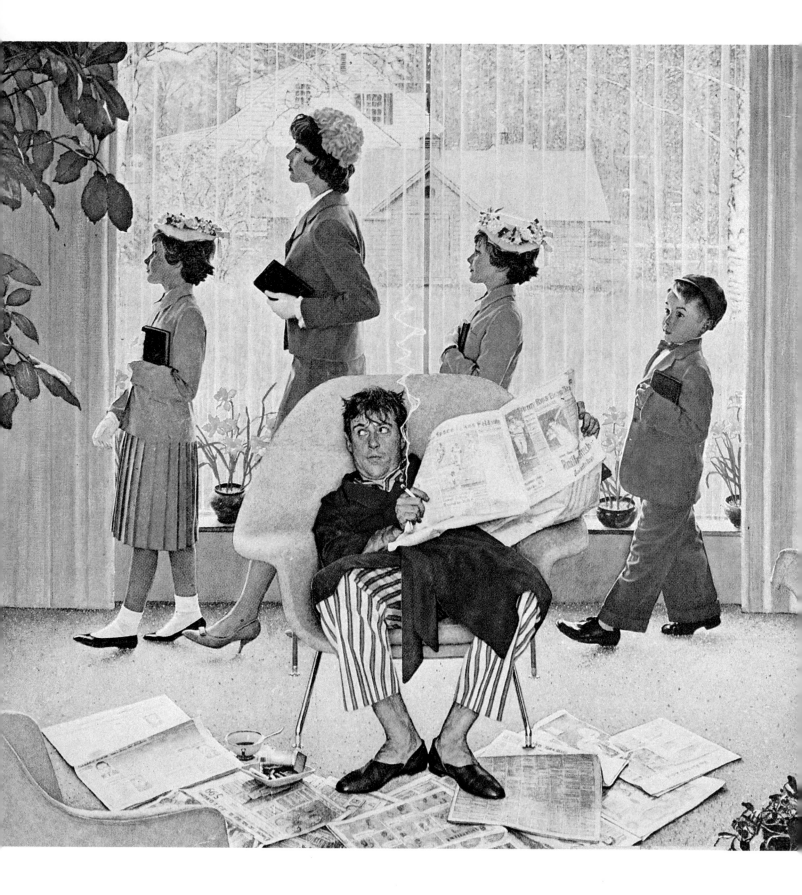

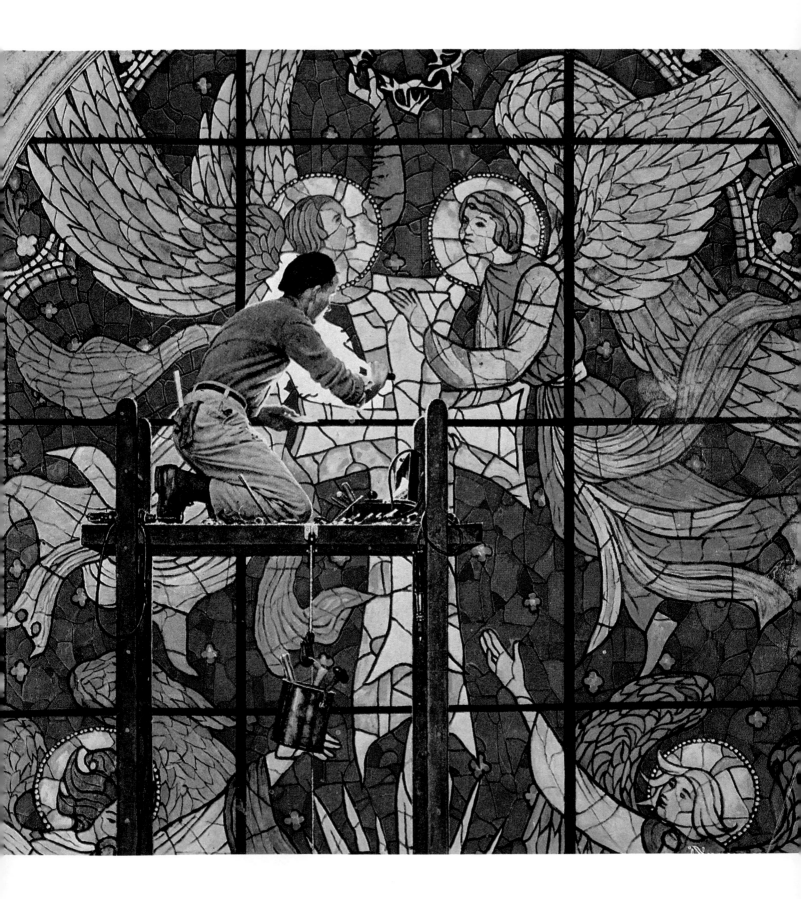

One a penny, *buns,*
Two a penny, *buns,*
One a penny, two a penny,
Hot cross buns!

One a penny, two a penny,
Hot cross buns,
If you have no daughters, give them to your sons;
But if you have none of these merry little elves,
Then you may keep them all for yourselves.

<div align="right">

—"Hot Cross Buns! Hot Cross Buns!"
Eighteenth-century cry of English vendors

</div>

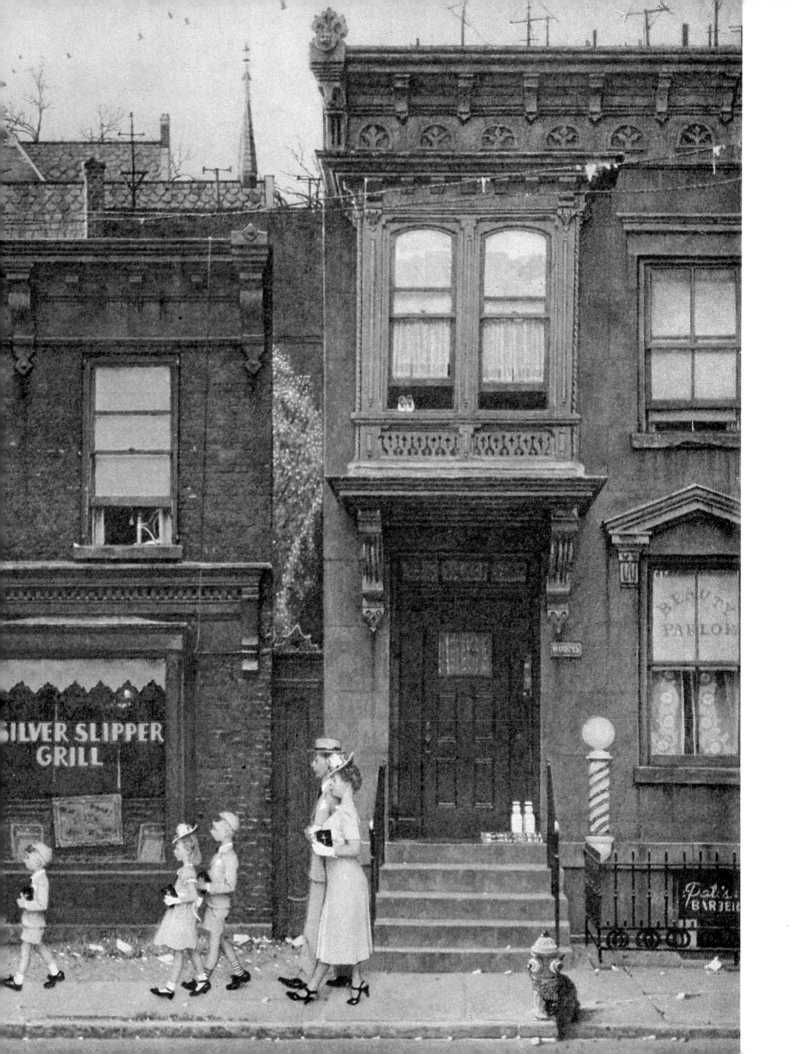

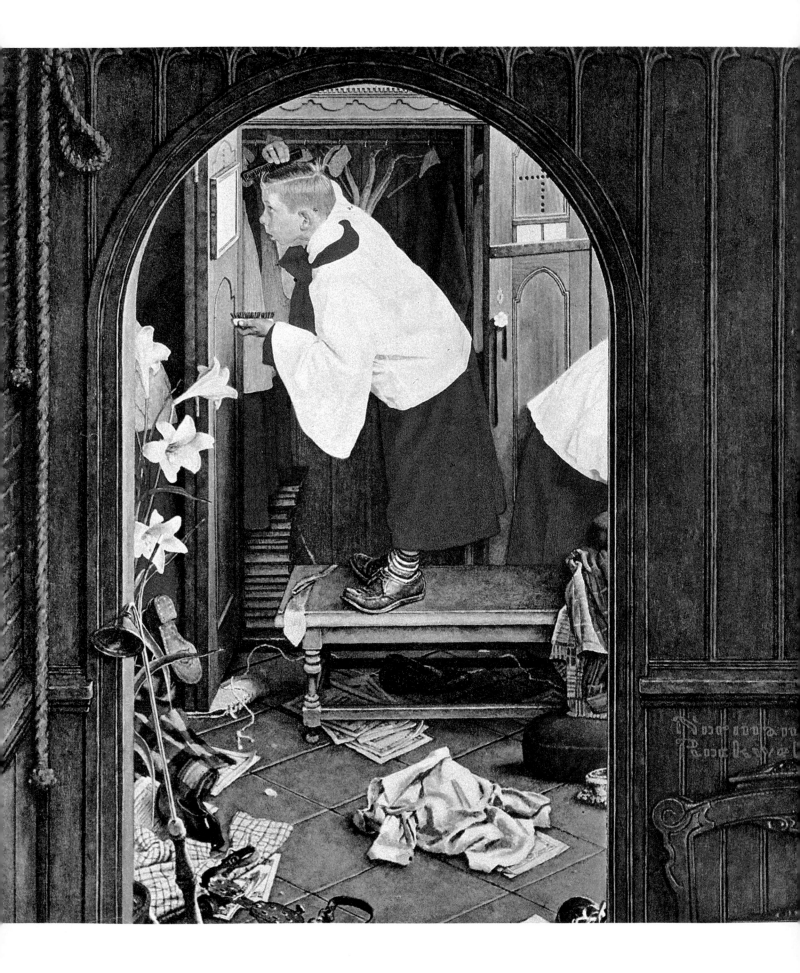

FORTUNE EGGS

CHILDREN NEVER SEEM to tire of a centerpiece which incorporates brightly colored eggs. To vary this favorite theme, try an idea from 1894 and prepare "Fortune Eggs." Dye blown eggs and into the hole of each, insert a tiny roll of paper bearing a written fortune. Coordinate the fortunes to the egg color. Some fortunes used in 1894 were:

The one who gets a golden egg
Will plenty have and never beg.

The one who gets an egg of blue
Will find a sweetheart fond and true.

The one who gets an egg of green
Will jealous be and not serene.

The one who gets an egg of white
In life shall find supreme delight.

The one who gets an egg of red
Will many tears of sorrow shed.

Who gets an egg of purple shade
Will die a bachelor or old maid.

A silver egg will bring much joy!
And happiness without alloy.

A lucky one—the egg of pink
The owner ne'er sees danger's brink.

The one who gets an egg of brown
Will have establishment in town.

The one who speckled egg obtains
Will go through life by country lanes.

A stripèd egg bodes care and strife,
A sullen man or scolding wife.

The one who gets an egg of black
Bad luck and troubles ne'er will lack.

—The Delineator, 1894

Oh, what am I, whom children hide,
Round, hard and smooth, yet soft inside?
Who's born all white, yet, strange to say,
Turns red and blue on Easter day?
Who has a yolk, but not a shirt,
Whose head when cracked does not feel hurt?
Who's boiled alive, unless too bad,
Whose dyeing makes the children glad?
Now, what am I? Pray guess, I beg.
Of course I am an _____!

—*The Delineator*, 1923

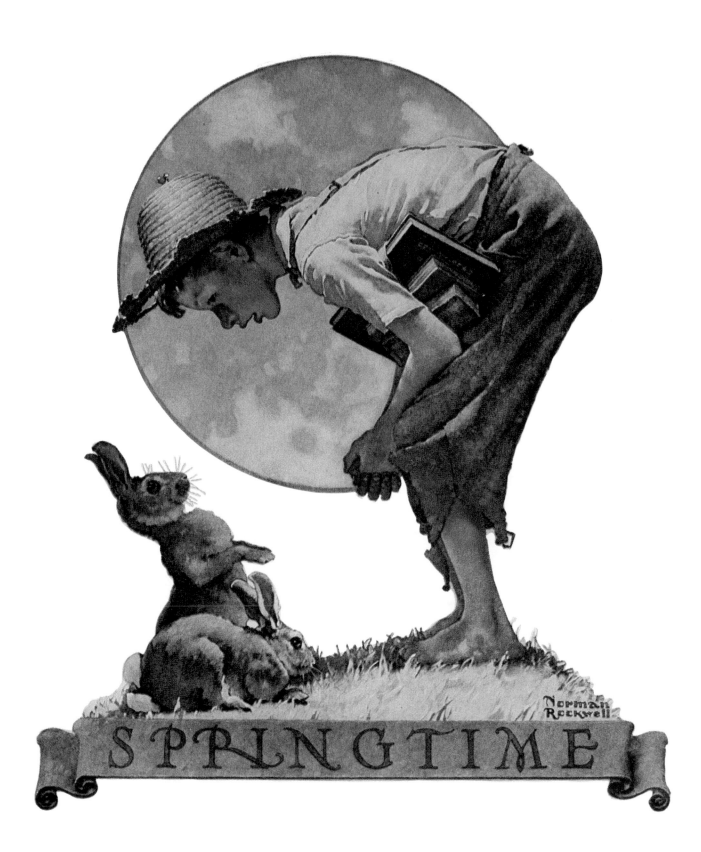

SPRINGTIME

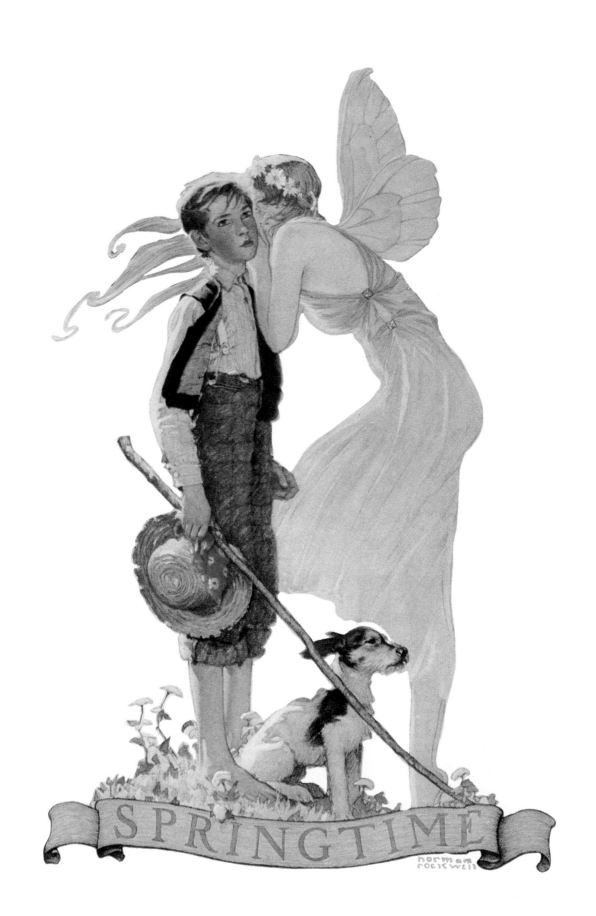

THE ANCIENT ROMANS observed the coming of spring in their festival honoring Flora, the goddess of flowers. The central feature of this celebration was the abundant use of blossoms in parades and dances. The festivities spanned the period from April 28 to May 3, the high point of which was May Day, the first of May, when the slaves were set free for the day after promising to return to their masters' houses that evening.

The greatest influence on our present-day celebration of May Day is the Druid spring festival called *Beltane*, "Bel's fire," after the custom of lighting fires on hill tops to honor the sun.

When the Romans occupied the British Isles, elements of the Roman and Druid feasts merged and the bringing in of the Maypole from the woods was added as an important element of the festivities. During the medieval and Tudor periods, May Day was one of the most important holidays.

The Maypole was set up by each village in the town square, and in medieval England, the towns competed to see which could produce the tallest one. In London, the Maypole was secured into the ground, and in 1661, London boasted one of the tallest, measuring 134 feet. Traditionally, the tree was adorned with three gilt crowns, streamers, flags, garlands of flowers, and other adornments. During the course of the celebration, which lasted almost the entire month of May, the Maypole became the center of activity. Games were played and jousts were undertaken and a special Robin Hood play was performed. The Robin Hood legend is very much a part of the May Day festivities. He is considered the Lord of May in all the games and the Queen of May is his faithful Maid Marian. Their attendants, dressed in green, are other Robin Hood characters such as Little John, Friar Tuck, and Will Stukeley.

Although May Day was an important holiday in England, it never became significant in the United States, especially as a home celebration, because the Puritan settlers frowned upon the Maypole and on dancing as frivolous. In time, however, the charming custom of May baskets, which are made and filled with flowers by children who then distribute them in the neighborhood in the early morning, has been adopted in many parts of the country. Schools throughout the country normally celebrate the day with field days and similar sporting events. Often, at these events, a May Queen is named and there is a traditional Maypole dance.

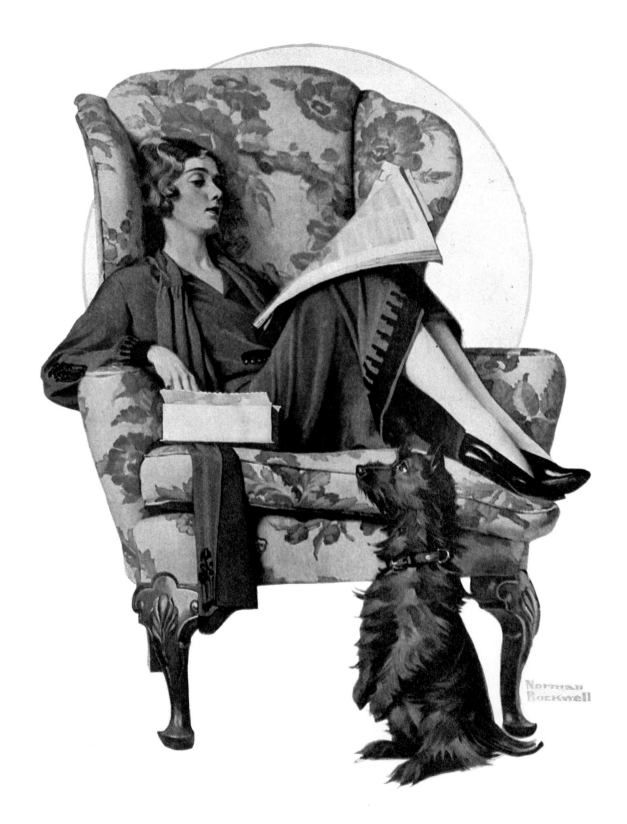

The day was fair, a gentle breeze invited,
 The flowers all gathered, by the basket lay,
The pole was trimmed, the shining drum well
 corded—
 Where could be found a lovely Queen of May.

For Polly giggled at the very notion,
 And Helen's frock was sadly torn that day,
And sunburned Ruthie's curls were wildly ruf-
 fled—
 Oh, for a queen, a stately Queen of May.

Close to his friends stood Rover, gentle collie,
 Whose faithful, loving eyes sure seemed to say:
"I'd gladly help you, if I could but do it—
 To choose a queen, a graceful Queen of May."

A happy thought came to the lads and lassies,
 They, laughing, trooped adown the sunlit way;
On Rover's head they laid a wreath of posies—
 And crowned *him* queen, their lovely Queen of
 May.

 —ALIX THORN
 "Their Queen of May"

It is a pleasant sight to see
A little village company
Drawn out upon the first of May
To have their annual holiday;
The pole hung round with garlands gay,
The young ones footing it away,
The aged cheering their old souls,
With recollections of their bowls,
Or, on the mirth and dancing failing,
Their oft-times-told old tales re-taleing.

—"The Country Maypole"

IN PRAISE OF GARDENING

If you wish to be happy for a day, get drunk;
If you wish to be happy for a week, kill a pig;
If you wish to be happy for a month, get married;
But if you wish to be happy for ever and ever, make a garden.

—*Chinese Proverb*

EDEN WAS, OF COURSE, a garden, and Paradise is said to be one. Between the lost and the regained lies the middle ground, the patch of earth we use to grow flowers, fruit, herbs, vegetables and weeds. Gardeners sow, mow and hoe for many reasons, ranging from the aesthetic to the economic. Gardening is hard, after-the-Fall work, no doubt of it. Yet the thought of a man-made Eden-Paradise preserve is an attractive and enduring fancy. As even George Bernard Shaw, a vegetarian but also a sturdy atheist, noted wryly: "The best place to find God is in a garden. You can dig for Him there." Francis Bacon, scientist and Lord Chancellor of England, wrote in 1627: "God Almighty first planted a garden. And, indeed, it is the purest of pleasures. It is the greatest refreshment to the spirits of man, without which buildings and palaces are but gross handyworks."

To the latterday Adam and Eve, the spiritual rewards of digging, raking and weeding may seem somewhat exaggerated. After all, God must also have created the rabbits, raccoons, deer (certainly the deer), woodchucks, cutworms, birds, moths, maggots, mites, moles and myriad other varmints that can devastate a hard-worked flower bed or vegetable patch with the efficiency of a legion of Goths. He also gave us the mosquitoes, gnats, wasps, hornets, deer fly, brambles and poison ivy that can leave a weekend plowman looking as if he had taken on Larry Holmes at Madison Square non-Garden. Certainly, the creators of the grand imperial Chinese gardens did not espy God amid the foliage; the Romans saw Priapus. Yet, almost from the beginning of literate time, writers in every language have tried, however mushily, to divine and define the bond between mankind and the earth and all growing things. . . . Gardening, of course, affords an unmatched challenge to get up early and stay out late, and share the bright hours with watchful birds, butterflies and clouds that may or may not bring rain at the right or wrong hour. Many a backyard Adam does not take a vacation away from home in summer, when a garden is at its most demanding and rewarding. But, almost uniquely, gardening spreads its rewards year-round. Even in dead of winter, it is time to make paper plots, plan strategies for spring. In January, the seed catalogues arrive, bearing in fulsome prose and opulent color promise of ever newer, hardier, bigger, earlier, more abundant species. This is the time that, mocking Keats, the late Katharine White described as the "season of lists and callow hopefulness."

Then, in early spring, it is time to turn the earth, to hunker down and dribble the shy, cold

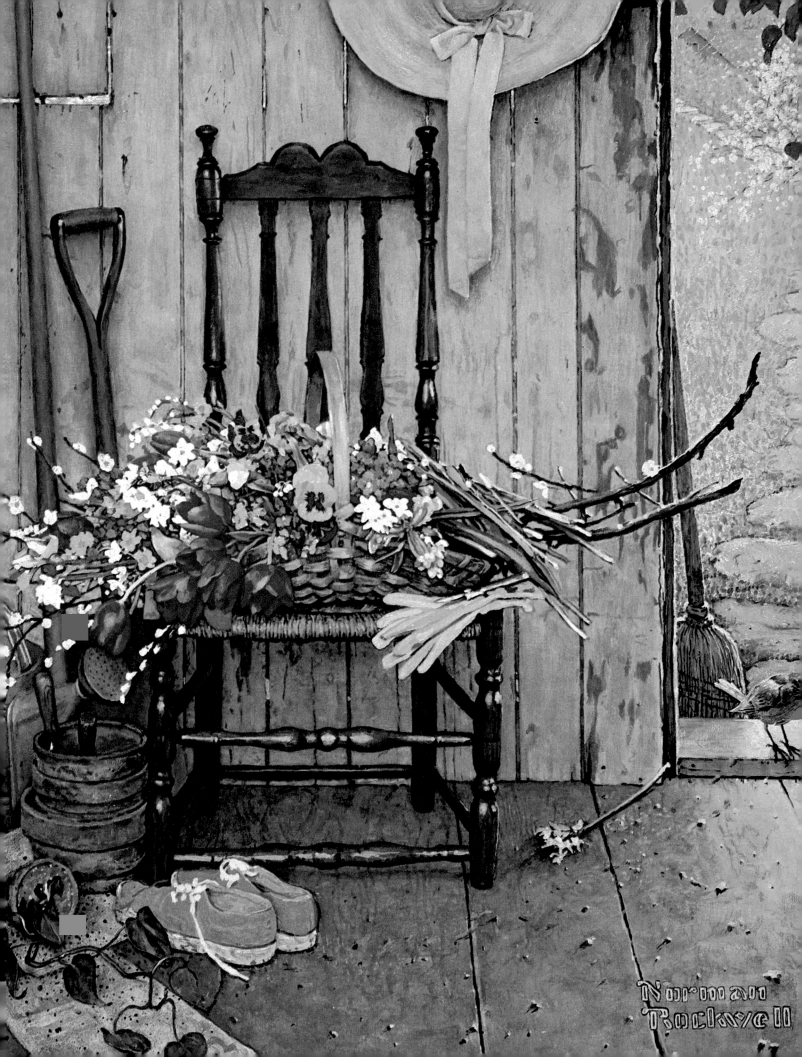

soil through your fingers; to remove the rocks the winter moon has pulled to the surface; to plant the early, cold-resistant crops: lettuce, spinach, chard, sugar snaps, brussels sprouts, peas and beans. To welcome back the worms. The vegetable season has its dramatic opening in mid-May (in the Northeast), when asparagus spears poke their tender, questing noses above the cold-crusted earth. Spring comes in on the yellow fire of forsythia, followed by primrose and crocus and daffodil. For the vegetable grower, the bounty is limited only by his skills, the leisure time available and the space at hand. (Back to statistics, the average American garden measures 595 sq. ft.) The season nears its climax when the first tomatoes loll incarnadined upon their vines, the prima donnas of the garden. No wonder the Elizabethans called these divas love apples. Is there a cuisine in the world that could entirely dispense with the tomato?

Even in late fall, when the last glamorous petal, leaf and pod has been plucked, a sturdy little band will soldier on through winter: brussels sprouts and all the cabbage varieties; and winter squash. But the work, the communion and the labor are not over. A garden should be cleared and tucked in for winter with a blanket of fertilizer for the snows and rains to drive into the ground. The compost heap gets its massive annual fix of fallen leaves; there are bulbs to be planted, trees and bushes to be pruned.

Even when frost and snow mantle the fallow field, its warmth glows on in chutneys, pickles, jams and jellies, in string bags of onions, in jars of dried herbs and blossoms in potpourri. For Adam and Eve by the woodfire, winter is but an extension of summer. They may invoke perhaps the gentle words of Elizabethan poet Nicholas Grimald:

> *Seed, leaf, flour, frute*
> *herbe, bee and tree*
> *are more than I can sing.*

—MICHAEL DEMAREST

THREE YEARS AFTER the death of her mother in May, 1905, Miss Anna M. Jarvis arranged to have her church in Grafton, West Virginia, dedicate a Mother's Day service to her mother's memory. Because her mother loved and cultivated carnations, everyone in attendance that Sunday was given one of these beautiful flowers.

From that day on, Miss Jarvis, who never married, waged a relentless campaign to have a day set aside to honor mothers. She wrote letters and enlisted the support of influential people. Gradually, more and more states proclaimed a Mother's Day, usually a Sunday in May. At the same time, the carnation became inextricably associated with the day, red blooms worn to honor mothers who are living and white those who have died.

On May 9, 1914, President Woodrow Wilson issued the first Mother's Day Proclamation, designating the second Sunday in May as a day set aside to express "our love and reverence for the mothers of our country." Every year a similar proclamation is issued by the President. Despite the success of her efforts, Miss Jarvis ultimately became disillusioned with the commercialism that began to surround the day and died bitter and disappointed.

The idea of honoring mothers did not originate with Anna Jarvis. The Romans celebrated a spring festival dedicated to the mother goddess, Cybele. This three-day festival, called the Hilaria, started on the ides of March.

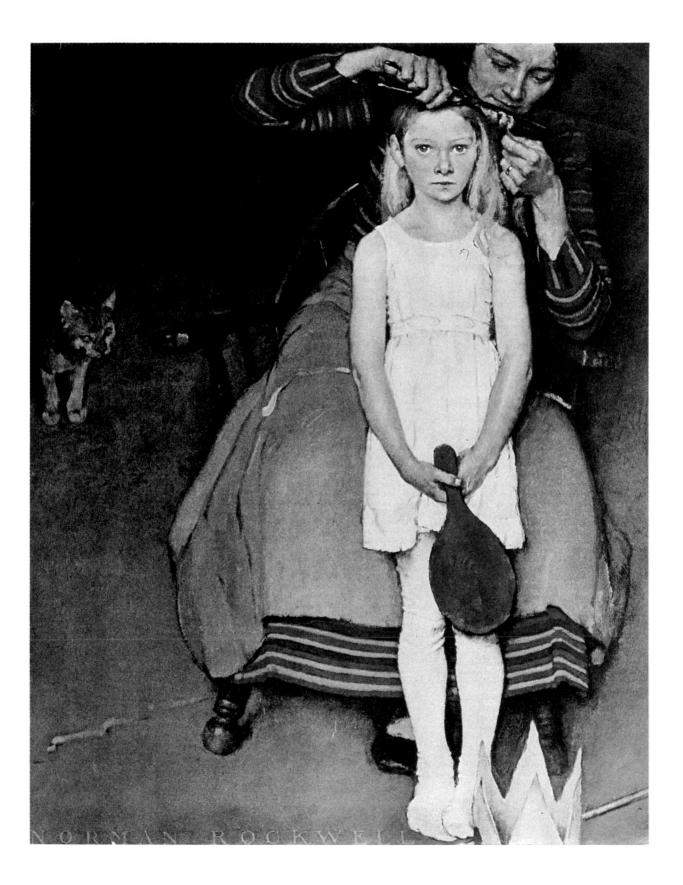

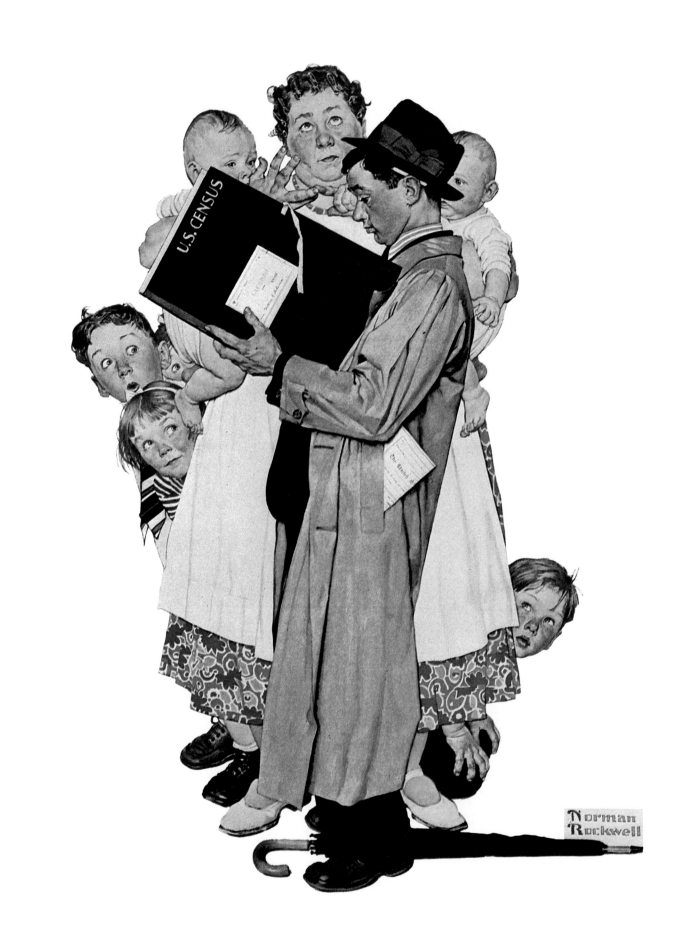

Mothers!

The gray-haired mother, whose successful sons and happy daughters bring flowers and love—

The young girl-wife, with her first baby in her arms—

The mother of seven, struggling against poverty and fear and want, but keeping the six patched and mended and in school, and the baby clean—

The mother in the shack on the prairie, in the homestead on the range, in the mountains far from church or neighbors, who becomes church and neighbors and civilization to her children—

The average mother of the average family, with the average amount of bills and worries over Johnny's measles and Mary's beaus—

Mothers!

May Providence strengthen them to go on with high hearts for another year—when we will again bear loving gifts of white carnations or, if far from them, send our grateful telegram.

Mothers! God bless them.

—*MARY CAROLYN DAVIES*
The Delineator, 1925

MOTHER'S DAY TREATS

LE GATEAU MARJOLAINE
(Marjolaine Cake)

Yield: 8 servings
 1 pound almonds, blanched
 10 oz. hazelnuts
 1½ lbs. granulated sugar
 20 egg whites
 1 lb. semi-sweet chocolate
 8 T. sweet butter
 2 cups heavy cream
 2 cups whipped cream
 1 T. confectioner's sugar
 2 oz. semi-sweet chocolate grated finely
 2 oz. corn starch

Place almonds and hazelnuts on separate baking sheets. Toast the almonds in a 350° oven until browned, stirring frequently. Toast hazelnuts at the same temperature until the skins begin to loosen. Rub hazelnuts in a cloth of rough weave until the skins come off.

Mix nuts together. Grind finely. Set half of this ground mixture aside. Take half of nut mass and sift with 4 oz. sugar and 3 oz. corn starch.

Combine 20 egg whites and 1 lb. 4 oz. sugar in a bowl. Place over medium heat and stir with a hand whip until whites are warm. Whip in mixer until stiff peaks are attained. Add nuts, sugar, and cornstarch mass and fold in by hand. Use a pastry bag with a one-inch open tip; tube out four strips 20 × 3 inches. This should be done on buttered baking sheets. Bake in a 200° oven for two hours.

Break chocolate into small bits and melt in a double boiler on low heat. Add butter in small pieces, stirring constantly. Remove from heat, cooling slightly. Whip the cream until stiff and fold into the chocolate. Stir until it is smooth and allow to chill.

Cover one of four meringue strips with a layer of chocolate cream. Place a second layer on top.

Spread the reserved nuts and whipped cream on top of the meringue. Cover with a third layer of meringue and another layer of chocolate cream and then the last strip of meringue. Sprinkle with confectioner's sugar and the grated chocolate. Smooth the remaining chocolate cream over the sides of the cake and decorate with the remaining chocolate flakes.

MOUSSE AU CITRON

Yield: 8 servings
 6 each, eggs
 7 oz. sugar, granulated
 ½ cup dry white wine
 ¼ oz. gelatin sheet
 ¾ cup lemon juice
 1 each, lemon, grated rind
 1 pint whipping cream

Separate egg yolks from egg whites and beat. Set aside, cook and dissolve 4 oz. sugar in white wine at 245°. (Reach medium ball stage.)

Soak gelatin sheet in cold water. Remove and squeeze tightly so as to rid of water. Melt gelatin over heat in a small sauce pan. Pour gelatin into the above mixture. Add lemon juice and grated rind. Stir until nearly coagulated.

Whip cream. Fold into the above mixture.

Beat egg whites to wet peak consistency adding remaining sugar and fold into the above mixture.

Place lemon mousse mixture in souffle dish, 9 inches diameter and four-inch depth. Place in refrigerator for 4 hours.

Decorate or garnish mousse with candied lemon slices, thinly cut. Small fresh mint leaves in sorettes of whipped cream can be attractive as part of the lemon slice decoration.

—*THE STANFORD COURT HOTEL*

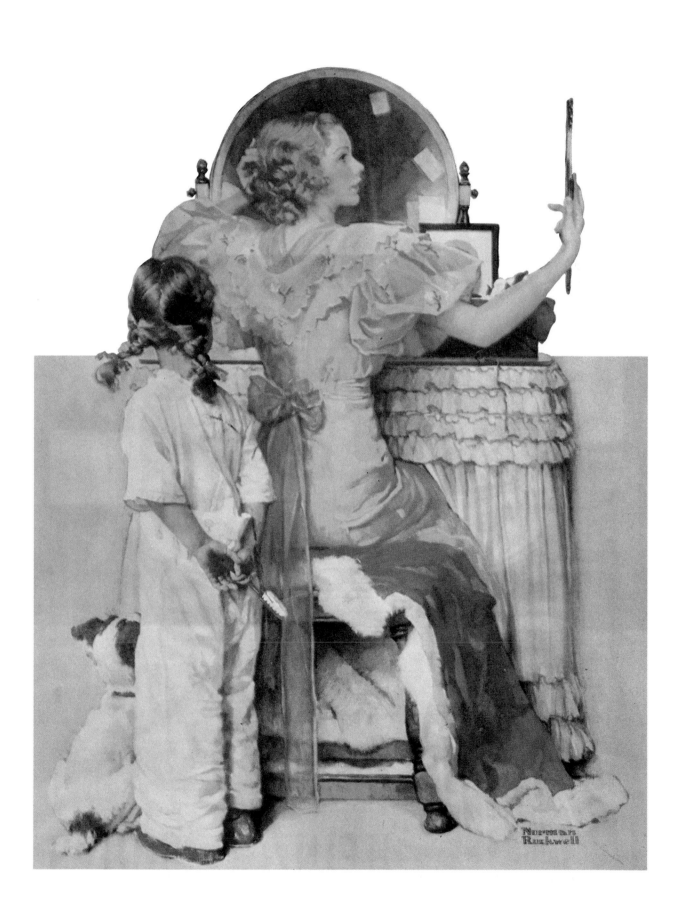

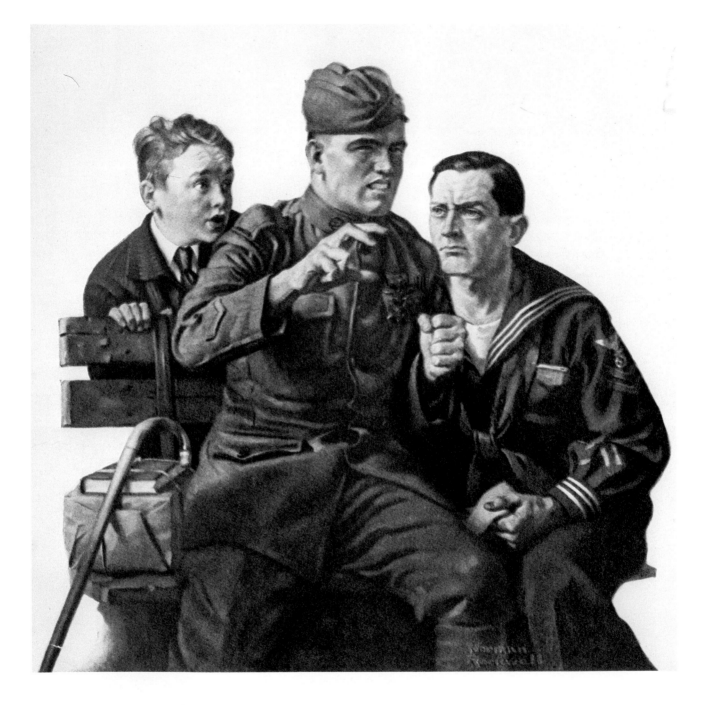

From hill, and dale, and glen, bring flowers
 To strew each soldier's bier,
In ev'ry springtime's golden hours,
 In ev'ry coming year.
Bring laurel, emblem of their fame,
 And myrtle, of our love,
Let violets remembrance name,
 And amaranth, life above.

Chorus

Then strew bright flow'rs on ev'ry grave
 Wherein a hero lies,
And let the dear old banner wave
 'Neath freedom's sunlit skies.

The first clear notes the bugle blew,
 Were special calls to them,
And with their country's weal in view,
 They went forth strong, armed men.
Left fathers, mothers, sisters, wives,
 And children young and pure,
And held as naught their precious lives,
 That homes might still endure.

Chorus

To them be honor, earnest, true
 And may we ne'er forget:
They died for me, they died for you,
 Where hostile armies met.
Come, lay upon each grassy bed
 A garland rich and rare,
Wherever sleep our soldier dead,
 Let them this tribute share.

Chorus

—*MISS P. A. CULVER*
"Then Strew Bright Flowers on Every Grave"
Godey's Lady's Book, 1876

Soldier, rest, thy warfare o'er,
Dream of fighting fields no more.
Sleep the sleep that knows not breaking,
Morn of toil, nor night of waking.

—*SIR WALTER SCOTT*

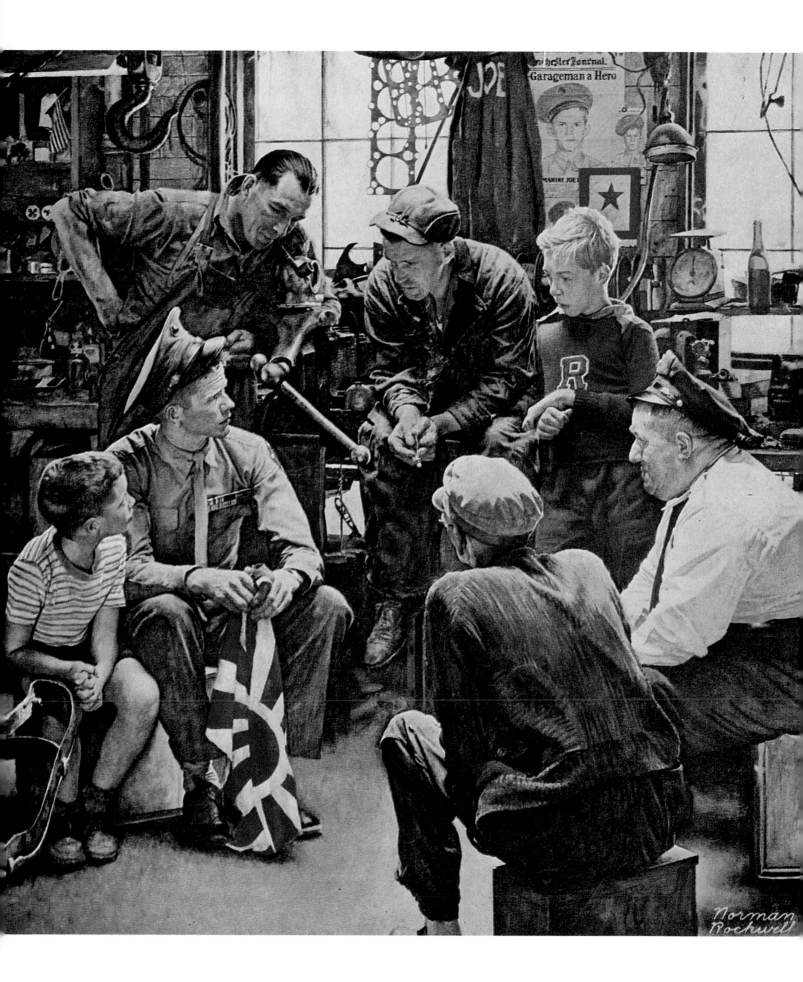

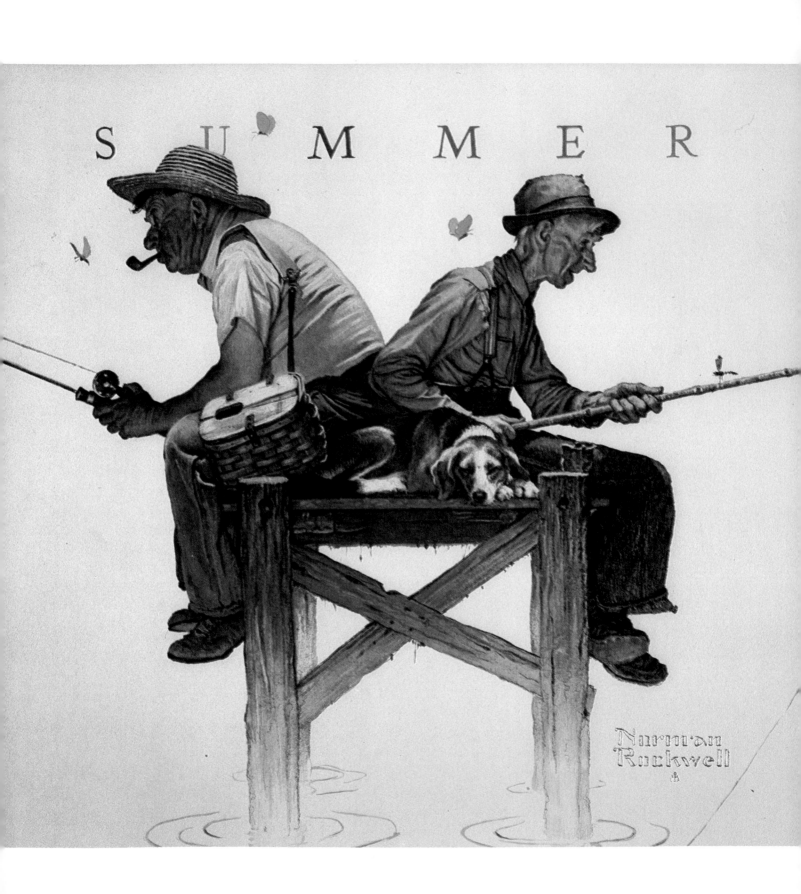

TROUT, AS RARE AS
THE WHITE WOLF

IN YUGOSLAVIA THERE IS a river called Gacka, which holds trout as large as your imagination. These native monsters are called white wolves and they are rarely seen anymore . . .

The best memories I know are those drawn from my days spent wandering a trout river and now, with the first, wet-cold nights of fall snapping at the window panes of my old Bedford farmhouse, I find myself being slowly lured back to summer drifting when I took the time to fish a favorite, faraway river called Gacka, in Yugoslavia.

For several years, and more I hope will come, I've been returning to this one particular limestone river in the flowerswept valley of Croatia. Why this most difficult, certainly most unpredictable, river attracts me more than any other river I've fished in the world is no mystery to this incurable nympholept.

Simply, in my mind's river-searching eye, the Gacka represents the quintessential river: it has in it a little bit of all the rivers I've ever touched, the slow and wide Battenkill in Vermont; the fast-running Boulder in Montana; the mint-flowing Test in England; the wild, moon-haunted rivers of Chile and Argentina.

By the end of the first week in June, I was suddenly there with my river Gacka. It had taken me nearly fourteen hours from my door (one hour north of New York City) to reach the airport, wait for the hour-late JAT jet to depart JFK, cross the Atlantic, land direct, non-stop in Zagreb, and then drive to the Hotel Gacka, Licko Lesce, Yugoslavia. Fourteen hours waiting to cast a fly for brown and rainbow trout that you knew from past trips ranged from two pounds to fourteen pounds and larger! A man who has his heart pumping wildly to get to his river could die in that time just from the sheer overwhelming yearning of wanting to be bankside before he physically reached his destination.

You who are river-seekers know this feeling; I know because I've fished with you on the sweet waterways of the world, and there is not a fisherman among you who does not hunger like a boy wanting his way when it comes to keeping a date with a river you love.

When I finally arrived at the Hotel Gacka, situated about fifty feet from the gurgling river, I had a strong espresso to try to stay awake. How I wanted to fish that very evening after so many hours of bumping around in the air and on the ground. But my second café could not keep me awake; I staggered to my room with its wraparound balcony overlooking the lovely, meadow-winding river and, opening the doors of the balcony wide to let in the sweet, mountain-valley breezes, I was soon falling into a deep, swoonlike sleep.

I woke at about an hour before dawn the next morning, and after a quick, hot shower and shave, I was soon dressed and stepping gingerly into my new Ranger hip boots. Gathering up my old Garrison eight-footer and a few fly books containing some of my favorite patterns for Gacka trout, I was out of the hotel like a furtive, hunting cat.

As I made my way upstream along the yellow and plum flowering bankside to the place I loved where the river took a sharp bend and channeled suddenly very deep, I thought to myself: here I am, I'm really here, I'm back again with you, old

river, don't you recognize your faithful, wandering friend?

If a river could speak, I suppose it would answer a man, but a river talks in other ways deeper than words and what you hear lasts forever and doesn't easily expire, the way inconsequential conversation does between people; a river sounds a man if he's got any sounding room at all and then it goes deep and stays, and that's a fact, not poetry.

I don't know what fly or streamer I knotted on first; it's really not that important. What was more important than anything else in the world to me was that very moment standing before my beloved river and knowing that somewhere very deep in her secret, undulating vaults there were great trout lurking in snakeweed and shadow.

One good, working cast and my line was across the river, sinking down across the hole of eternity, and though I could not see my fly darting through the darkness with its brilliant feathers opening and closing as it flashed over and under both weed and stone, I could see it as though it were the only star in the night. A trout fly sunken deep is like a star, when you think about it; it dazzles, it sparkles, it shoots out lambent messages to preglacial creatures, and it is as alive as you want it to be. It is a star, for it is being looked up to, and if you play your line right, it will take that native Gacka trout, rarely caught anymore, the brown trout the Croatian fishermen call the white wolf.

As the saturnine clouds began to filter through the first rays of summer light, I felt an electrical jolt at the end of my line that sped like a rocket to my heart and capsized all my romantic thoughts of being with my Gacka once again. What was this fury that had my treasured bamboo rod bent to the breaking and all my line running off my reel down into the hole of eternity? Had I struck, finally struck after all these years the elusive white wolf trout? Had my star-fly aroused in him some instinctive urge to strike from his paradisiacal cave, to take down the twitching, breathing, feathery intruder? Was it hunger or anger that made this unseen missile rake the barb of the hook and nail my heart against the bank with fear?

For more time than I can remember the great force that came from the hole of eternity held me fast as though, indeed, I were the prey; it held me until my arm ached and my fingers felt they would never open again. Once the rod shook with such violence that I nearly fell from the slippery ledge of the bank into the river.

I tried desperately to take in line, but the trout was unrelenting and would not be budged from its snakeweed crater. Truly, I thought, this must be the rare white wolf trout that I had heard fishermen talk about and search for, a native holdover from years past, a survivor from the time before the glaciers to the present age of our doomsday world.

"I can't fight you much longer," I said to the trout. "My hands are numb. My arm feels dead. Won't you give a little?"

My rod shuddered with the shock of an even greater force trying to wrench it from my grip.

"You are the white wolf trout, aren't you?" I shouted, hoping some other fisherman might hear.

Suddenly an explosion shook the center of the

hole of eternity and millions of sun-filled droplets showered up into the sky filling with the earth colors of flowers and grasses and sky. It was a towering, bursting rainbow fountain erupting all at once with tremendous force and beauty, and concealed within its dazzling plumes was the thrashing, rare white wolf trout.

For a flash of time, the great trout slashed across my eyes and then it was gone like a dying storm into the whirl of the hole of eternity. Shaking, wet all over, I sat down on the bank and tried to recapture in my mind what I had just seen and experienced.

"No need to try to measure it," I kept saying to myself over and over again. "No need to know it was the largest trout you've ever seen in all the world. It's gone and maybe you're finished too, because losing such a battle makes a man feel like he can never get up again."

Then I shouted into the hole of eternity: "You killed me, white wolf trout! How many men have you killed like this?"

Now the river throbbed in the deep, calm channels where the blue, inky currents came together folding over and under each other, and I listened a long time to the river. Closing my eyes, I let it heal my wound, my defeat.

"But it's gone," I said to the river, talking out loud. "How many chances has a man to come so close . . . to taking such a great and rare trout that all fishermen seek?"

The river kept moving through me and soon I heard the sounds of birds singing as they sailed back and forth over the hole of eternity. I opened my eyes and got to my feet. The sun was warm and sparkling off the river and the flowers seemed to be dancing in the sunlight. All I wanted to do now was to go back to the hotel and have a double espresso and perhaps talk to another fisherman who might find my morning interlude with the white wolf trout more than an apocryphal tale told by a river dreamer.

—GEORGE MENDOZA

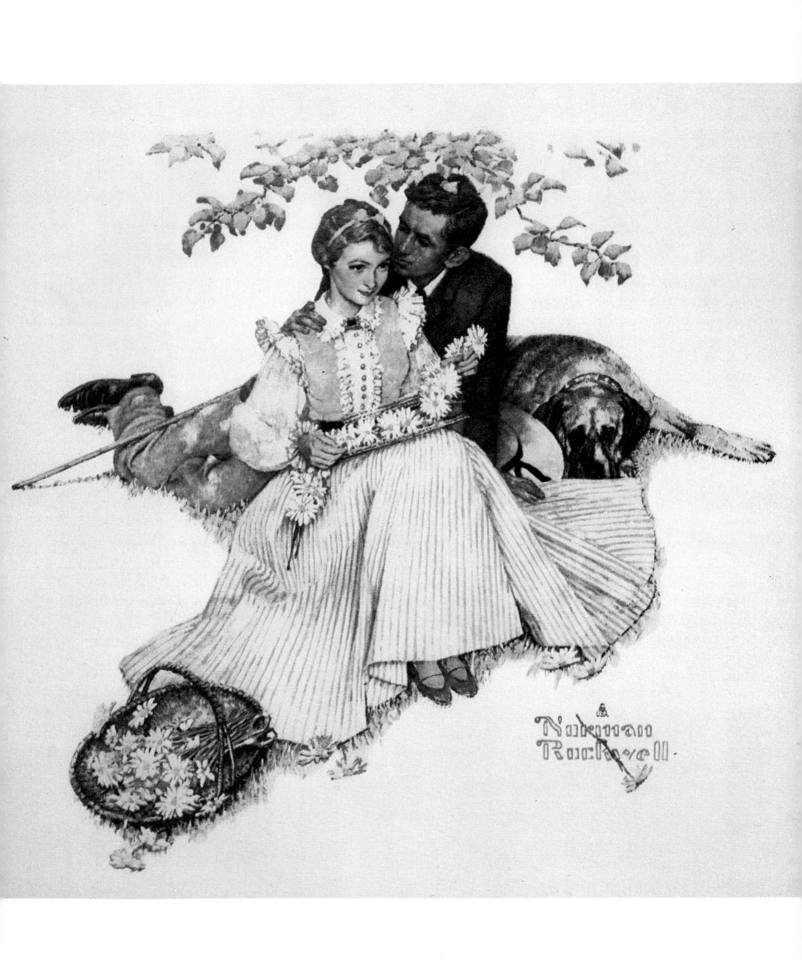

When daisies pied and violets blue
 And lady-smocks all silver-white
And cuckoo buds of yellow hue
 Do paint the meadows with delight,
The cuckoo then, on every tree,
Mocks married men; for thus sings he,
 Cuckoo;
Cuckoo, cuckoo: O word of fear,
Unpleasing to a married ear.

When shepherds pipe on oaten straws,
 And merry larks are ploughmen's clocks,
When turtles tread, and rooks, and daws,
 And maidens bleach their summer smocks,
The cuckoo then, on every tree,
Mocks married men; for thus sings he,
 Cuckoo;
Cuckoo, cuckoo; O word of fear,
Unpleasing to a married ear.

—*WILLIAM SHAKESPEARE*
"Spring"

WEDDING ANNIVERSARIES

CELEBRATING wedding anniversaries with some sort of simple entertainment is a charming way to observe a notable and happy occasion with one's friends. The origin of the themes for the anniversaries is unknown (maybe they were devised by some enterprising shopkeeper), but according to an 1894 *Delineator* booklet entitled "Weddings and Wedding Anniversaries," the "anniversaries have been recognized by the following titles for many years and are variously celebrated." The booklet gave the following list. (Modern additions and changes to this list are in parentheses.)

One year, cotton (paper) wedding
Two years, paper (cotton) wedding
Three years, leather wedding
(Four years, silk or flowers wedding)
Five years, wooden wedding
(Six years, iron wedding)
Seven years, woolen wedding
(Eight years, bronze wedding)
(Nine years, pottery wedding)
Ten years, tin wedding
(Eleven years, steel wedding)
(Twelve years, silk or linen wedding)
(Thirteen years, lace wedding)

(Fourteen years, ivory wedding)
Fifteen years, crystal wedding
Twenty years, china wedding
Twenty-five years, silver wedding
Thirty years, pearl wedding
Thirty-five years, lace (coral and jade) wedding
Forty years, ruby wedding
(Forty-five years, sapphire wedding)
Fifty years, golden wedding
Fifty-five years, emerald wedding
(Sixty years, diamond wedding)
Seventy-five years, diamond wedding

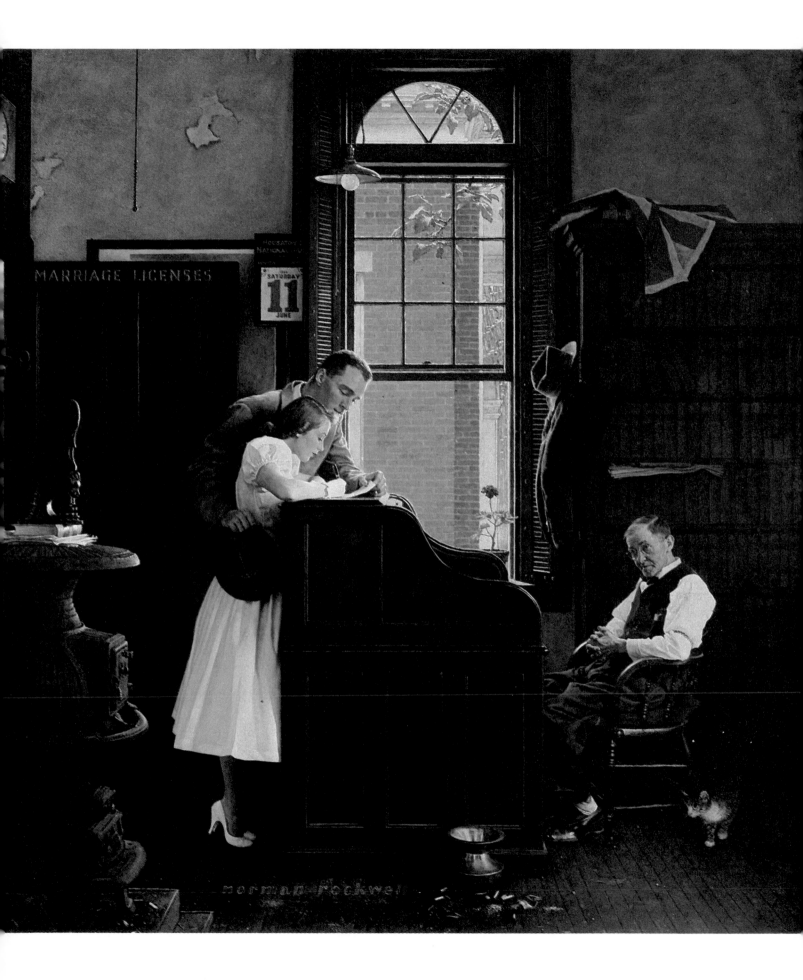

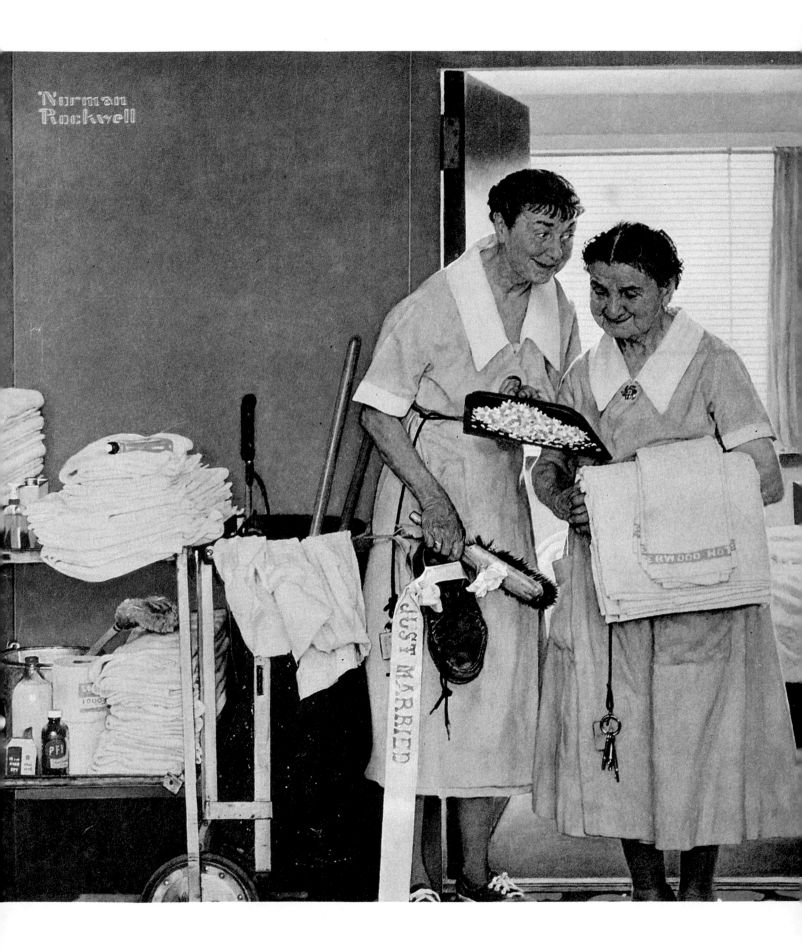

Drink to me only with thine eyes,
 And I will pledge with mine;
Or leave a kiss but in the cup
 And I'll not look for wine.
The thirst that from the soul doth rise
 Doth ask a drink divine;
But might I of Jove's nectar sup,
 I would not change for thine.

I sent thee late a rosy wreath,
 Not so much honouring thee
As giving it a hope that there
 It could not withered be;
But thou thereon didst only breathe
 And sent'st it back to me;
Since when it grows, and smells, I swear,
 Not of itself but thee!

—*BEN JONSON*

In winter I get up at night
And dress by yellow candle-light.
In summer, quite the other way,
I have to go to bed by day.

I have to go to bed and see
The birds still hopping on the tree.
Or hear the grown-up people's feet
Still going past me in the street.

And does it not seem hard to you,
When all the sky is clear and blue,
And I should like so much to play,
To have to go to bed by day?

<div style="text-align: right">

—*ROBERT LOUIS STEVENSON*
"Bed in Summer"

</div>

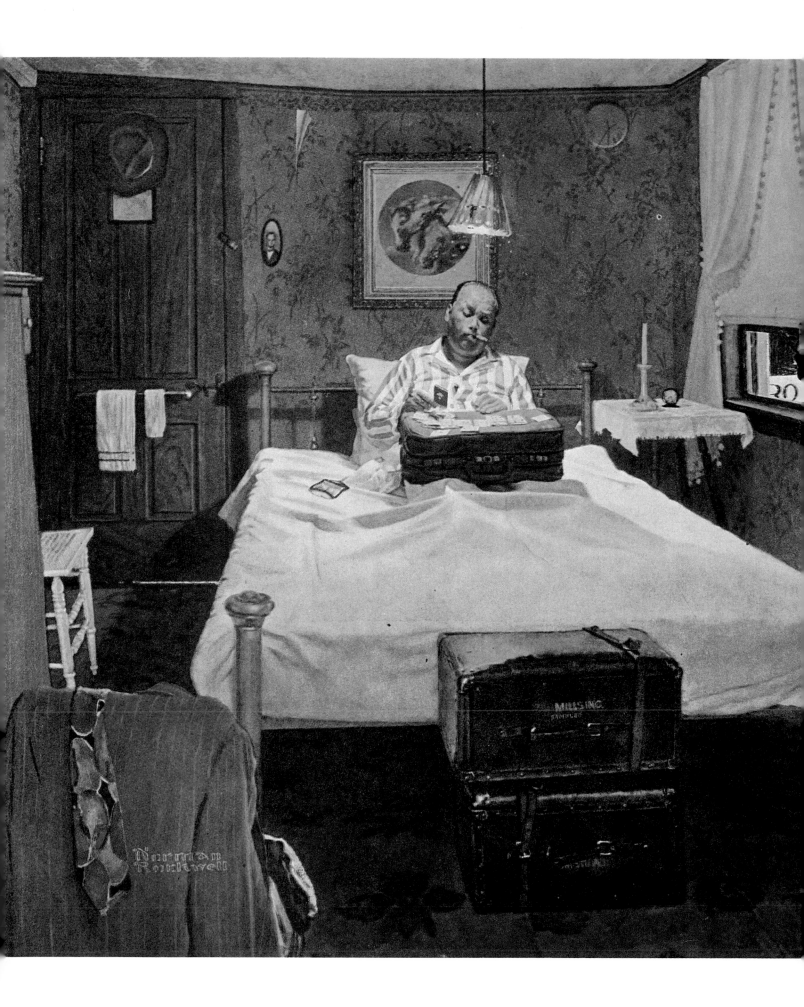

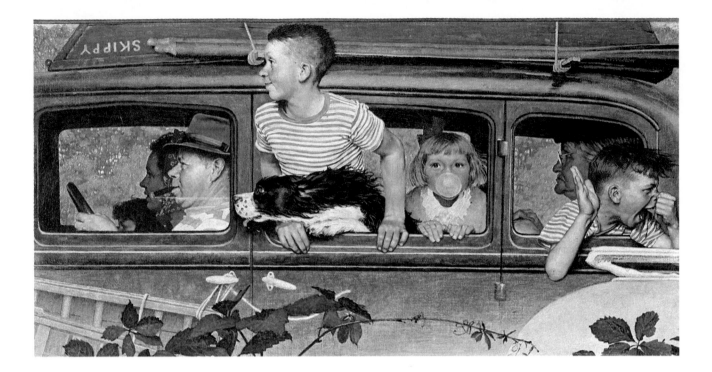

TWO WEEKS IN MARE'S NEST

NANTUCKET, Mass., June 26

—Excerpts from a vacationer's diary:

Saturday—Arrived exhausted and trembling after fourteen-hour drive. This house is named "Mare's Nest" and has a library consisting of every *National Geographic* published up to 1938, a complete set of the Bobbsey Twins, two novels by Marie Corelli, and a copy of *Beau Geste.* The children have gone to bed in a state of shock. Reason: No television set. Bambi wants to go home first thing tomorrow. Little Archie says, "I feel like I've been amputated."

Sunday—A 48-hour day of rain. Am bitten by a spider.

IT'S STILL RAINING

Monday—Rain continues like an all-day bombardment. Buy the children a radio to give them some noise. It seems to soothe them a little, but not much. Josette flies into a rage upon being refused permission to use the car and bites Rover. Bedsheets are damp. Mold growing on the carpets. Read *The Bobbsey Twins Go to the Seashore* and seventeen issues of the *National Geographic*, and pray for sunshine.

Tuesday—Sunshine! Glorious sunshine! Everyone rushes to the beach, soaks up four hours of sun. Have just returned from Dr. Vetch's for treatment of acute sunburn. "Stay out of the sun for at least a week," he warns. "What am I going to do?" I ask. "Drop by my house," he says, "and I'll lend you some back copies of the *National Geographic* to help pass the time."

SURREPTITIOUS PURCHASE

Wednesday—Sneak into town and buy a copy of *Playboy.*

Thursday—Josette bends the car around the fence post trying to get out of the yard. Damage: About $150.

Friday—Every fuse in "Mare's Nest" blows out at 8:10 P.M. Conduct a two-hour search for the fuse box and finally locate it in a secret chamber under the back porch. Strike head on nail-studded rafter and have to visit Dr. Vetch for tetanus injection.

Saturday—Finally solve mystery of why Bambi, Josette and little Archie have been so serene the past few days. They have found a friend with a television set and are sneaking off to his

house to mainline big injections of *McHale's Navy* and *Gunsmoke.* In a most effective lecture, tell them I feel the purity of our vacation has been violated. Bambi and little Archie promise not to do it again. Josette demands permission to take the car and drive home.

Sunday—Rain. Play Go Fish for six hours with children.

Monday—Finish the last *National Geographic* in the library. Josette loses the car key at the beach. Little Archie undertakes to fix the antique grandfather's clock on the stairway, and it now strikes 52 times every fifteen minutes.

Tuesday—Carried to Dr. Vetch's by ambulance for eight stitches in scalp after being struck by an escaped surfboard while floating in the water off the south shore.

Wednesday—The clock repairman comes and for $29 restores things temporarily to working order. Since 7 P.M., however, the clock has been striking 208 times every hour.

Thursday—Our neighbors in "Heathcliffe's Nightmare" complain to the police that our clock is keeping them awake. The clock man promises to take it away and replace it with an even more antique clock for $335. Little Archie got up on the roof this afternoon and kicked off half the shingles on the east end of "Mare's Nest."

Friday—Awakened by 3 A.M. today by a sense of dampness about the feet and found the lower half of the bed afloat as a result of heavy rain pouring in through the damaged roof. Developed a fever of 103 about noon, and Dr. Vetch urged going into the hospital as a precaution against pneumonia. Refused when he told me the hospital had just gotten the latest issue of *National Geographic.*

Saturday—Roofers came today. Felt so much better I decided to treat everybody to lobster dinner. Price of lobster: $2 a pound. With cutting wit, told fish dealer "in that case maybe I'd better have the chinchilla." "We don't have none," he said. Concluded that he was too oafish to get the point, but discovered on arrival back at "Mare's Nest" that he had unpegged the cutting claw of a three-pounder. Visited Dr. Vetch for treatment of severely jagged laceration of the right index finger while preparing dinner.

A REAL JOY

Sunday—Leaving "Mare's Nest" for home within the hour. Have not felt so good for a year. Children have never been happier. Dr. Vetch just dropped in to say good-by, but as the clock was striking the hour it was impossible to converse. Sensed, however, that he was genuinely going to miss me, and in a moment of emotion handed him my copy of *Playboy.* He seemed as delighted to get it as I was to see the end of another vacation.

—RUSSELL BAKER
"Sunday Observer"
The New York Times Magazine

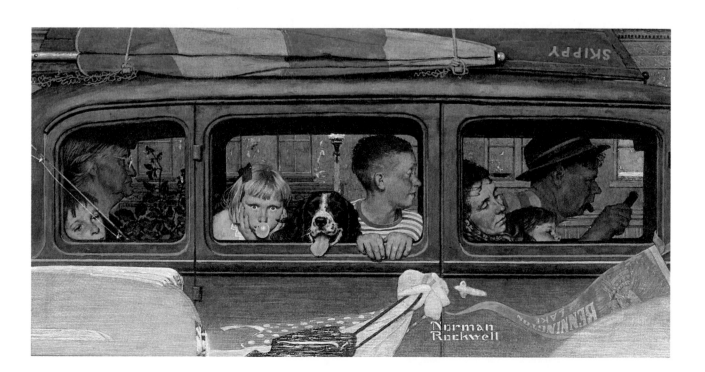

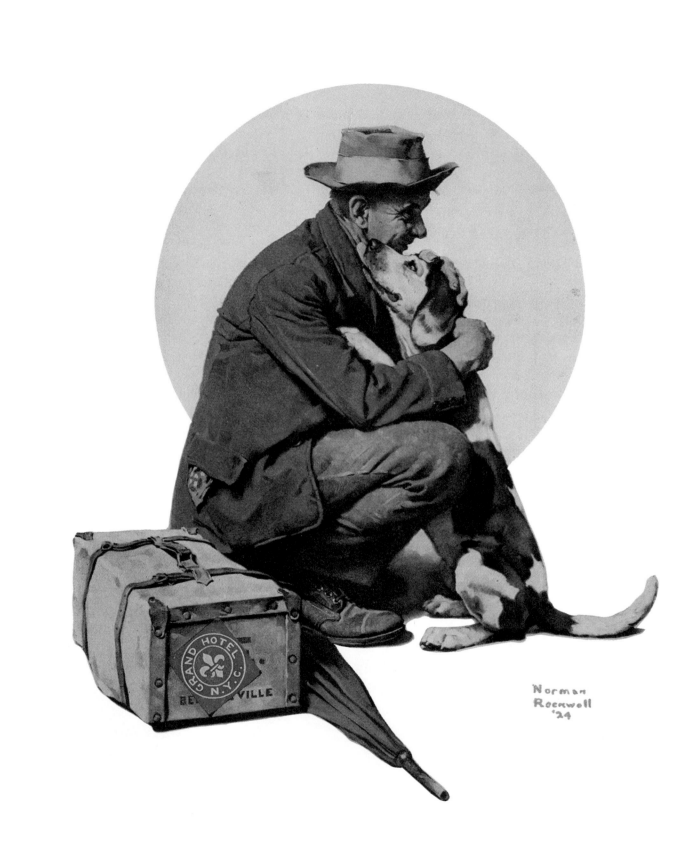

My bags are falling apart
from all the yanking and pushing,
squeezed into planes, jammed into taxis,
thrown about so much leather and thread.
Another journey maybe they'll hold,
"Hey, old boys, are you going to drop,
split open your seams?"
Old bags, old boys, why do old travellers,
still keep packing young dreams?
Who can answer?
I'm amazed they still follow me.
How many more trips are they waiting for?

—GEORGE MENDOZA

WHY DO PEOPLE TRAVEL? To escape their creditors. To find a warmer or cooler clime. To sell Coca-Cola to the Chinese. To find out what is over the seas, over the hills and far away, round the corner, over the garden wall—with a ladder and some glasses you could see to Hackney Marshes if it wasn't for the houses in between, in the words of the old music hall song, the writer of which one feels was about to take off.

Why have I travelled? Difficult to answer, that is when not engaged in the equivalent of selling Coca-Cola to the Chinese (large size dresses in Leeds), or travelling as a sailor or a soldier. Partly, undoubtedly, for amusement and sheer curiosity and partly, as Evelyn Waugh wrote in the preface to a book I wrote which described a journey through the Hindu Kush, to satisfy 'the longing, romantic, reasonless, which lies deep in the hearts of most Englishmen, to shun the celebrated spectacles of the tourist and, without any concern with science or politics or commerce, simply to set their feet where few civilized feet have trod'.

—ERIC NEWBY
A Traveller's Life

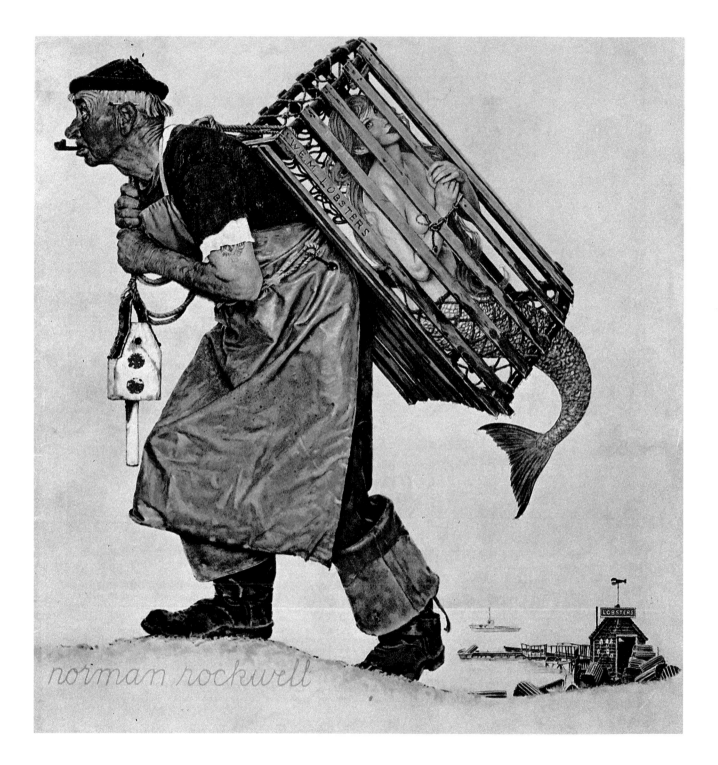

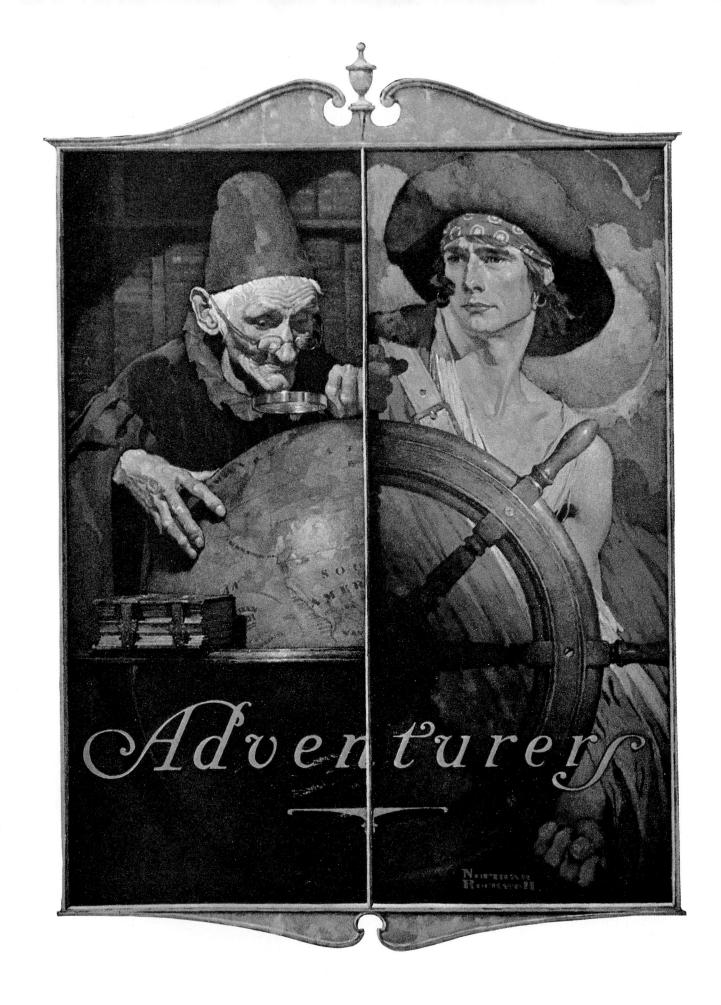

Adventurers

25 REASONS FOR PLAYING TENNIS

1. It is fun!
2. It is a lifetime sport played by youngsters from eight through eighty.
3. It is an international sport—played in more countries than any other sport.
4. It is a family sport—one that the entire family can enjoy together.
5. It is a highly sociable sport—one that both sexes can enjoy together or separately.
6. It is an inexpensive sport—considering relative costs of clothing, equipment, instruction and court time.
7. It is an excellent complementary sport—to team sports having the advantage of requiring only two players.
8. It builds strong, healthy bodies without the risk of injury inherent in contact sports.
9. It challenges the mental, physical and emotional capabilities of the most gifted athletes.
10. It develops physically well-balanced athletes who must have quickness, speed, strength and stamina.
11. It improves body-mind coordination.
12. It teaches poise, self-confidence and self-reliance.
13. It equalizes the advantage that height and strength have in most other sports.
14. It teaches teamwork and partnership as players blend their skills in doubles.
15. It satisfies the physical and/or emotional needs of most players in sixty minutes or less.
16. It can earn valuable college scholarships for the player who works at it and excels.
17. It encourages self-expression due to the variety of styles, strokes and strategies inherent in the game.
18. It teaches the importance of preparation, including sound instruction, regular practice, hard work and good eating and sleeping habits.
19. It can provide a part-time, weekend or summer job or even a career opportunity!
20. It teaches a pattern of dealing gracefully with success (winning) or failure (losing).
21. It fills youngsters' time with a wholesome, constructive activity and provides them with a healthy outlet for emotions.
22. It teaches the care of and the importance of good clothing and equipment.
23. It allows the tournament player to travel extensively and meet new and interesting people.
24. It has a very unique scoring system that provides drama and excitement to every game, set and match whether in a friendly practice session or in a tournament.
25. Tennis creates life situations which should be viewed by parents and coaches as opportunities ... opportunities which, if seized upon, can be used to teach Christian Character ... or, if ignored, these same life situations can teach undesirable behavior patterns and negative character traits.

 (1) It can teach Honesty—truthfulness, fairness, and sincerity ... or it can teach lying, cheating and gamesmanship.
 (2) It can teach Obedience—respect for authorities, including parents, coaches, officials and other players ... and also respect for the rules ... or it can teach disrespect, disobedience and discourtesy to others ... and it can teach abuse, indifference and flagrant disregard for rules.
 (3) It can teach Humility—modesty and meekness ... or it can teach arrogance and pride.
 (4) It can teach Self-control—both of attitude and emotions ... or it can teach anger, bad temper, grumbling, etc.
 (5) It can teach Resourcefulness—flexibility, acceptance and the skill and ingenuity to adjust and adapt to changing conditions, different situations and new circumstances ... or it can teach refusal or resistance to adjust to changing situations, inflexibility and stubbornness.
 (6) It can teach Kindness—unselfishness, thoughtfulness and consideration of others ... or it can teach faultfinding and rudeness.
 (7) It can teach Perseverance—endurance, patience and fortitude—continuing effort in spite of difficulties, problems, obstacles and handicaps ... or it can teach slothfulness, half-hearted effort, giving up, quitting, etc.

—WADE L. HERREN

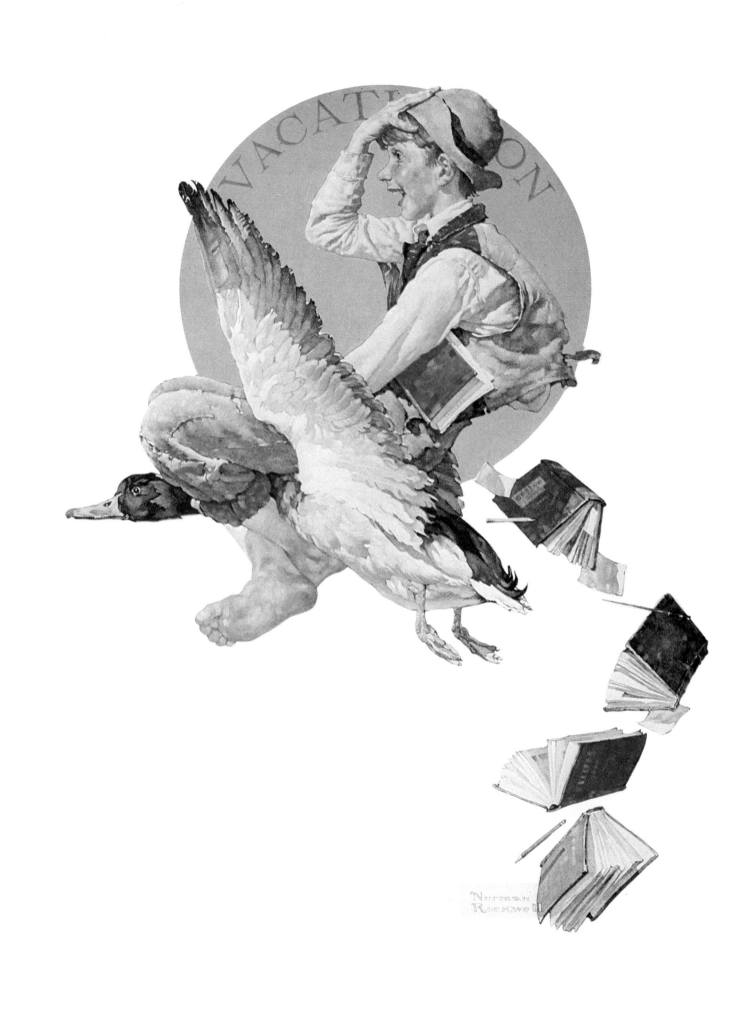

Summer has two beginnings,
Beginning once in June,
Beginning in October
Affectingly again,

Without perhaps the riot,
But graphicker for grace—
As finer is a going
Than a remaining face—

Departing then forever,
Forever until May.
Forever is deciduous
Except to those who die.

—ALGERNON CHARLES SWINBURNE
"Summer Has Two Beginnings"

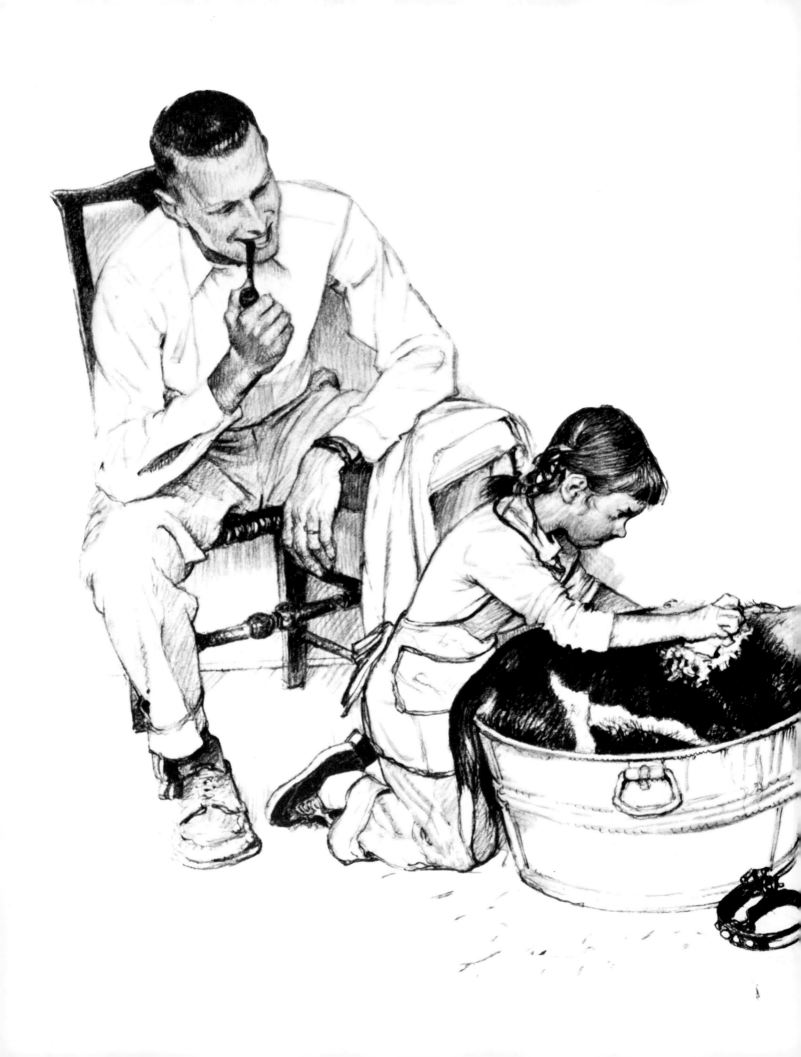

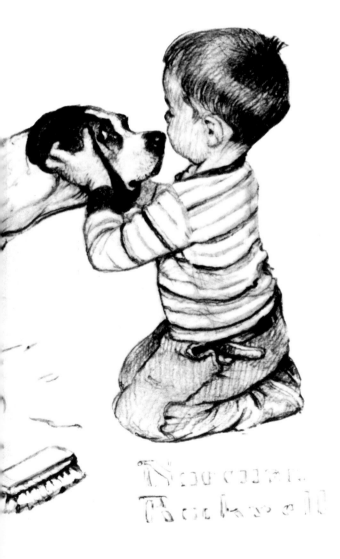

THE THIRD SUNDAY in June is Father's Day in this country, the time when the man of the house gets unusual attention and is really "King for a Day." This holiday is not so old as others, but it has a worthwhile object—to cherish "the honor and dignity of fatherhood."

In various nations round the globe, the father's role in the family differs, just as it has since ancient days. In some places the father "rules the roost"; in Japan, for example, he demands and receives respect from every member of the family. He walks ahead of his wife when they go out together, is the first served at meals, and makes decisions for his family. Here in the United States the father is supposedly the head, although if he has an especially strong-minded wife, he may take a second place.

—*MAYMIE R. KRYTHE*
All About American Holidays

FATHERS' DAY

JUNE IS THE MONTH not only of roses and weddings, but it is the month that celebrates a far less frequently sung fete. Fathers' Day comes this month on June 22nd. The rose, any kind or color, is the emblem of Fathers' Day, and all who wear one on June 22nd will be known to be paying tribute to Father, living or dead. Father himself was not the inventor of this celebration. It was a woman who devotedly admired her father and her husband who made the suggestion. Happy and admiring daughters and wives all over the country have taken it up. There is a slow but sure gathering feeling among women that in spite of the heavy artillery used against men in the fight for suffrage, after all, Father is a pretty fine old Father, and that we will tell him so once a year, no matter how we ignore and maltreat him the remaining three hundred and sixty-four days.

—*The Delineator*, 1915

ED DISTRAUGHT CHAIN FATHER-OF-EIGHT TYPE TRAGEDIAN
 EXECUTIVE SMOKER

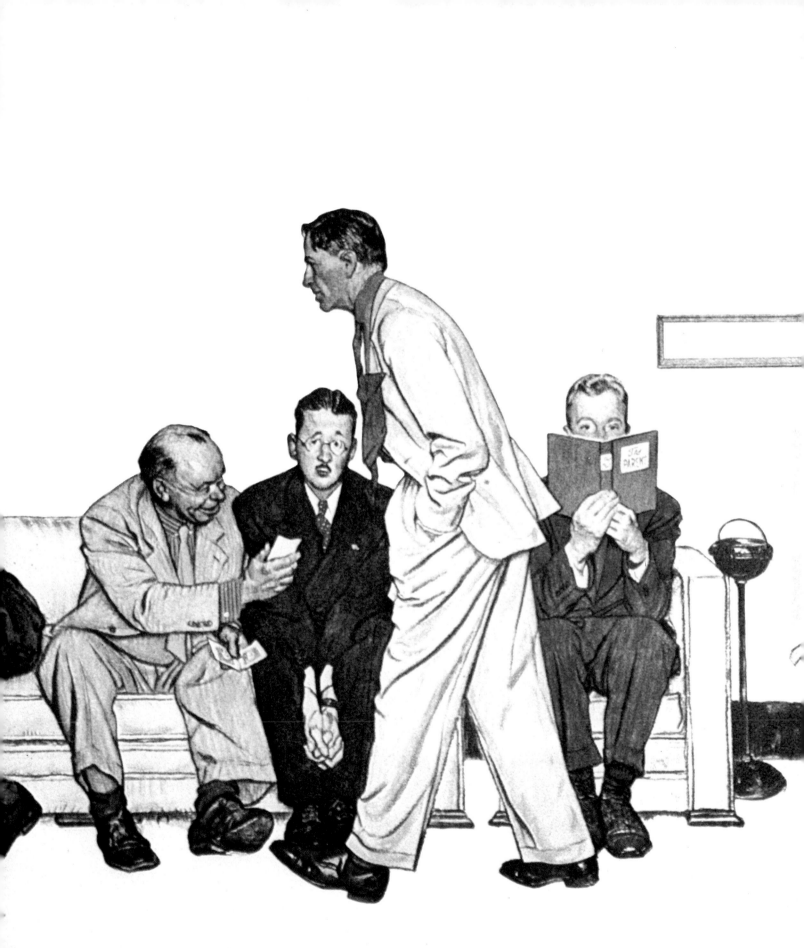

HEARTY-SALESMAN
TYPE

BELIEVER IN
THE WORST

PACER

THE EARNEST-
PARENT TYPE

Who cannot remember his father?
Are you not the son?
All his son?
Is he not the father of your tidal desires?
Are you not the son of his dark spun songs?
O speak the son, where is the son,
who would crush a feather of his father's
 soarings?

—*GEORGE MENDOZA*

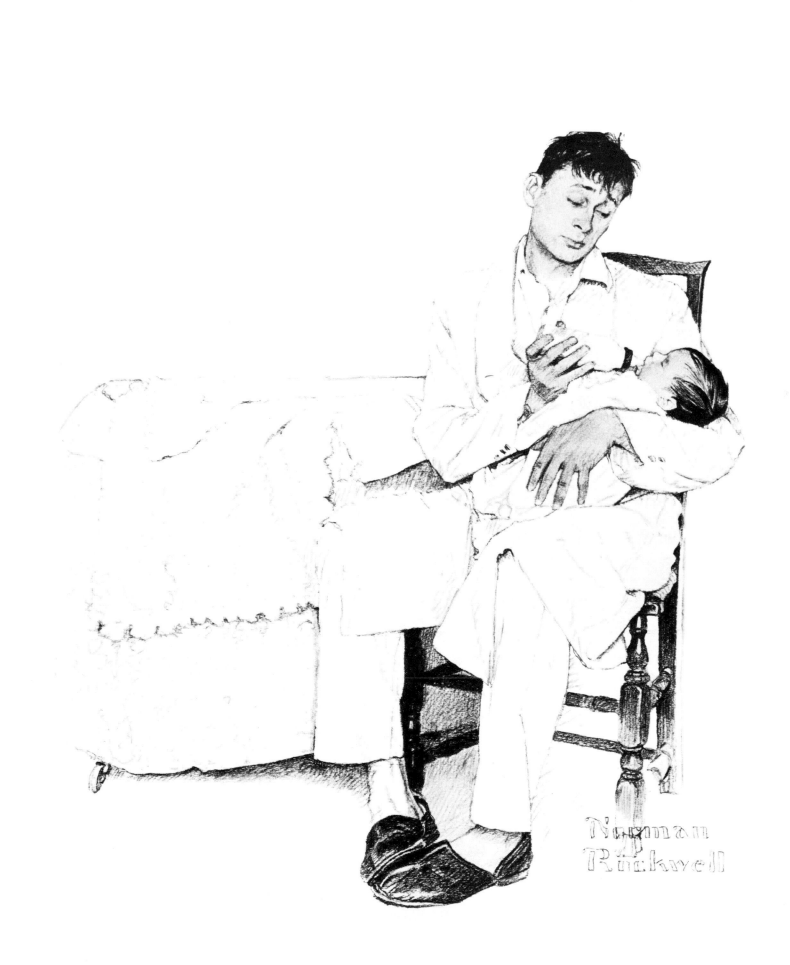

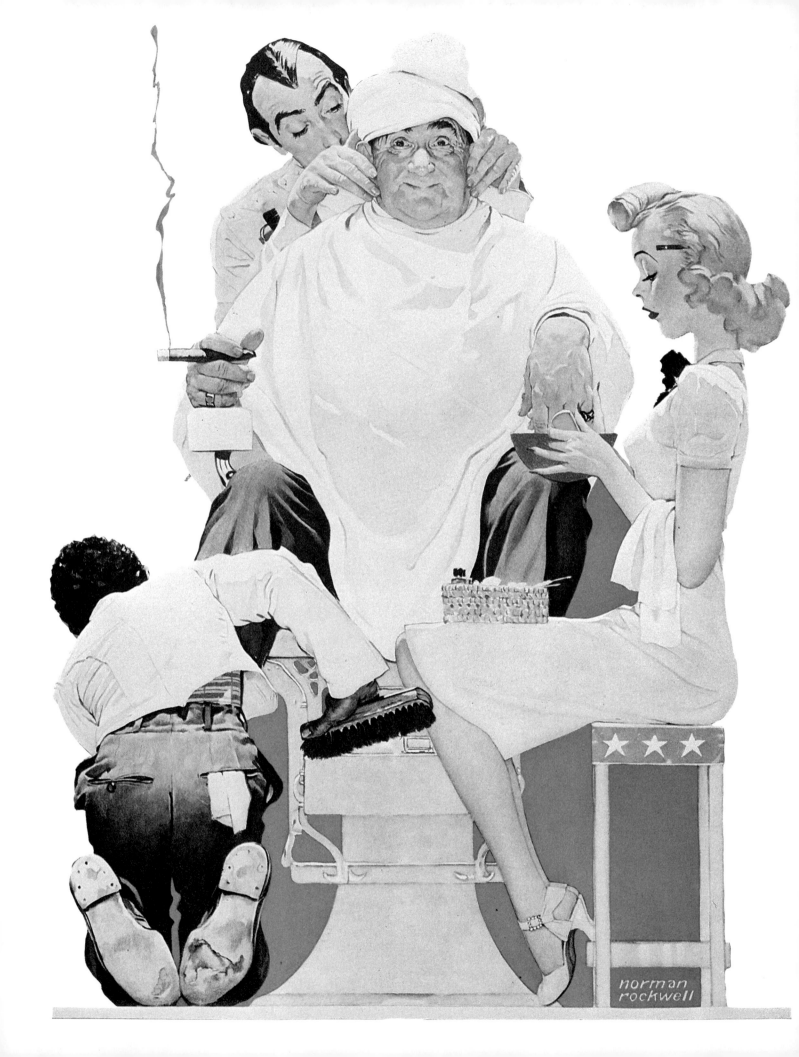

FATHER'S DAY FAVORITE

ROAST RACK OF LAMB, SAUCE AUX AROMATES

Yield: 4 servings
2 full racks of lamb, 8-rib, about 8 pounds each
Marinade
Sauce aux Aromates

Have a butcher saw and French bones. Save bones for sauce. Trim racks down to silver skin, removing all fat. Racks will now weigh about 2 pounds 8 ounces to 3 pounds.

Immerse racks in marinade and refrigerate 24 hours, turning occasionally. Drain and pat dry. Protect bones with aluminum foil. Roast racks in 475° (very hot) oven 25 minutes for medium rare. Halve or cut up racks. Ladle sauce onto plate and arrange half rack per serving on sauce.

MARINADE:

¼ cup onion, chopped
3 garlic cloves, mashed
1½ T. lemon juice
¾ cup wine vinegar
1½ cups dry red wine
½ cup fresh tomato, chopped fine
½ cup tomato paste
1 can (1 lb.) whole peeled tomatoes, pureed
1 stalk celery, sliced thin
1 carrot, sliced thin
1 or 2 sprigs fresh thyme, chopped
1 or 2 sprigs fresh tarragon, chopped
1 sprig fresh rosemary, chopped
1 T. minced parsley
1 bay leaf
1 T. fresh ground pepper

Pound garlic and onion, or chop in food processor, to a liquid consistency. Combine with lemon juice, vinegar, wine, fresh tomato, tomato paste, and canned tomato. Add celery, carrot, thyme, tarragon, rosemary, parsley, bay leaf, and pepper.

SAUCE AUX AROMATES:

1⅓ cup dry red wine
lamb bones from trimming rack
⅓ cup carrot, chopped fine
¼ cup onion, chopped fine
2 tsp. olive oil
2½ cups demi-glace
1⅓ T. glace de viande
½ small bay leaf
1 T. fresh mint, chopped
1 T. fresh rosemary, chopped
1 T. fresh thyme, chopped
2 garlic cloves, mashed
½ cup tomato paste
salt
pepper
1 T. julienne-cut hard cooked egg white
1 T. julienne-cut mushroom
1 tsp. julienne-cut sour pickle
1 tsp. julienne-cut smoked ham

Pour wine over bones. Add carrot and onion. Marinate, refrigerated, 24 hours, turning occasionally.

Remove bones; pat dry. Oven brown in 500° (very hot) oven about 30 minutes.

Strain marinade, saving liquid, carrot, and onion. Saute vegetables in oil until very lightly browned. Drain and add to lamb bones. Mix well. Transfer to stock pot. Add demi-glace, glace de viande, bay leaf, mint, rosemary, thyme, garlic, and tomato paste. Add wine in which bones were marinated and simmer very slowly 24 hours. Salt and pepper to taste. Strain contents through fine sieve or cloth. Adjust seasoning.

Add egg, mushroom, pickle and ham.

—THE STANFORD COURT HOTEL

I remember how at the source of the stream
We used to clasp hands and weep
Because, my friend, we had the same heart.

—*WANG WEI to P'EI TI*

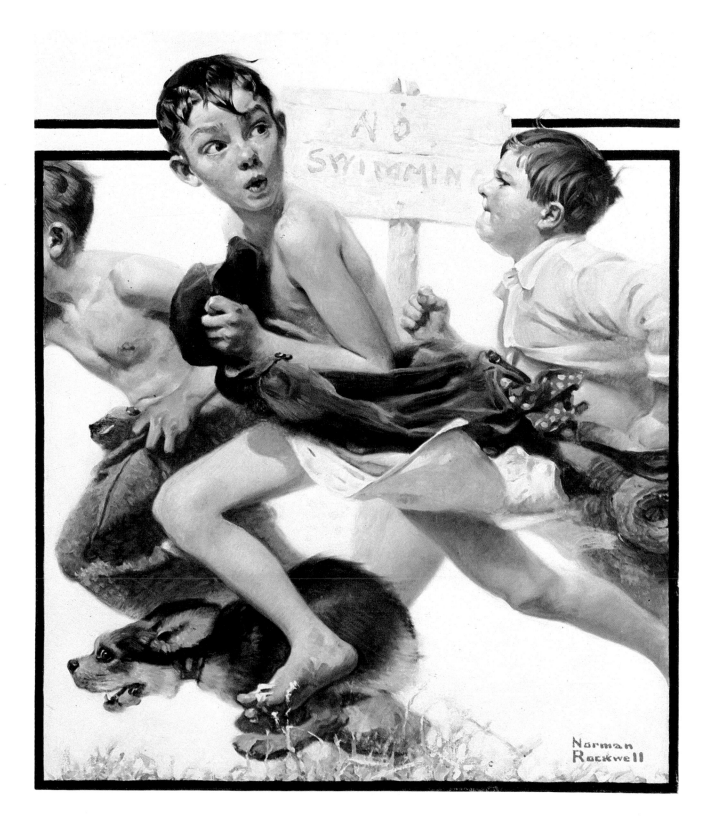

I PLEDGE ALLEGIANCE to the flag of the United States of America and to the republic for which it stands, one nation under God, indivisible, with liberty and justice for all.

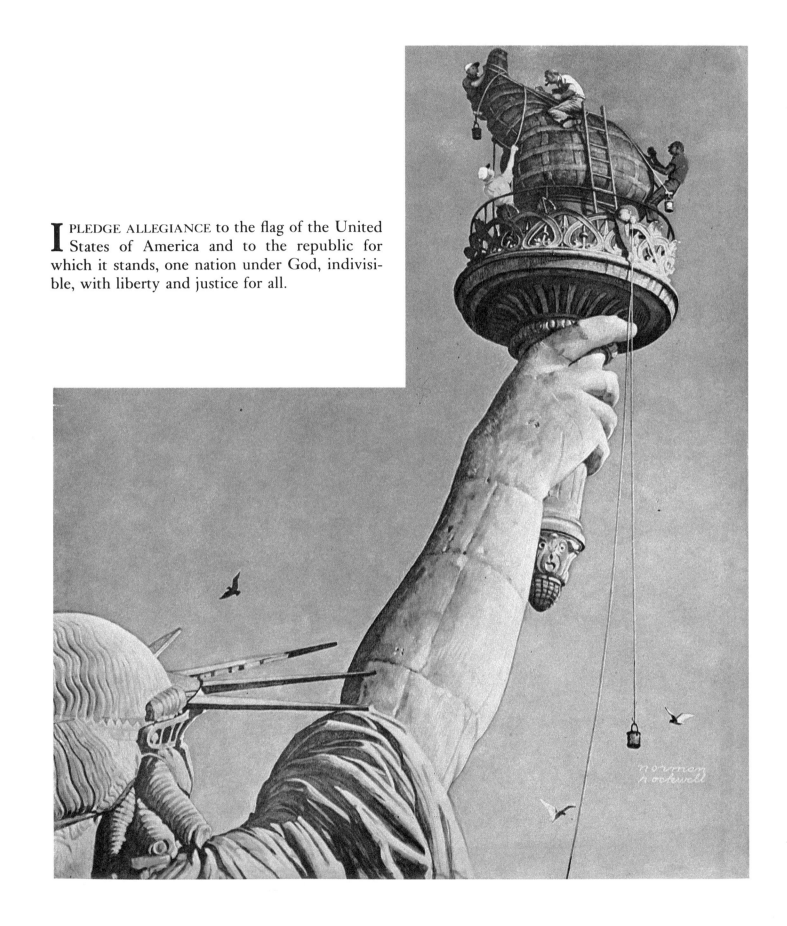

O, Columbia the gem of the ocean,
 The home of the brave and the free,
The shrine of each patriot's devotion,
 A world offers homage to thee.
Thy mandates make heroes assemble,
 When Liberty's form stands in view;
Thy banners make tyranny tremble,
 Three cheers for the Red, White and Blue.
 Three cheers for the Red, White and Blue.
 Three cheers for the Red, White and Blue.
Thy banners make tyranny tremble,
 Three cheers for the Red, White and Blue.

When war winged its wild desolation,
 And threatened the land to deform,
The ark then of freedom's foundation,
 Columbia, rode safe through the storm;
With her garlands of vict'ry around her,
 When so proudly she bore her brave crew,
With her flag proudly floating before her,
 Three cheers for the Red, White and Blue.
 Three cheers for the Red, White and Blue.
 Three cheers for the Red, White and Blue.
With her flag proudly floating before her,
 Three cheers for the Red, White and Blue.

"Old Glory" to greet now come hither,
 With eyes full of love to the brim;
May the wreathes of our heroes ne'er wither
 Nor a star of our banner grow dim;
May the service united ne'er sever,
 But they to our colors prove true,
The Army and Navy forever,
 Three cheers for the Red, White and Blue.
 Three cheers for the Red, White and Blue.
 Three cheers for the Red, White and Blue.
The Army and Navy forever,
 Three cheers for the Red, White and Blue.

 —THOMAS BECKET
 "Columbia, the Gem of the Ocean"

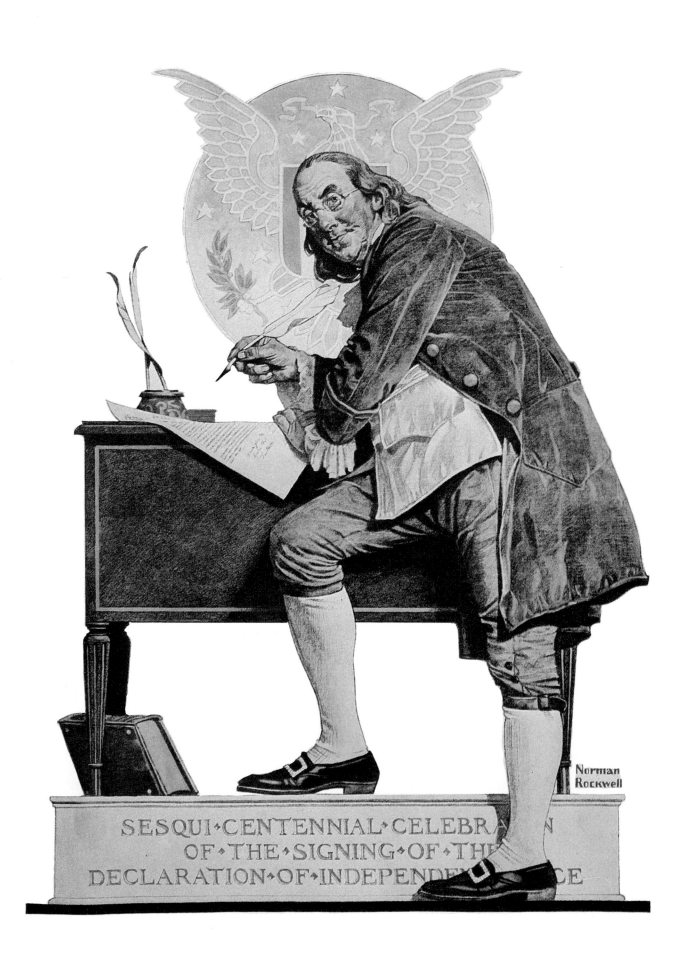

SESQUI·CENTENNIAL·CELEBRATION
OF·THE·SIGNING·OF·THE
DECLARATION·OF·INDEPENDENCE

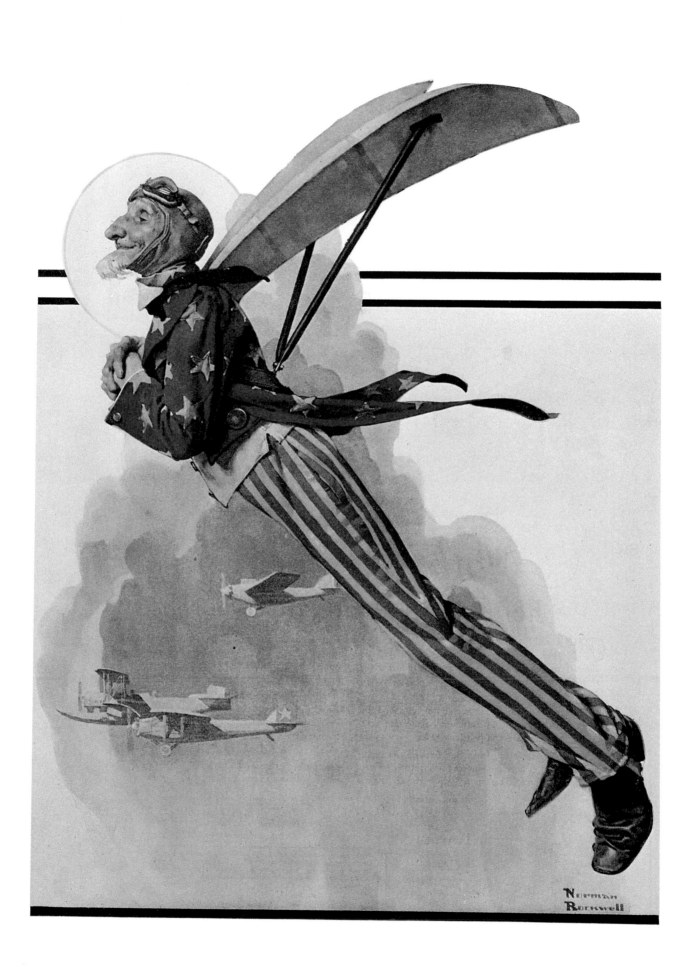

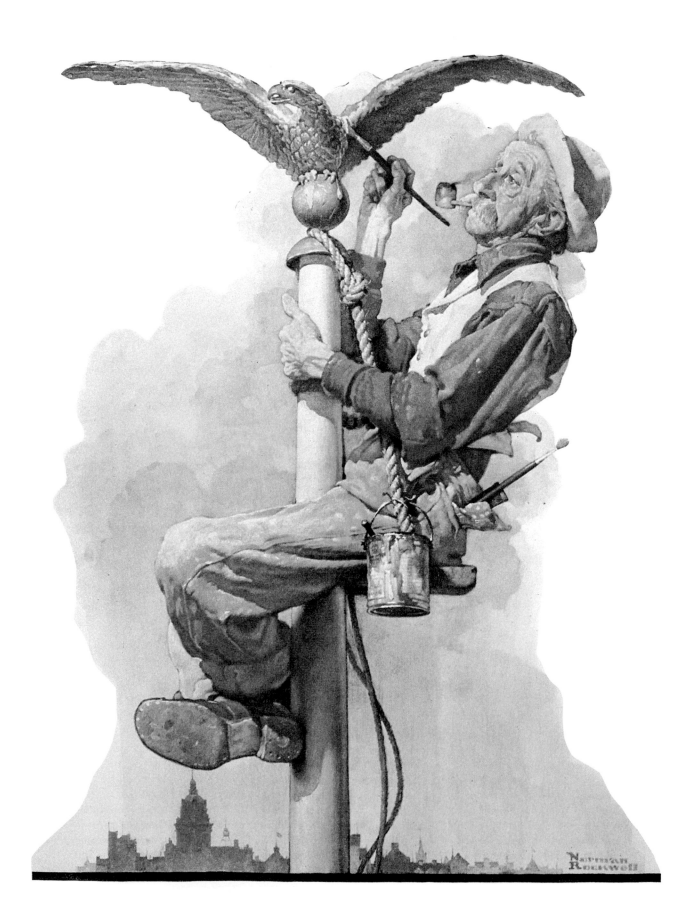

Not guns, not thunder, but a flutter of clouded
 drums
That announce a fiesta: abruptly, fiery needles
Circumscribe on the night boundless chrysanthe-
 mums.
Softly, they break apart, they flake away, where
Darkness, on a svelte hiss, swallows them.
Delicate brilliance: a bellflower opens, fades,
In a sprinkle of falling stars.
Night absorbs them
With the sponge of her silence.

—BABETTE DEUTSCH
"Fireworks"

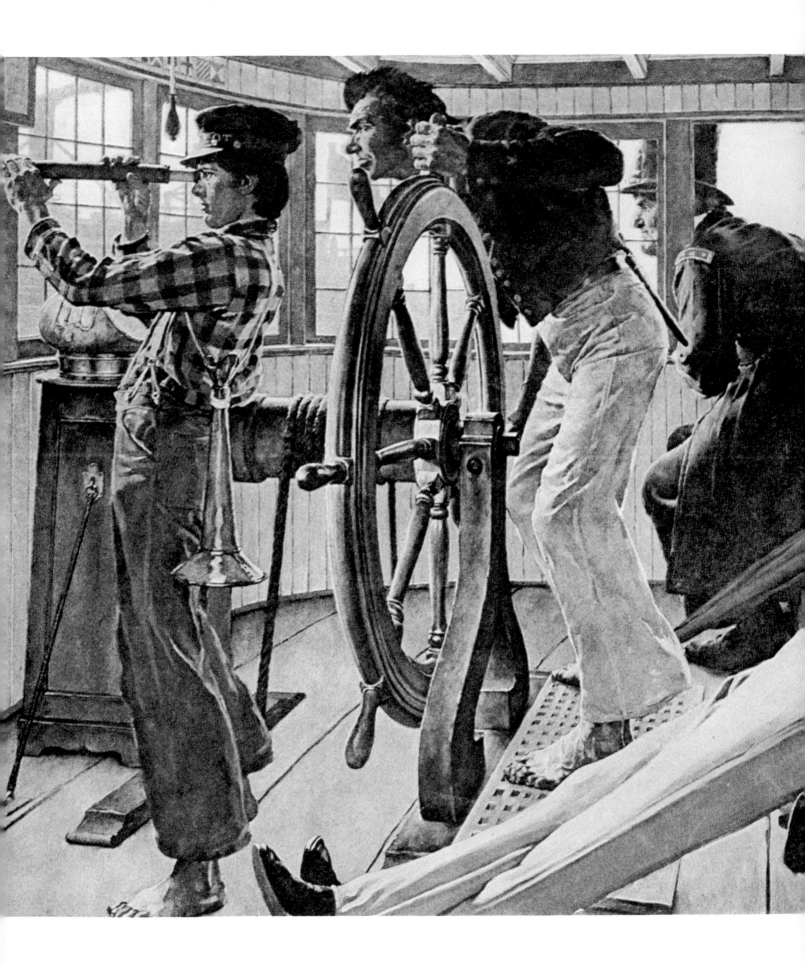

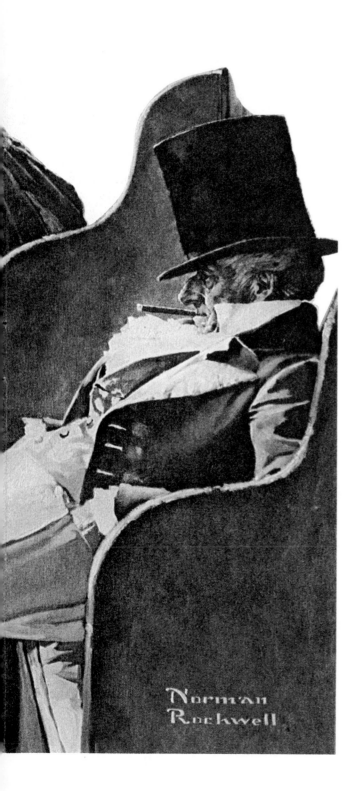

ON WEDNESDAY EVENING, 17th July (1717), the king embarked at Whitehall in an open barge and sailed to Chelsea. Accompanying him were so many other barges with important personages on board that one could say that almost the whole river was covered with boats. In one boat specially set aside for music by the City Authorities fifty musicians with instruments of all types were accommodated. All the way from Lambeth they played the most beautiful symphony which Mr. Handel had written expressly for the occasion. His Majesty received so much pleasure from it that he had the music played three times in succession on the journey to and fro. At eleven o'clock His Majesty alighted at Chelsea where supper had been laid out. Afterwards, about three o'clock in the morning, the King returned back again, and music played all the way to the landing stage.

—London *Daily Courant*, July 19, 1717

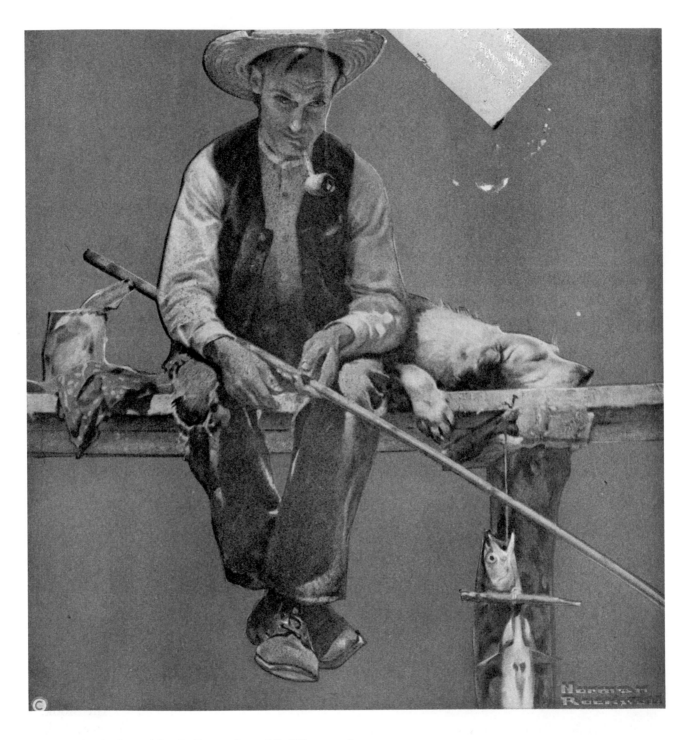

"But isn't it a bit dull at times?" The mole
ventured to ask.

"Just you and the river, and no one else to pass
a word with?"

—KENNETH GRAHAME
The Wind in the Willows

THE FISH THAT GOT AWAY

WHEN I WAS ABOUT NINE years old my father rented a summer cottage by a brook in Jamaica, Vermont. The brook was wide and shallow, and downstream there was an iron bridge crossing where the water suddenly became mysterious and deep.

The brook was like a wild child tumbling spring-cold from the Green Mountains, its banks filtered with fern and birch and alder leaves. I remember the finger-deep coves near the edge of the bank that sheltered minnows and little trout. Here, as a boy from the city, I came to dream, to drift, to get lost in a world I had never known before.

I did not know it then but that brook was to shape my life forever. It was to make poetry of my manhood, turn all my being onto the course of natural things—stars in the eyes of fish, pebbles in the grass and the sound of wind in dreams. It made me a romantic, a lover, a gypsy.

All that summer it seemed I spent my time wandering from one rock to the next along that brook. Upstream I went and downstream, discovering, listening, sometimes falling asleep with the song of the brook playing in my head.

A trout would splash and I would feel a wild sensation come over me. What was the fish seeking? The mystery of this underwater creature suddenly blooming in air like a bird, then gone into the pebbly depths. *How can I catch you?* I wondered, *bring you to my hands?*

My first trout rod was a wobbly metal contraption with a reel wound with black string that looked more like a toy for Central Park goldfishing. But I took that rod and reel seriously; indeed I did, as I had assured myself that this was the rod and reel that would take my first trout.

I went back to the place where I had seen that glorious trout appear, and, sticking a sweet worm on my hook, I cast for the fish. It was a sloppy cast and my worm went everywhere but into the water. Again a worm, again a cast.

Nothing happened. Where was that fish hiding? I tried again and again, hoping my fish would reward me for my efforts. I had about given up hope, thinking that this brook held no fish, at least no fish for me, when suddenly a tug, a great shock came into my hand—a fish! I had hooked into my fish!

That trout leaped and thrashed, how he leaped and thrashed, a brook trout of about twelve gleaming inches, a garden of flowers growing out of his silvery sides. I couldn't believe my eyes. Then I felt my knees and legs begin to tremble, my hand and arm quivered down into my heart and it seemed as though I could hear the trout talk to me: *You'll not hold me, wandering boy, but this day I'll give you a memory that will haunt you for all your days.*

I've got you now, I had thought. He had flopped upon a nest of rocks in a shallow of the brook. I remember I had just begun to reach for him when he wiggled free of the hook. For a stunned moment I could only watch him slip slowly back into the water.

Frantically I fell upon the fish with my whole body. I wanted that trout. More than anything in the world I wanted that trout to be mine forever.

I don't know how my fish got away but he did, and I've been looking for him in brooks and rivers and ponds and along banks ever since that time.

I know he's somewhere, big and strong and beautiful. I tell myself he will never be caught. And if he has been hooked, he got away as he did when he was young and a daring fighter.

Something else too, a secret thought:

I don't think I'll ever find my trout, and in my heart I hope I never will. If I did, maybe the haunting road of river calling would be gone, and a brook would come to be only the bones of a long-ago time. I would never want that to happen, so I keep searching.

I hear splashing
under a tree.
Trout rolls over
like a crescent moon
in the water dark.
If you see my eyes

by a river bank
I have come a-searching
like a gypsy boy.

—GEORGE MENDOZA

HEROIC LUGGAGE

I FIGURED I HAD TWO PIECES of luggage to worry about: one to fit under the seat ... ARMOR-COATED! POLY-MOLY-PROPYL-VINYL. LIGHTEST MOST DURABLE MATERIAL KNOWN TO MAN. BETTER THAN ELEPHANT HIDE! IT WILL OUTLAST YOU! And one to fit in the seat ... the old body of man, durable, but vulnerable, not nylon or vinyl, but prone to rashes, bites, fatigue, bruises, aches, and microbes.

My mind was ready for a trip around the world, but was my body? Vaccinations whirled through my vision: malaria, yellow fever, cholera, smallpox, plague, typhoid, tetanus, pertussis (what's pertussis?) Tender, swollen arms, ague, and fever hovered in discouraging images.

"Plan your cholera shot for a long weekend."

"Well, cholera's not really the worry; they just still require the shots. It's Dengue fever. Cracks your bones. No, there's no shot for Dengue. Just wear a mosquito net at all times. Thick clothing also helps." It's a choice between a tan and Dengue fever.

And what if? A hospital?

"The hospital care in China is excellent. You just have to get used to the dirt floors."

And dysentery. James Michener says it's three days no matter where you go. And I mean, Michener's been a lot of places! Does around the world mean three days at every stop? I have already learned one traveler's truth: when the bowels go, you immediately lose interest in shrines (except those in white porcelain), museums, and quaint folk art. The charms of ethnic embroidery just can't keep a body from wanting to lie down ... preferably in its own bed. If you keep your vacations to a week, you can be home in time to get sick. Around the world takes longer. Does Angkor Wat have clean restrooms? "Nepal is beautiful, but the whole country smells of merde."

If my mind can't rise above my own bowels, how can it rise above a whole country's?

So far, the luggage under the seat is fine. The luggage the mind must travel in seems a frail package, increasingly prone to trembling.

"A few drops of common laundry bleach in each glass of water is an effective measure against the common tourist problem." Also good for cleaning the tongue, I think.

"Avoiding the local waters altogether is often the most reliable measure." What about shaving with it? What about nicks and cuts? What about bathing in it? I mean, the mind spins with the variations of amoebic cunning!

"Bottled beer or wine are also effective alternatives." But will I remember the trip? Well, one always has the pictures.

And that requires camera, telephoto lens, wide-angle lens, extra batteries, flash unit, one hundred rolls of film plus a flashlight, binoculars, tape recorder, journal, passport, traveler's checks, reading novel, maps, local explanations, bug repellent, medications, toilet kit, snacks, money, hat, raincoat, and footgear, and there you have the adorned archetypal tourist-body, a modern beast of burden.

Add jet lag to the beast, and you begin to see it stumble.

"Remember, the rest of the world is not America. Phones don't always work. Electric

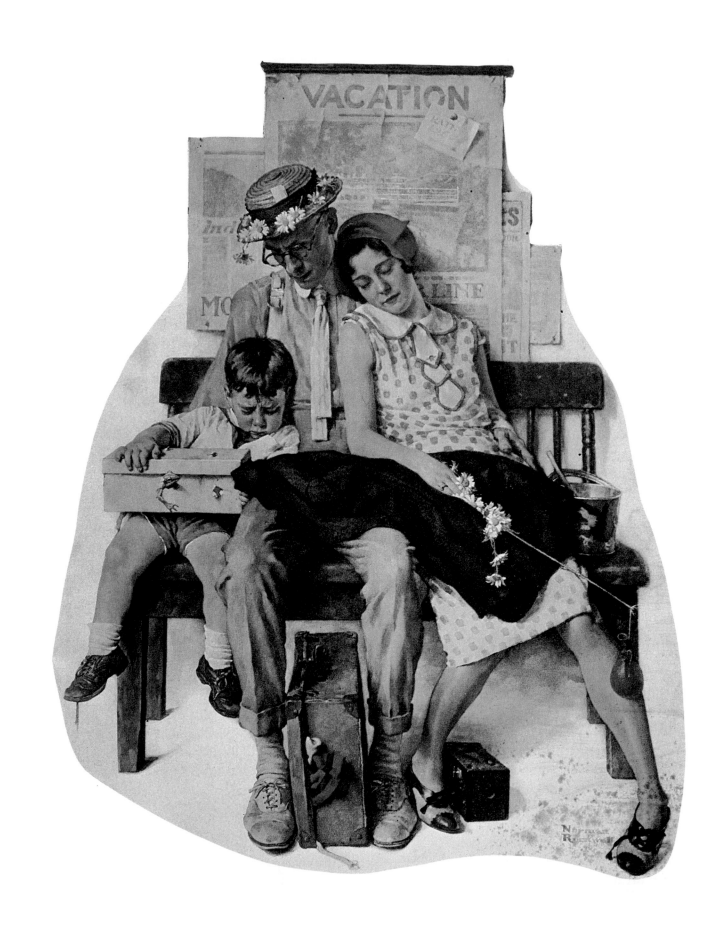

power can be erratic." (Does dealing with Con Ed help?) Train schedules are invented daily, if not hourly. (Does commuting on ConRail help?) Planes fly when the spirit moves. (I do worry about the planes. If they can't sterilize water, how do they get airplanes up and down?) A first-class hotel (translate: clean) costs $100 and up, and reservations are a matter of intent not fact. Thus, the art of waiting, the capacity to disorient the mind into time and space, leaving the body to wait, sitting mute, immobile like luggage, is a virtue worth practicing.

So the body asks, "Why around the world?"

And the mind replies, "I want to make it finite; I want to make it embraceable. I want to circumnavigate the concept as well as the thing. I want to erase the intimidation of size. I want to relocate my reference points. I want to expand the landscape of my thoughts. I want to add a dimension to my soul that only conquering time, distance, and space can add. It is not for pleasure.

"I want to conquer an ever-receding horizon, the horizon that I will surpass and yet only come to. I want to leave home, knowing home is before me. Facing it, by turning my back, it is before me as I leave it. It is Through the Looking-Glass. Where I am is where I will be, where I arrive by leaving.

"With the known at my back, I travel to the known to rediscover it. It is a journey toward, while a journey from, and as it recedes behind me, I know it looms in front. It is to reknow the known that I also set forth. I retrace nothing, yet come eventually upon the beginning. And when done, the beginning will be new, the familiar unfamiliar, the old discovered, the first last, and first again.

"It is the horizon finally finite, finally turning back on itself to reveal me that I chase. And coming upon my reflection, to reconsider it, to see it part of the new, the foreign, the rediscovered. For journeying-self to suddenly discover remaining-self and to surprise it into new meaning, that is why a trip around the world, that is why a journey away from and back to self . . . that is why, body. For both the going and the returning. For both the process and the end."

So I looked at luggage. Soft luggage, hard luggage, luggage with straps, luggage with wheels, hanging luggage, carry-ons, two-suiters, three-suiters, leather, vinyl, nylon, cloth, cut-resistant, tear-proof . . . I looked at it all, and finally bought a piece. As were they all, it was guaranteed. It would return from around the world as it left, untorn, unbroken, bumped, beaten and pummeled, but unbowed without broken hinges or zippers . . . guaranteed.

But as far as the luggage on the seat, there were no guarantees. It came only one way: "AS IS" . . . accompanied by the mind at its own risk.

And so, body, you must be heroic luggage. Vulnerable leather, venerable portmanteau, unmodern, of ancient design, scratchable, breakable, but resilient, you must rise to the challenge. For, old friend, I cannot go alone. So carry me, rickshaw of the spirit, embraced, that I might in turn embrace the curvature of the sky.

—TOM SYDORICK

TEN RULES FOR TRAVELERS

1. Do unto the other fellow in his country as you would like to have him do unto you in yours.
2. Go abroad to learn how things are done outside America, not to declaim how much better everything is done at home.
3. Don't think that the louder you talk the more apt you are to be understood—and *appreciated.*
4. A small tip with a large smile often goes further than a large tip with a scowl.
5. Remember that you are unofficially representing your country, and that by your actions it is being judged.
6. Plan your trip as if you were building a house. Don't think it's "smart" to be vague.
7. Motor when you can. You get a much more intimate sense of a country and its people than in train travel.
8. Travel light.
9. Don't worry.
10. Don't hurry. If you have too little time, cut down the number of things to see.

—*CLARA E. LAUGHLIN*
The Nomad

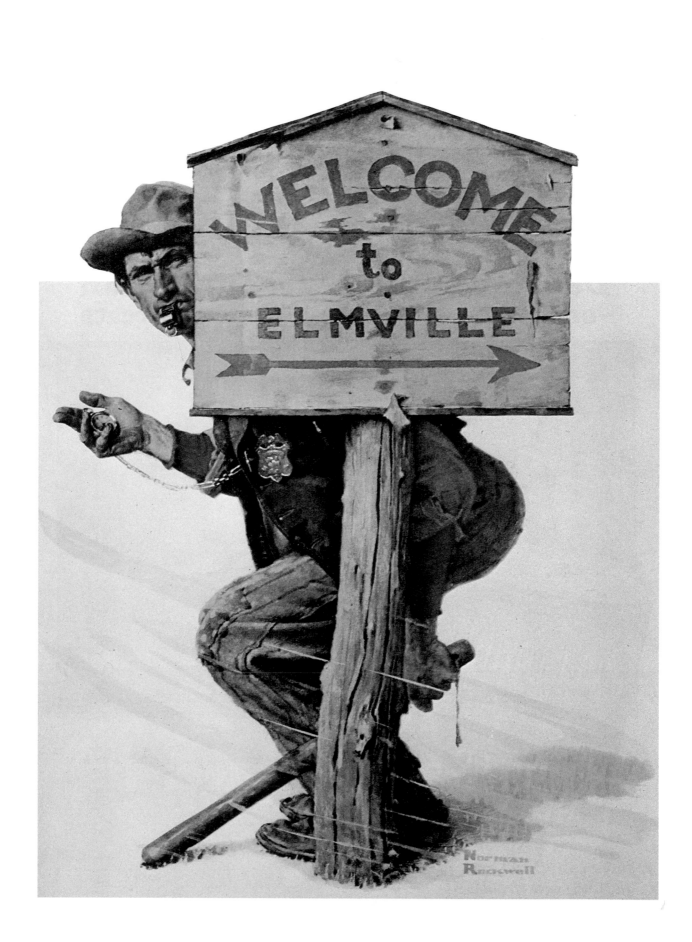

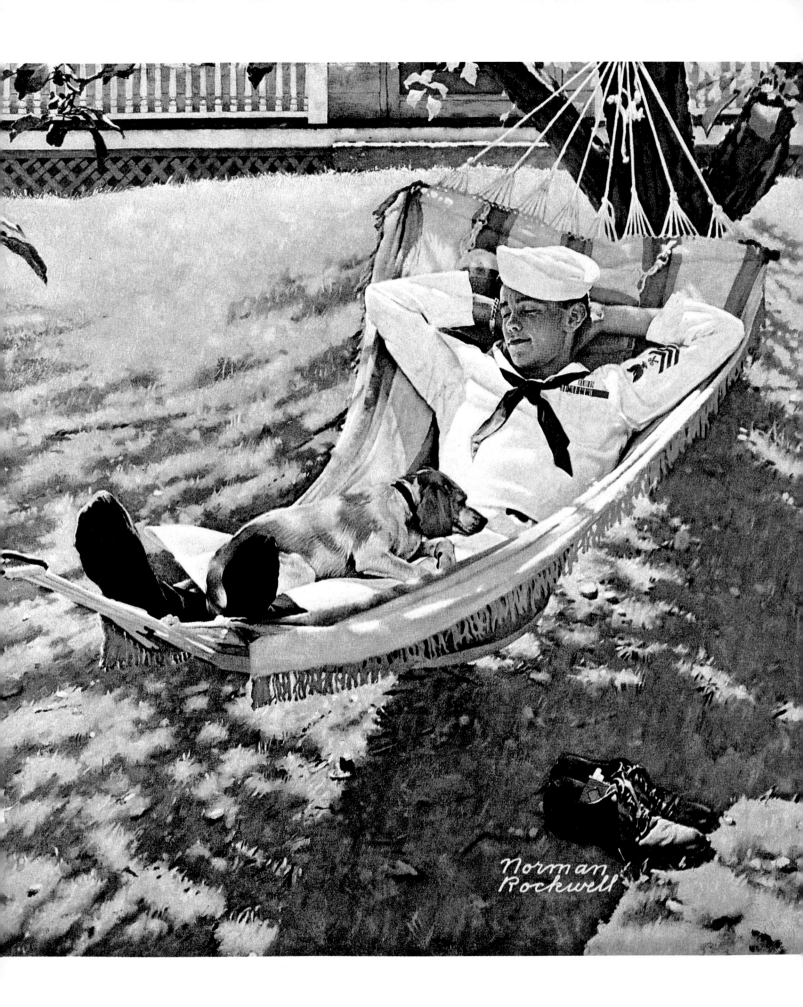

LEISURE WILL KILL YOU

THIS COUNTRY IS PRODUCING so much leisure equipment for the home that nobody has any leisure time anymore to enjoy it. A few months ago I bought a television tape recorder to make copies of programs when I was out of the house.

Last week I recorded the Nebraska-Oklahoma football game. When I came home in the evening, I decided to play it back. But my son wanted to play "Baseball" on the TV screen with his Atari Computer. We finished four innings when my wife came in the room and asked me if I would like to listen to the Vienna Opera on our hi-fi stereo set. I told her I was waiting to finish the baseball match so I could watch the football game I had recorded.

She said if I watched the football game for three hours, I would miss *Love Boat*. I told her I would record *Love Boat* and we could watch it later in the evening. She protested that *Casablanca* was showing on Channel 5 at 11:30 and she wanted to see it again.

"Don't worry," I assured her, "we can watch *Love Boat* late Saturday and *Casablanca* on Sunday morning when we get up."

"But if we watch *Casablanca* tomorrow morning when can we see the instant Polaroid movies you took of Ben yesterday afternoon?"

"We'll see them after we play backgammon on the new table."

"If we do that," my daughter said, "we won't be able to see the Washington Redskins-New York Giants football game."

"I'll record the Redskins-Giants football game and we'll watch it while *60 Minutes* is on the air. We can see *60 Minutes* at 11 o'clock."

"But," my son said, "you promised to play the pinball machine with me at 11."

"Okay, we'll play pinball at 11 and watch *60 Minutes* at midnight."

My wife said, "Why don't we listen to the Vienna Opera while we're eating and then we can save an hour to play computer golf?"

"That's good thinking," I said. "The only problem is I've rented a TV tape for *Cleopatra* and that runs for three hours."

"You could show it on Monday night," she suggested.

"I can't do that. I have to return the tape Monday afternoon or be charged for it another week. I have an idea. I won't go to work Monday morning and we'll watch it then."

"I was hoping to use our Jacuzzi Monday morning," my wife said.

"Okay, then I'll tape *Cleopatra* and you can see it Monday afternoon."

"I'm using the set Monday afternoon," my son said, "to play digital hockey on the TV screen."

"You can't do that," I said. "I have to watch the *Today* show in the afternoon if I'm going to watch *Cleopatra* in the morning."

"Why can't you watch the *Today* show at dinnertime?" my wife asked.

"Because the Wolfingtons are coming over to hear me play 'Tea for Two' on the electric organ."

"I thought we might play computer bridge at dinner," my wife said.

"We'll play it after my encore," I assured her.

"Then when will we see *Monday Night Football?*" my son wanted to know.

"Tuesday," I said.

"Does that mean you're not going to work on Tuesday?" my wife asked.

"How can I go to work," I yelled, "when I've got so much leisure time on my hands?"

—ART BUCHWALD
Laid Back in Washington

People are always complaining about jet lag.
 Oh praise jet lag! Endless days of jet lag.
 What euphoria! Ah the lambent drifting.
 It's the greatest high because you don't feel
 you've quite got your feet on the ground.
Champagne, jet lag and being six miles up
 under the stars is for me. I could go on like
 that forever.

—GEORGE MENDOZA

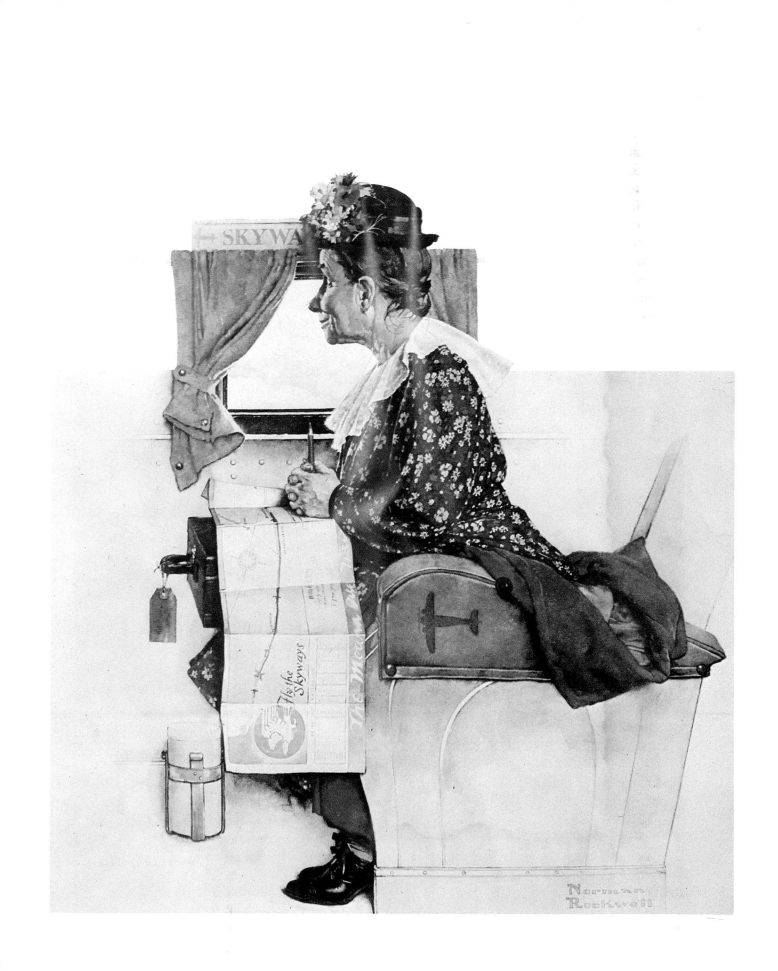

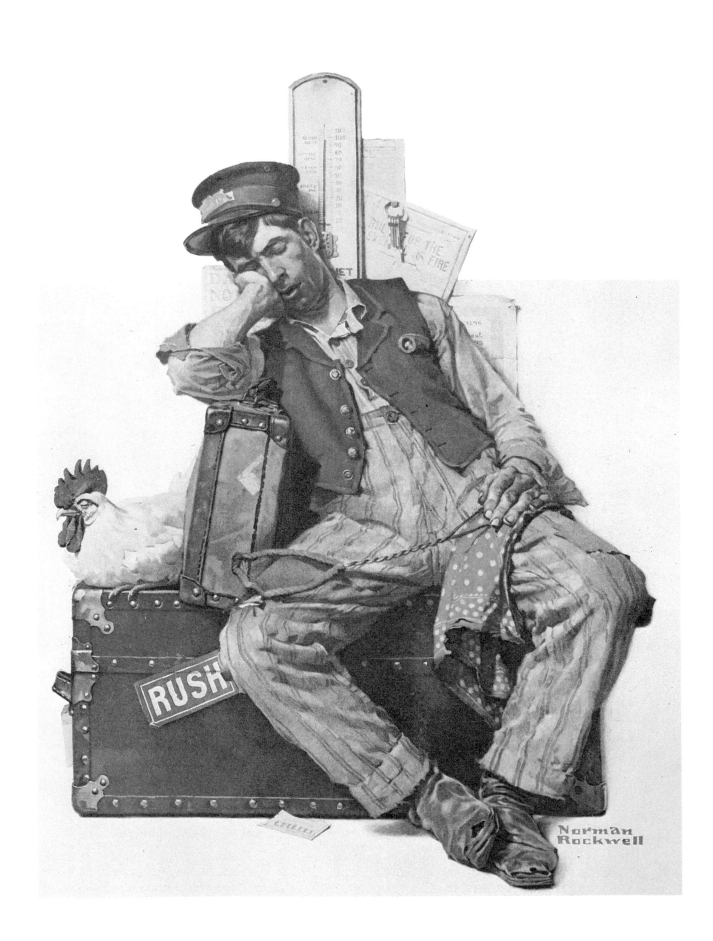

FLYING CLIPPER CRUISE ITINERARIES

THE FLYING CLIPPER CRUISES leave Miami every Sunday—Direct connections by air or rail from northern cities.

TWELVE DAY CRUISES: Inclusive fare from Miami $865.00.
- Sundays—Miami to San Juan, Puerto Rico
- Mondays—San Juan to Port-of-Spain, Trinidad
- Tuesdays—Port-of-Spain to Belem, Pará, Brazil
- Wednesdays—Belem to Recife, Pernambuco, Brazil
- Thursdays—Recife to Rio de Janeiro
 Remain in Rio Friday, Saturday and Sunday. Return trips leave Rio Mondays arriving in Miami the following Thursday.

NINETEEN DAY CRUISES: Inclusive fare from Miami $895.00.

Leave Miami on Sundays as in the case of the Twelve Day Cruises, but remain in Rio ten days. (Friday to a week from the next Monday after arrival there.) Buenos Aires extension, if desired, $143 additional. Leave Rio on Mondays, as above, for the return trip.

WHAT THE CRUISE FARE INCLUDES:

- Air Transportation from Miami to Rio de Janeiro and return.
- Full 55-pound baggage allowance. Extra charges for additional baggage.
- Transportation between airports and hotels en route.
- Meals aloft and ashore.
- Hotel accommodations (except laundry, wine, liquors) at all stops on the airway and in Rio.
- Sight-seeing drives and services of expert guides in Port-of-Spain and the two special trips in Rio.
- Charges for passport, Brazilian visa, etc., are additional.

—*PAN AMERICAN WORLD AIRWAYS*
"The Way It Was in 1936"

THERE'S NO ENDING

ALL MY LIFE I've been giving over to a way out of this world. I've always believed that the path of escape was a winding road of rocks with water running wild and beneath, jewels of fish as mysterious as life itself. What does a river mean to a man? What comes into his head when the river is near? What are his dreams?

A pure fisherman is a poet, full of beauty and flight. He knows the names of flowers that grow along the stream, and he speaks to the waxwings in the branches above. He fishes the river not to catch the trouts but to become one with his soul and his God. A pure fisherman reads and remembers poetry. He dreams of one day fishing in the mountains of Andorra or among the flowers of Asturias.

Most fishermen I have known are quite boring and oddly overweight. They are too preoccupied with their acquired knowledge of the sport and what clubs they belong to, and behold their fancy gear!

No, this is not the pure fisherman. This is a hunter, a man who wants to run against you, a man who has missed the meanings of the river.

And so the boy still walks in me
as he wandered long ago
on a Vermont brook
when the boy discovered
the world had a beginning . . .
and in the trees
the wind made songs
and the leaves were like
the lips of a child . . .
And in the boy
there is no ending
as the man watches him
and tries to catch up.

—*GEORGE MENDOZA*

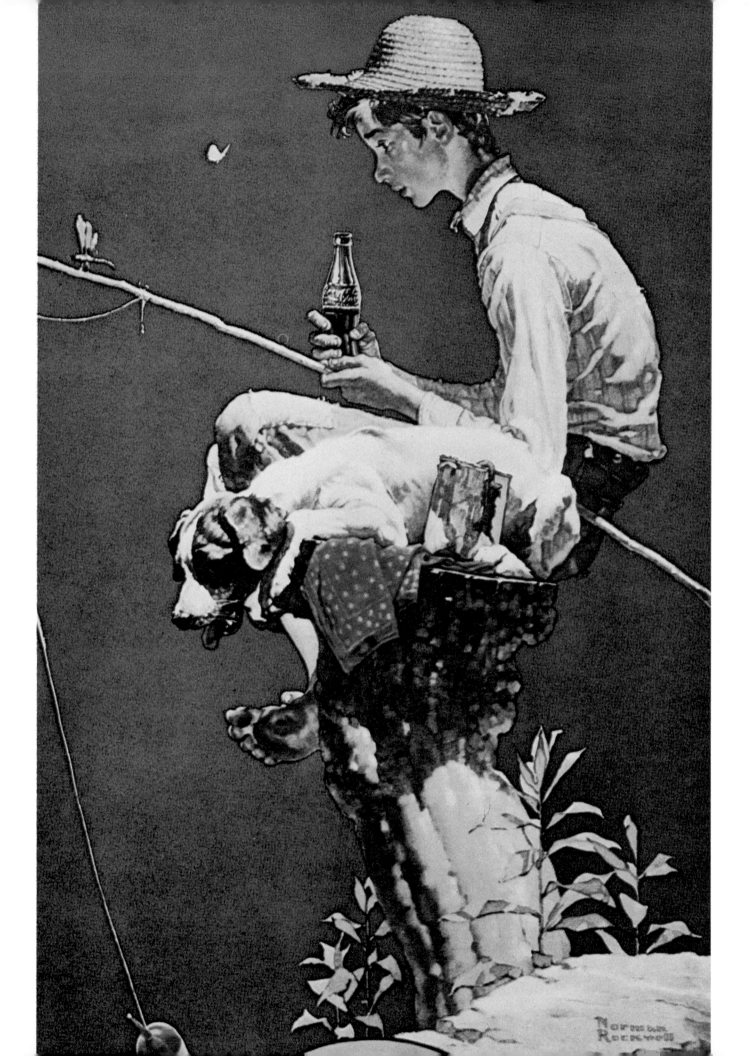

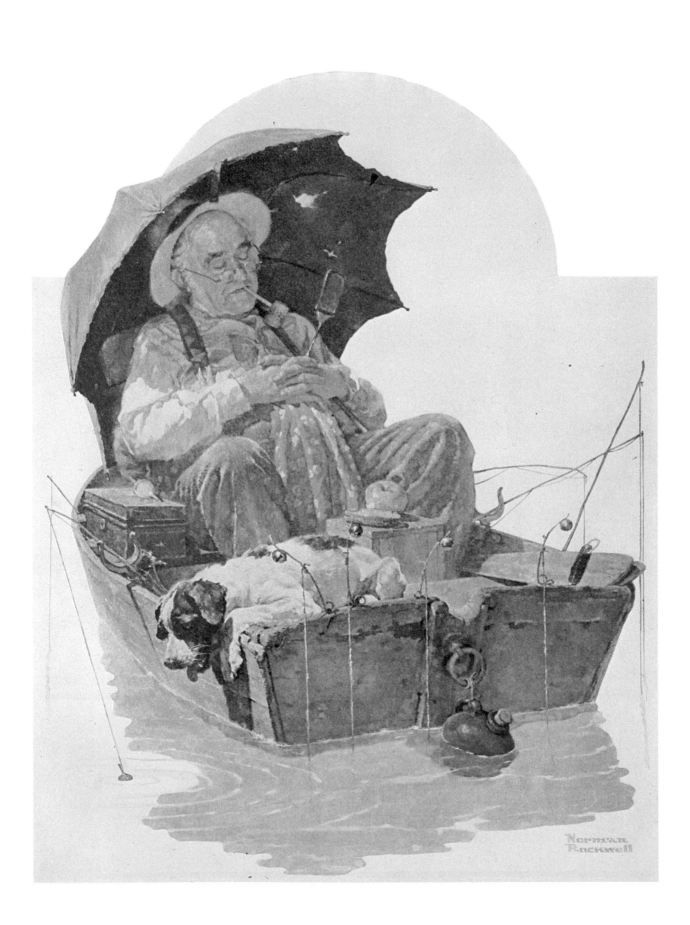

URHO FRANSSON'S MAINE PERCH SOUP

Yield: 6 servings
 six lake white perch (4 to 6 inches each), dressed and pan-ready with heads and tails intact (for flavor)
 1 large onion, chopped
 4 peppercorns
 4 whole allspice—these add the "special" touch
 salt to taste
 3 medium-sized potatoes, cut into quarters (or smaller if preferred)
 1 tsp. flour
 1 cup milk (or half-and-half)
3–4 pats butter

Put fish, onion, spices, and salt into soup pot with roughly ¾ quart water. Bring to boiling point and cover and simmer till fish begins to break apart. Mash mixture in pot (this creates the thick consistency of the soup). Strain, reserving liquid in pot . . . discard rest.

Add potatoes and simmer until done to desired tenderness.

While potatoes cook, mix 1 tsp. flour into 1 cup of milk (if half-and-half used for a richer soup, lessen flour).

When potatoes are done, mix in flour/milk mixture, stirring constantly. Cook over low flame for two or three minutes.

Put butter pats on soup and serve immediately.

This soup is a delicious, light meal. We serve it with thick slices of buttered pumpernickel or rye bread.

CHECK UP ON THOSE CHILDHOOD PROMISES

AS A CHILD you read about surf riders at Waikiki, camels in Arabia, elephants in Ceylon. You gloried in pictures of the great Wall of China, the Grand Canyon of Arizona, the giant redwood trees of California, big enough to admit an automobile through the trunks! You resolved one day to see all those exciting and curious things for yourself. That day has come! The delights which aroused your youthful imagination are beckoning to you. The years have brought changes—to them and to you—but you'll be astonished at the way Travel will recapture your lost illusions, once you embark on the pilgrimage you first planned when learning the three R's.

—*House Beautiful*
February 1932

ON THE BEACH

IT IS A SUMMER DAY. Hot. Beautiful. A perfect day, someone has decided, to be cooked in oil and eaten by flies. We lie basting on beds of sand while insects roam over us, smacking their chops and uttering little cries of "yum yum" upon sinking their mandibles into dainty morsels of human.

My companions feel superb. "Natural vitamin," they murmur. "So healthy." This alludes to our absorption of powerful ray emissions from the sun which are already attacking our pigments, changing our skin coloration and probably making a royal mess of our genetic coding machinery.

Occasionally, one of us enters the ocean to garnish the hair with seaweed and have the bones pounded by surf. It is a harmless amusement and afterward the sinus tubes gurgle with salt water.

My own pleasure in this outing comes from body watching. Not until I had passed years of excruciating embarrassment about the prospect of exposing my torso on the beach did I open my eyes to the rest of the parboiling population and see what any clear-eyed child would have seen in infancy.

This is that the great mass of humanity, when stripped down to a few threads and exposed to bright light, looks no more appetizing than I do. For years I had suffered under the impression that I was the only person on the beach who looked like a spavined ruin.

The blame for this misapprehension can probably be laid to Charles Atlas, the famous 97-pound weakling turned Adonis who sold his muscle-building program with an advertisement that showed a chap resembling Michelangelo's statue of David kicking sand in the face of an undernourished youth who looked like me and striding off with the voluptuous eyeful who had accompanied the ineffectual Mr. Bones on the beach.

Throughout those years when a young man's fancy turns to voluptuous women, I never dared invite one to the beach, such was the power of this ad. There was no doubt in my mind what would happen if I did. She would be instantly coveted by the hordes of Weissmullers who patrolled the American littoral, I would end up with sand in the face and a crushing right hook to my protruding ribs, and she would abandon me in reproach for my lack of any pectoral or trapezius muscles worth mentioning.

The fact, of course, is that voluptuous women of the sort I had in mind are no more common than men constructed like Michelangelo's David, so that the necessity to avoid taking one to the beach was not a full-time problem. Whenever I did meet one, however, I favored taking her to late-autumn football games at which my bone structure and musculature could be concealed under yards of horse blanketing.

Finally, of course, as it must to all men, the age of utter shamelessness arrived. At that age one wears glasses, has a touch of gray in what is left of hair, quits struggling against the downward rearrangement of the frontal contours. It is safe finally to go to the beach with anyone, even voluptuaries.

What young god of the beach would kick sand in the face of a man twice his age? If any did, would the old gentleman not profit outrageously from the tender sympathy evoked in his voluptuous companion?

At the age of shamelessness, a man takes his eyes from his own fascinating person a little more frequently and looks out upon others. Looking out upon others at the beach, I was shocked by the spectacle.

Not a Weissmuller in sight, much less an Adonis. Here and there, a finely muscled lifeguard or a youth with a surfboard who had a little spring in his step. Even these, however, suffered from the self-consciousness of the young. This kept them too absorbed in carrying the shoulders just so and keeping the abdomen carefully sucked in for best display of the chest expansion to allow them time to notice, much less abuse, 97-pound weaklings.

The multitude, male and female, displayed all the imperfections that screen, television and Madison Avenue have labored two generations to persuade us are nonexistent in the human race except among idiots who resist the sponsor's commer-

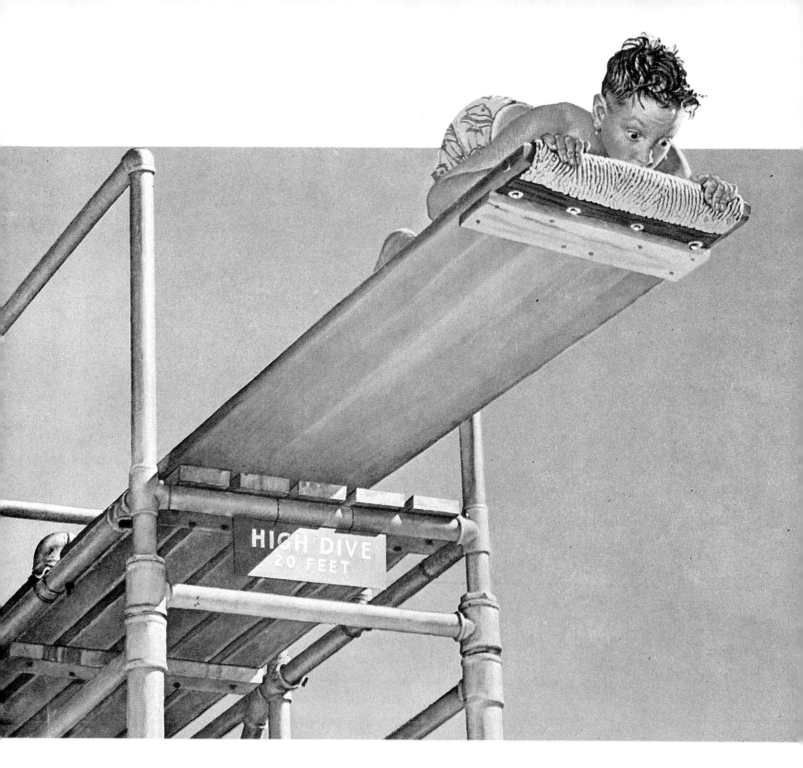

cial. Fallen belly, sunken chest, flabby midriff, meatless ribs, clanking knees, buckled spine, withered biceps.

On the beach you can see that we are all pretty much the same when it comes to beauty, and that the scrumptious Southern California boys and girls who pass for Americans on television are a gang of frauds.

It's worth being cooked and eaten occasionally to have this truth verified. I hope any 97-pound weaklings in the audience will put down their barbells, go out to the beach and look for themselves, instead of at themselves for a change, and then wink at that voluptuous dish before it's too late. If after winking, they look, they will probably see she's not exactly voluptuous so much as a little overweight front and aft, but humanly amenable to a little companionship.

—RUSSELL BAKER
"Sunday Observer"
The New York Times Magazine

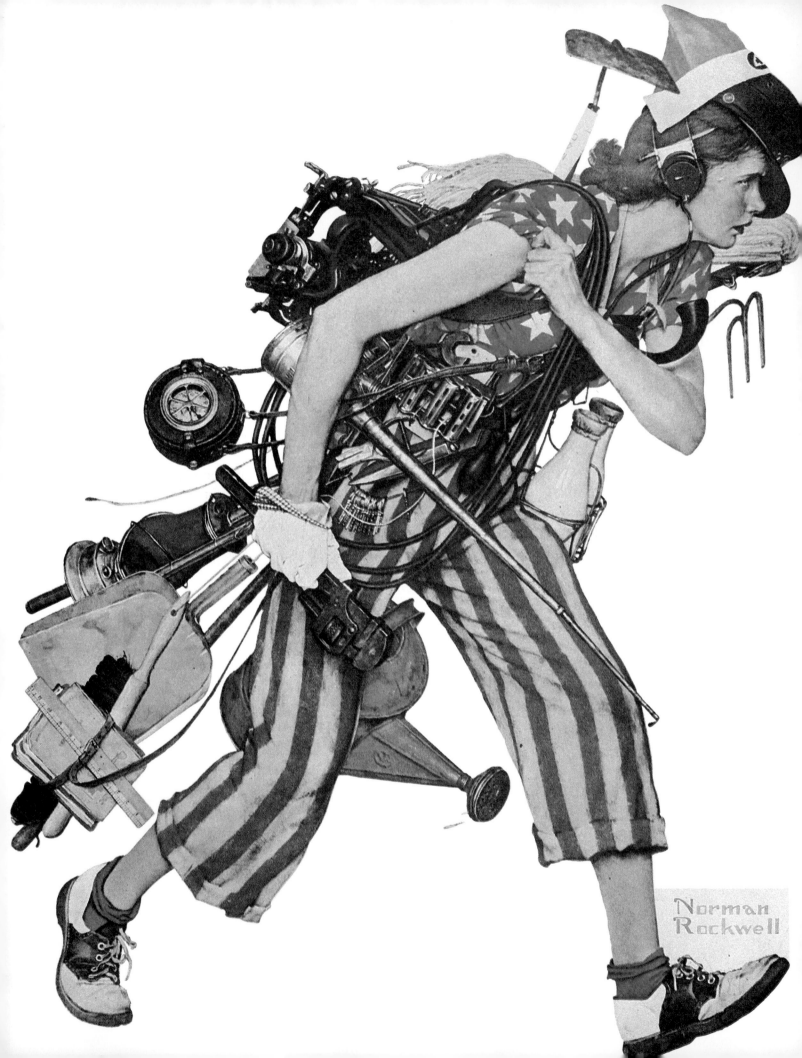

BY THE MIDDLE OF the nineteenth century, industrialization had progressed to the point where a working class had defined itself. The cult of honest, manly labor had gained considerable prominence, especially in the United States. The labor movement had, as well, a messianic fervor and conceived of itself as the vanguard of all social progress. Consistent with the optimism of the time, it was believed that society could be made nearly perfect if the idealism of the labor movement could hold sway over society.

In this environment, it was natural for the labor movement to want to set a day aside to commemorate the working man. In fact, the idea was first proposed by Peter J. McGuire, a leader of the Knights of Labor and the founder of the United Brotherhood of Carpenters and Joiners of America. It was in 1882 that Mr. McGuire made his proposal to the Central Labor Union in New York City and on September 5 of that year, ten thousand workers marched around Union Square in New York City and staged the first Labor Day Parade. Oregon was the first state to recognize Labor Day on February 21, 1887, and it was made a national holiday by Act of Congress in 1894.

With time, the association between Labor Day and the labor unions has diminished to the point where, today, it is a general family holiday. It is considered the last holiday of summer, when traditionally there is a picnic or outing to have one last celebration before fall.

—The Delineator

A DAY'S WORK is a day's work, neither more nor less, and the man who does it needs a day's sustenance, a night's repose, and due leisure, whether he be painter or plowman.

—*GEORGE BERNARD SHAW*

Death is the end of life; ah, why should life all labour be?

—*ALFRED, LORD TENNYSON*

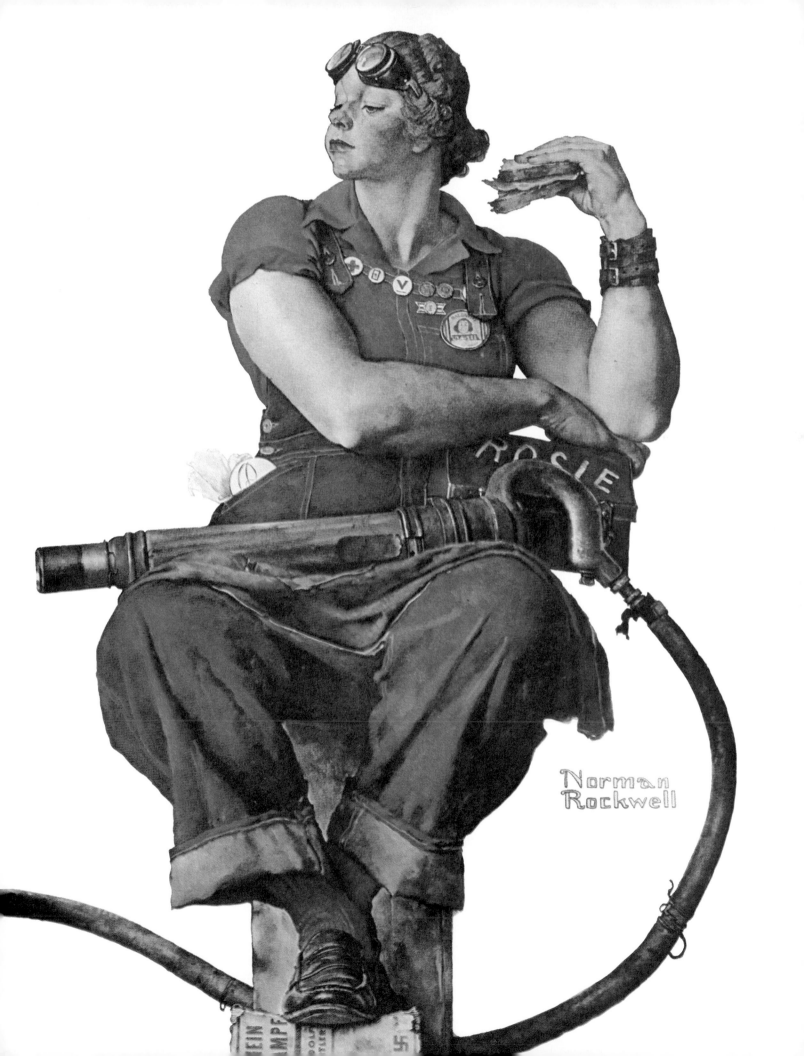

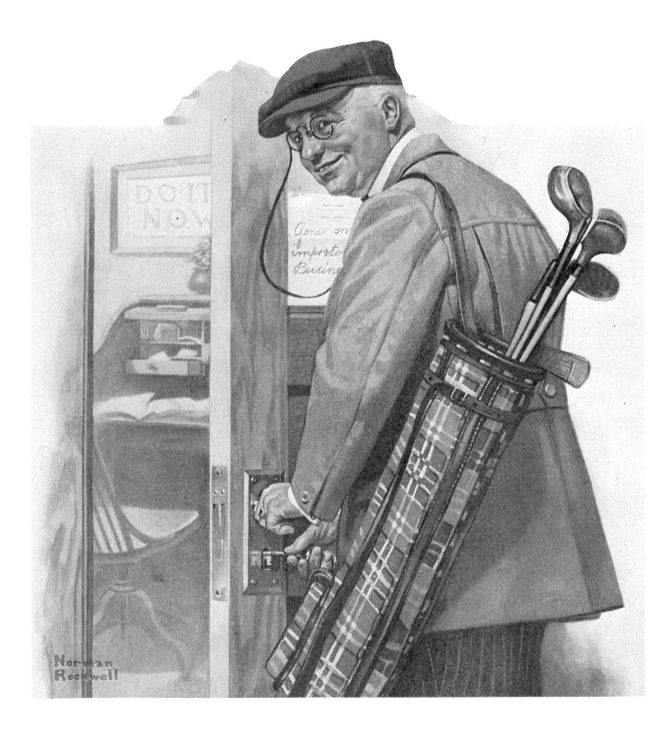

Nothing to do but work,
 Nothing to eat but food,
Nothing to wear but clothes,
 To keep one from going nude.

Nothing to breathe but air,
 Quick as a flash 'tis gone;
Nowhere to fall but off,
 Nowhere to stand but on.

* * *

Nothing to sing but songs,
 Ah, well, alas! alack!
Nowhere to go but out,
 Nowhere to come but back.

* * *

Nothing to strike but a gait;
 Everything moves that goes.
Nothing at all but common sense
 Can ever withstand these woes.

—*BENJAMIN FRANKLIN KING, JR.*
The Sum of Life

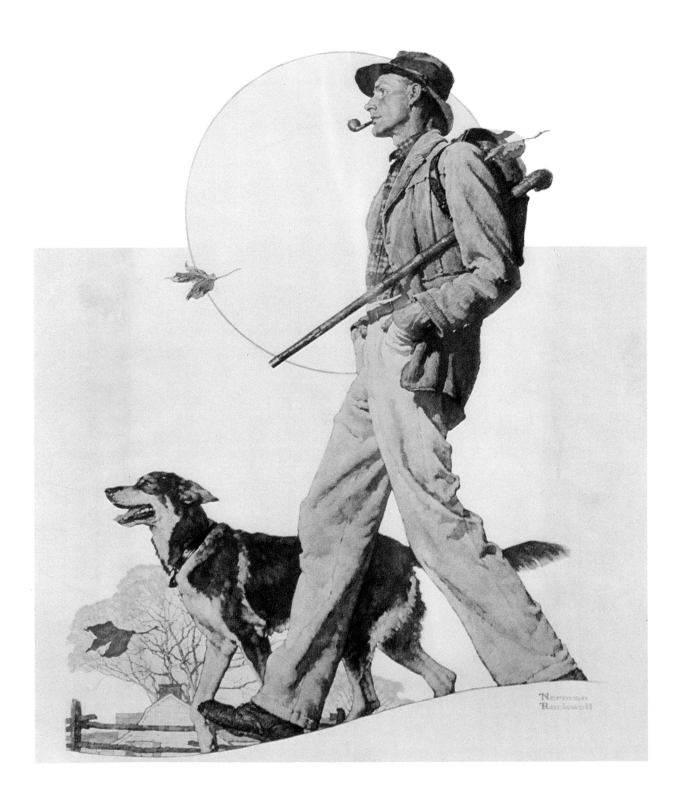

It was a little shack by a river
with a brick rust chimney singing out a
 slate roof.
It was a place a man could go
to escape the slashing world . . .
where he waited for nothing more
than a metal coffee pot to whistle from a
 wood stove . . .
while the winds from the forest of pine flows
crossed the deer-run banks
and smoked all day in your head . . .

I drove a September Sunday to see my friend
who owns the little shack by the river
to share river spinning in some coffee—
but when I reached his cedar door
a sign scrawled out at me:
"ON VACATION. GONE TWO WEEKS.
 AL."

> —GEORGE MENDOZA
> "Vermont Logic: September 18, 1970"

I come to this mystical brook-river
to escape awhile,
to take my drink as though I were a thief with
 time:
to dream by the brook-drifting bank,
to cloud my head in the clouds,
sailing on the dark brook-rippled top,
to tie a speck of winged fly
to a leader silken as a fair girl's hair,
to walk across fresh-cut fields of rye and wheat
to a stretch the poet Soper said was fast, so deep
and sun-gold, like the tassled corn,
to talk to a friend, my poet friend,
under a brook-moon with stars dusting them-
 selves
like crystal dew spanning the yards of the Dipper.

O let the world spin old.
My dawn is sweet,
September-cold.
Mist-wind is creeping low
as a serpent with its head under a rock
and its tail still weaving in the grass.
On the brook before the flower's opened
I'm casting by the dam,
old dam, weather-planked by the burned-down
 mill
where yellow butterflies flutter above charred
 timbers
and by the stream wild trout lilies and boneset
 and mint
tilt like windmills,
and clover balls pop like little plums in the brush
 weed.

The smell of the brook is swimming in my head,
my soul reaches for a somewhere prayer.
I know the lunkers are nymphing from the deeps,
but before the morning wind is up
I'll be wandering like a gypsy boy down the
 stretch below,
where the white house high on the birch bank
peeps through the peeling trees,
where the brook-river bends like a bough
and the alder leaves drop in the brook-furrows
to ride and play beside my fly.

—*GEORGE MENDOZA*
"As Though I Were a
Thief with Time"

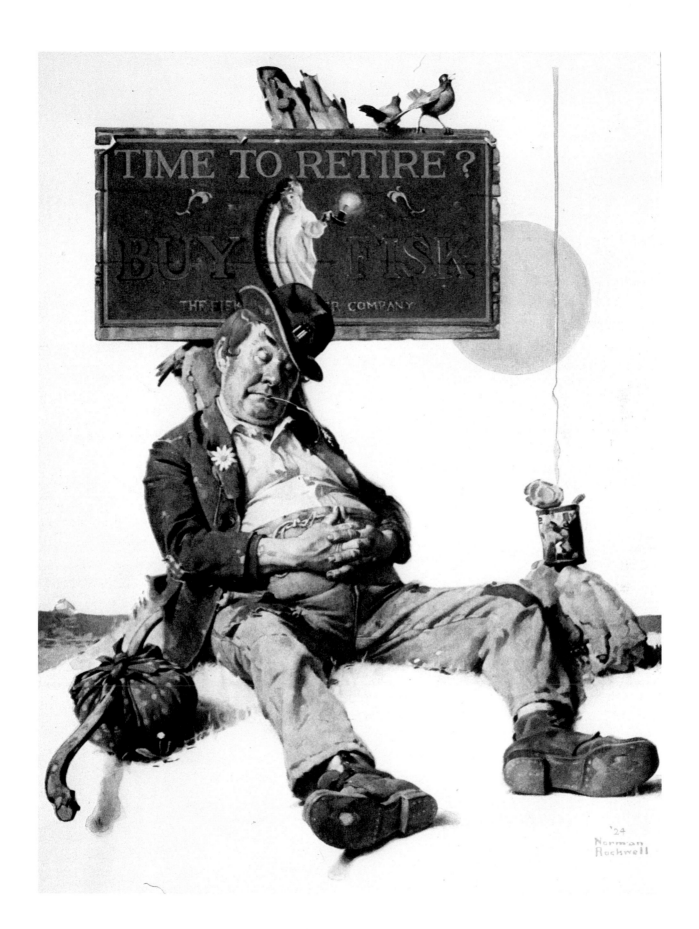

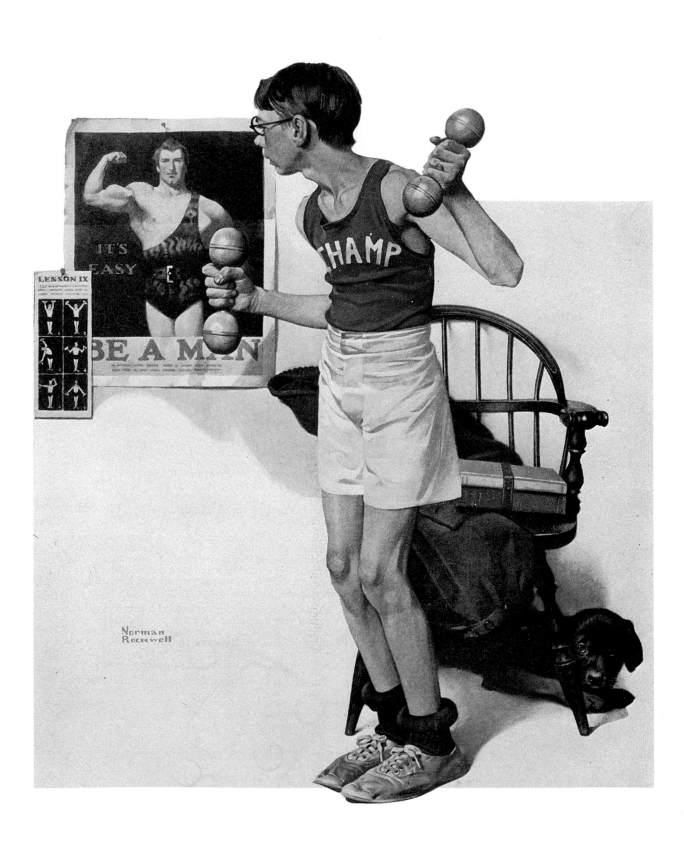

The skinny kid
 leaped for the leaf;
 he thought he could catch it—
one green leaf.
It would fall in its own time
but now, wind-turning,
red-speckled with orange suns spinning,
green still running in its rivers,
it held the bough that bore it.
The skinny kid will kick it
in a week or so
if he has a mind to.

<div align="right">—GEORGE MENDOZA</div>

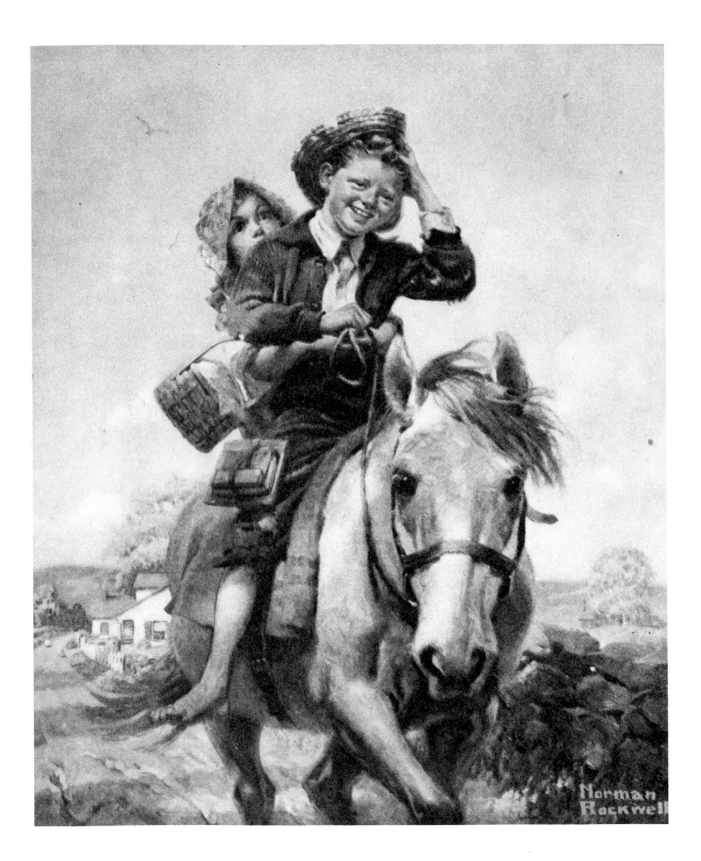

In the other gardens
and all up the vale,
From the autumn bonfires
See the smoke trail!

Pleasant summer over
And all the summer flowers,
The red fire blazes,
The grey smoke towers.

Sing a song of seasons!
Something bright in all!
Flowers in the summer,
Fires in the fall!

—ROBERT LOUIS STEVENSON
"Autumn Fires"

FESTIVE
HUNT FEAST

Hors d'oeuvre
Paté Maison in Madeira Gelée

Hot Buffet
Roast Watertown Gosling, Apple Dressing, Danoise
Lynnhaven Oyster Pot Pie Southern Style, Vin Blanc
Scallopina of Young Ogeechee Venison, Sauce
Poivrade
Roast Fresh Loin of Piglet, Apple Sauce
Guale Corn Soufflé Glazed Silver Skin Onions
Brussels Sprouts Lanier

Cold Buffet
Cauliflower Vinaigrette
Spiced Seminole Kumquats Habersham Apple Sauce
Pickled Whole Midget Corn
Cucumber Slices in Sour Cream

Salads
German Potato Salad Altama, Hot Virginia Bacon Dressing
Satilla Cole Slaw Fresh Fruits Ambrosia
Country Cottage Cheese and Chives
Brook Watercress and Garden Salad with Croutons

Pain de Ménage
South Georgia Cracklin' Bread
Date Nut Bread Gloucester
New England Brown Bread

Desserts
Glacé Fruit Tarts
Pumpkin Pie Chantilly Frederica Petit Fours
Picadilly Mincemeat Pie
Old English Trifle Holiday Fruit Cake
German Chocolate Layer Cake
Slice of Turkish Cassata German Apple Strudel
Swiss Chocolate Mousse Grand Marnier

—THE CLOISTER

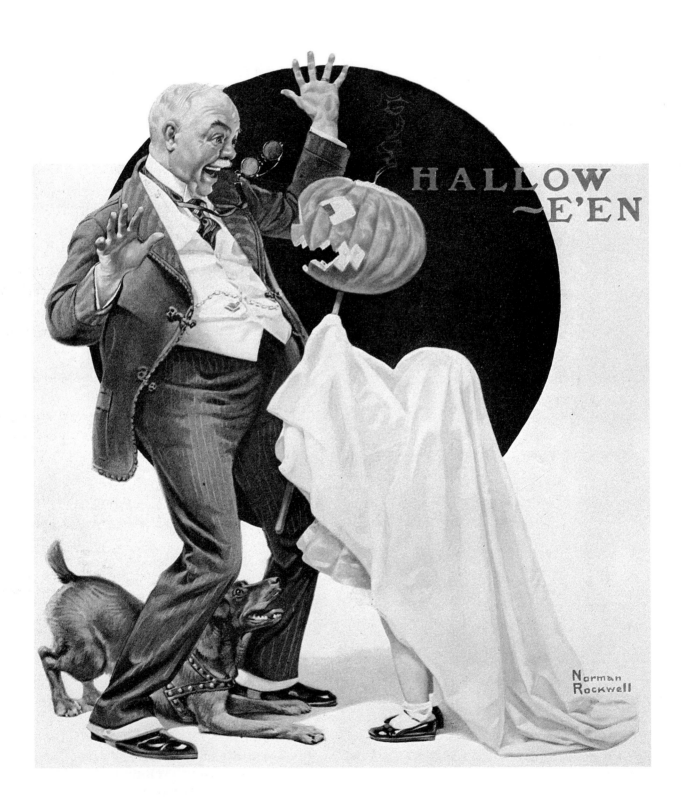

THE HIGHLY MYSTICAL Druids worshipped nature and imbued it with supernatural qualities. They attributed great spiritual significance to certain plants (mistletoe is a prime example) and worshipped the Sun God and the Lord of Death. During the Samhain festival [on the last day of October], the Druids appeased the Lord of Death, since it was believed that he allowed the spirits of those who had died that year to return to earth for a few hours to warm themselves by the fireplace and to mingle with their families once again.

Another important rite practiced during this holiday was the lighting of great bonfires on hill tops to honor the Sun God and to frighten away evil spirits, as it was thought that ghosts and witches fear fires. For days before, children would go around begging for material for the fire. The concept of witches developed among the Druids from their belief that there were women who had sold themselves to the Devil. This idea was also common among the early Egyptians and Romans. And ghosts were considered to be the souls of the dead. Samhain was a night on which bats, black cats, elves, and fairies stalked about. With visions of ghosts, witches, and other spirits filling their minds, people would dance and sing around the bonfire. Some people would dash through and over the flames.

When the Romans occupied Britain, it was inevitable that elements of the Roman harvest feast of Pomona, the fruit goddess, would intermingle with those of the Druid festival. For this reason fruit centerpieces, apples, and nuts feature prominently in our present-day festivities. The popular game of bobbing for apples was played by the ancient Romans and cider was drunk. Nuts are symbolic of food stored for the winter.

Since Samhain marked the beginning of the new year, there was interest in making predictions for the coming year, and fortune-telling became an important part of this holiday. Among the Druids, it was the custom to tell the future from the peculiar shapes of various fruits and vegetables. Young women would try to discover who their husbands would be, and young men would peel apples in the hope that the shape of the peels would reveal the initials of future sweethearts.

Pope Gregory III in the eighth century designated November 1 as All Saints' or All Hallows' Day. By the Middle Ages, October 31 was known as All Hallows' E'en (*e'en* representing the shortening of *evening*). Today this is further contracted to Halloween. . . .

Halloween costumes, which are an important part of our present day celebration, are connected with the belief that the souls of the dead return as ghosts and visit their families on this day. The custom may also derive from the practice among early Christians of displaying relics of saints on All Saints' Day. Among the poorer churches, which did not have relics to display, processions were held in which parishioners would dress like saints, angels, or the devil. . . .

Going from door to door seeking alms goes back to the Druids' practice of begging for material for the bonfire. The *trick* feature of trick or treating results from the belief that the ghosts and witches created mischief on this night, so that any practical joke could be blamed on these supernatural forces.

The influence of the Irish immigrants on the celebration of Halloween can be seen in the jack-o'-lantern. The jack-o'-lantern comes from the legend of an Irishman named Jack who lured the Devil up a tree to fetch an apple and then cut the sign of the cross on the bark to prevent him from coming down. Jack forced the Devil to promise never to seek his soul. When Jack died, he was turned away from Heaven because of his drunken and nasty ways. Seeking a place to go, Jack went to hell but the Devil would have no part of him and, as Jack was walking away, the Devil threw a hot coal from the fires of hell at him. Jack was eating a turnip at that moment and caught the hot coal with it. Jack has wandered the earth with his jack-o'-lantern ever since, seeking a place to rest.

From Ghoulies and Ghosties,
And long-leggity Beasties,
And all things that go bump in the night,
Good Lord deliver us.

—*OLD CORNISH LITANY*

Little Willie from his mirror
Licked the mercury right off,
Thinking, in his childish error,
It would cure the whooping cough.
At the funeral his mother
Sadly said to Mrs. Brown:
" 'Twas a chilly day for Willie
When the mercury went down."

—*AUTHOR UNKNOWN*
"Little Willie"

1st Witch. Round about the cauldron go;
In the poison'd entrails throw.————
Toad, that under coldest stone,
Days and nights hast thirty-one
Swelter'd venom sleeping got,
Boil thou first i' the charmed pot!

All. Double, double toil and trouble;
Fire, burn; and, cauldron, bubble.

2nd Witch. Fillet of a fenny snake,
In the cauldron boil and bake:
Eye of newt, and toe of frog,
Wool of bat, and tongue of dog,
Adder's fork, and blind-worm's sting,
Lizard's leg, owlet's wing,
For a charm of powerful trouble,
Like hell-broth boil and bubble.

All. Double, double toil and trouble;
Fire, burn; and, cauldron, bubble.

3rd Witch. Scale of dragon, tooth of wolf,
Witches' mummy; maw, and gulf,
Of the ravin'd salt-sea shark;
Root of hemlock, digg'd i' the dark,
Liver of blaspheming Jew,
Gall of goat, and slips of yew
Silver'd in the moon's eclipse;
Nose of Turk, and Tartar's lips;
Finger of birth-strangled babe,
Ditch-deliver'd by a drab,
Make the gruel thick and slab:
Add thereto a tiger's chaudron,
For the ingredients of our cauldron.

All. Double, double toil and trouble;
Fire, burn; and, cauldron, bubble.

2nd Witch. Cool it with a baboon's blood;
Then the charm is firm and good.

—*WILLIAM SHAKESPEARE*
Macbeth

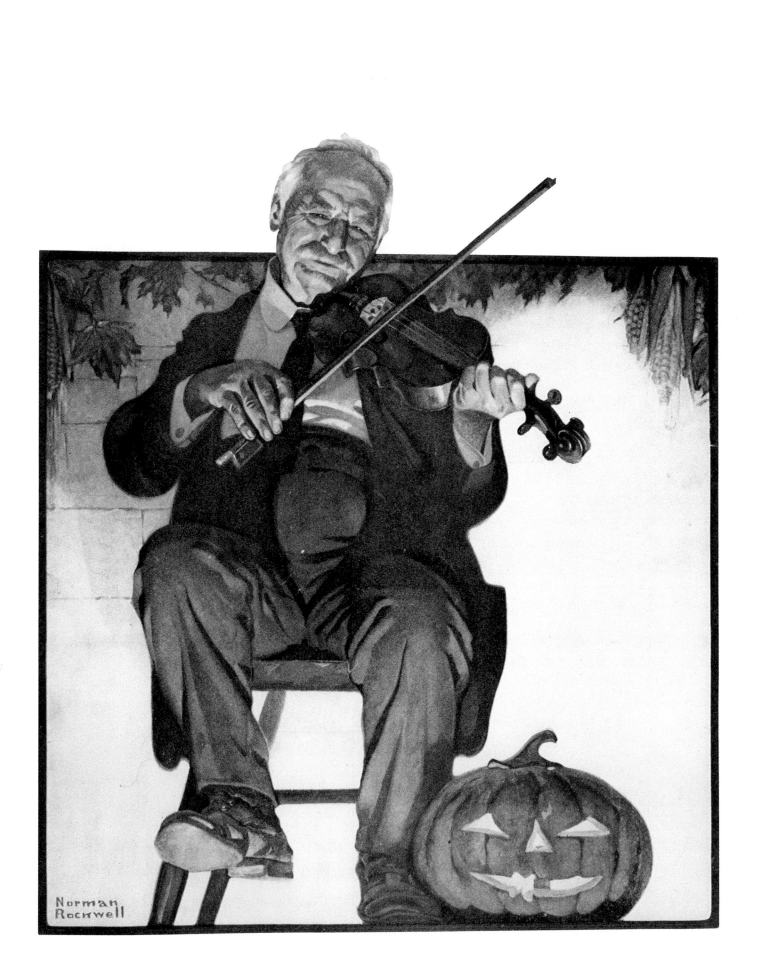

HALLOWEEN FEAST

Your choice of poison served by red-eyed repro-
bates in red coats—drink and be merry!

Bloody Cranberry à la Dracula
Chopped Liver of a Churlish Chicken
Satanic Sea Spider Cocktail
And from the Cauldron—
Bubbling Broth Julienne Voodoo Vichyssoise
Gruesomely Prepared Churning Chowder Murky
with Corn
Relics from the Relish Tray
Rustling Branches of Celery Blood Shot Olives
Coffin Nail Carrots
Lucifer's Lobster, Baked and Bedeviled,
Stuffed and Slimy with Bewitched and Battered Butter
Offensive Omelette Oozing with Sea Urchins
and Covered with Cheesey Goo
Diabolical Duck Dripping in Orangey Juice
Served with Dark and Dreary Dabs of Rice
Roasted Rib of Crazy Cow with
Petrified Pudding from Yorkshire
Creepy Crawly Creole of Shattered Shrimp,
Steaming Risky Rice
Taunted Tenderloin Strangely Stroganoff Served
with Skinny, Scrawny, Naked Noodles
Cold and Clammy Chef's Platter with
Gory Green Garnish
Petrified Parisienne Potatoes Squeamish Squash Soufflé
Bewitched Bothered and Buttered Sprouts
Repulsive Rolls and Morbid Muffins
Shaken and Shivering Salad à la Caesar the Cold.
Tossed and Tired Lettuce Hearts—
Dressed or Undressed
Your Just Desserts
Black Car Eerie Eclair Lucifer's Lemon Slab
Curdling Cream Pie à la Nesselrode the Nasty
Murky Mocha Frozen by Terrible Turks
Old Bog Blueberry Pie with Leftover Crumbs
Cemetery Pears, Hag Helena Style
Harvest Moon Pumpkin Pie
Jittery Jell-O
Hell Frozen Over Ice Creams and Shivering Sherbets
Forbidden Fruits and Rat-Trap Cheeses

—THE CLOISTER

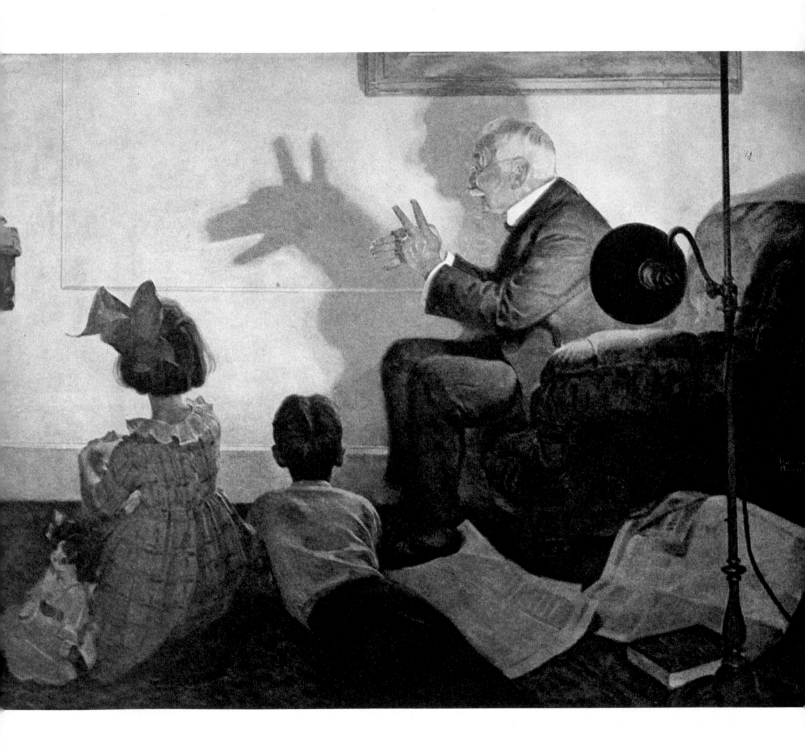

THE HAIRY TOE

THERE WAS A WOMAN, an old gnarled stump of a woman, who went out one day to pick beans in the bean patch behind her house, which looked like an old crooked cobweb abandoned a long time ago.

There she was, bending and picking, bending and picking, when all of a sudden—she found a hairy toe.

"Gwot!" cried the old woman and ran with her beans and the hairy toe back to her house and locked all the doors and the shutters too.

That night the old woman stood at the stove, stirring a pot of stew. She stirred the beans she had picked and an old knotted spud. And floating on top of the pot was the hairy toe.

"Gwot!" cried the old woman as she sat down to eat, devouring and licking with glee every last morsel in the pot.

Then she smacked her lips, patted her belly, and crawled into bed.

Now, as the old woman lay asleep, snoring and croaking like a bullfrog, the night turned bark-black and the wind began to curl around the old crooked house, coiling and creaking through the shutters and the old wooden floors. Then far off in the distance a small voice began to moan:

Who's got my hair-r-r-y to-o-o-e-e-?
Who's got my hair-r-r-y to-o-o-e-e?

"Gwot!" cried the old woman in her sleep, and she scrooched down deeper under the covers.

But the wind rose wailing through the old wooden house and the voice came still closer and closer:

Who's got my HAIR-R-R-R-Y TO-O-O-O-E-E?

Who's got my HAIR-R-R-R-Y TO-O-O-O-E-E?

The old woman opened one eye, and peering over the covers, she searched the darkness of the room.

The shutters rapped against the old house and the wind rumbled down the old chimney and the voice seemed to be coming from outside the door.

WHERE'S MY H-A-I-R-Y T-O-E?

WHO'S GOT MY H-A-I-R-Y T-O-E?

The old woman stiffened in her bed. The voice *was* coming from outside the door.

Then all at once the door cracked open and the voice was booming inside the old crooked house.

W-H-O'S G-O-T M-Y H-A-I-R-Y T-O-E!

W-H-O'S G-O-T M-Y H-A-I-R-Y T-O-E!

And the old house shook and the voice was so close the old woman could feel it breathing down on her head.

And the old woman bolted up in her bed, screeching—

GWOT!

I ATE IT!

—*GEORGE MENDOZA*

The garden's grown over
like a high seaweed tide
the corn never took
but the orange carrot barrels
were endless earthly invasions—
the lettuce curled and bunched tight,
luring grasshoppers into leafy inns
far from the hunters of the night—
and poppies and poppies and poppies
came rising like purple ocean moons
till their petals fell
under the glide of fall.

—*GEORGE MENDOZA*

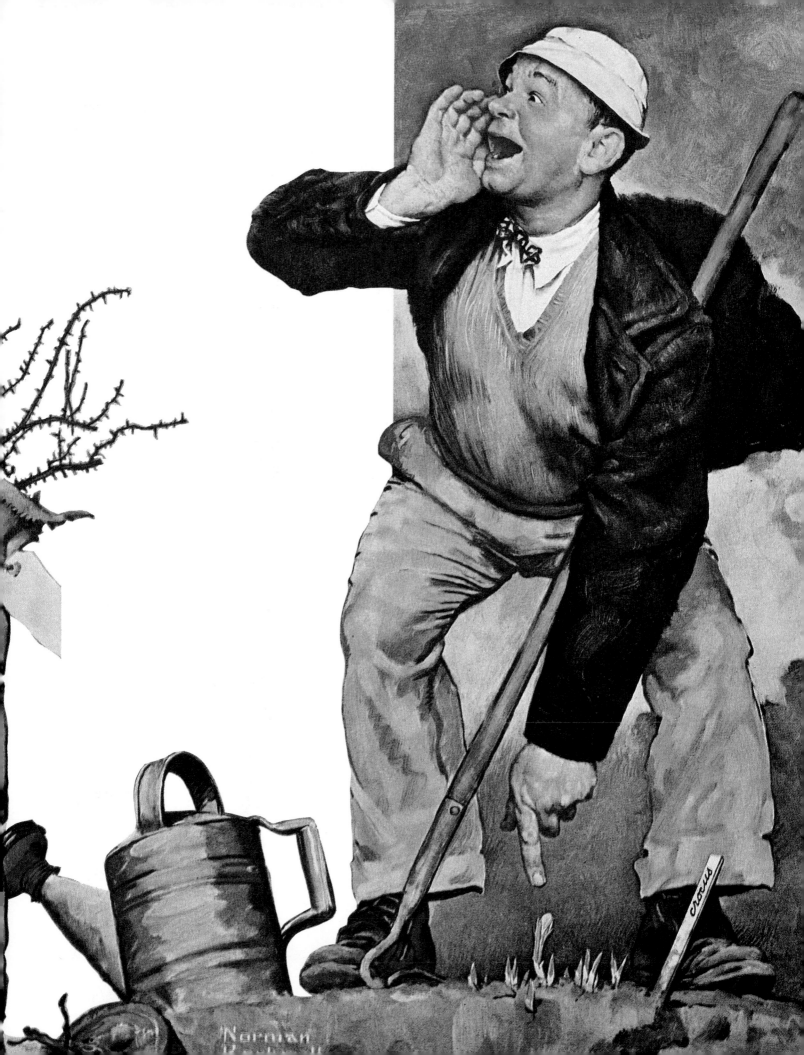

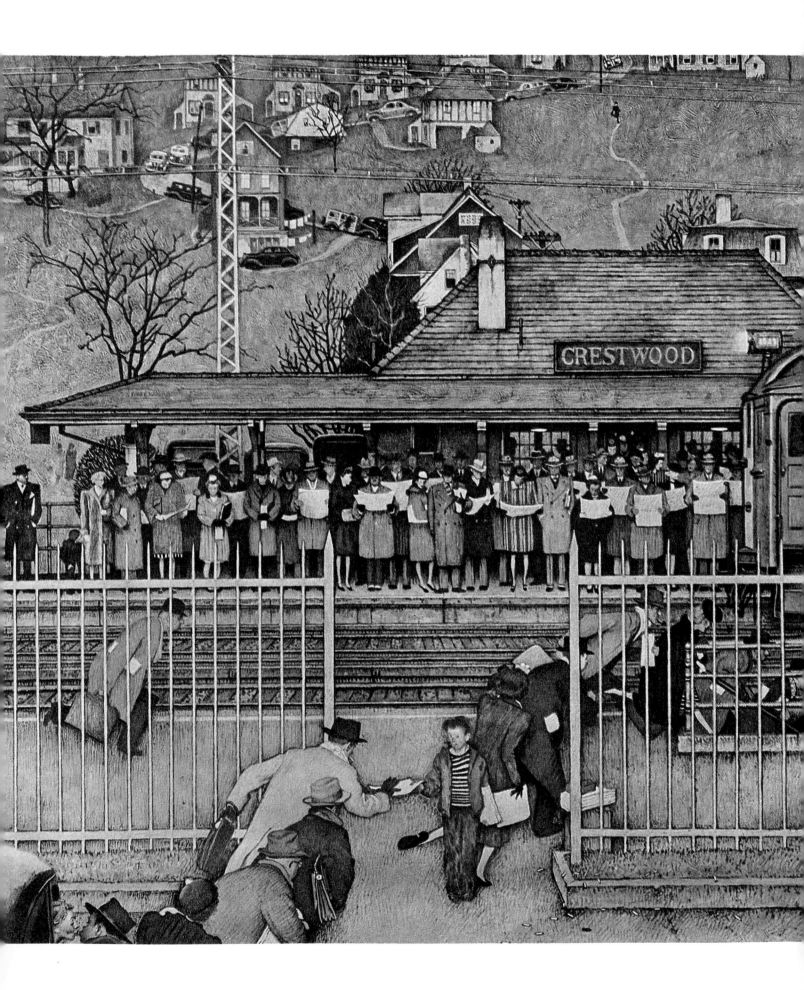

Summer's gone and over!
Fogs are falling down;
And with russet tinges
Autumn's doing brown.

Boughs are daily rifled
By the gusty thieves,
And the Book of Nature
Getteth short of leaves.

Round the tops of houses,
Swallows, as they flit,
Give, like yearly tenants,
Notices to quit.

Skies, of fickle temper,
Weep by turns and laugh—
Night and Day together
Taking half-and-half.

So September endeth—
Cold, and most perverse—
But the month that follows
Sure will pinch us worse!

—*THOMAS HOOD*
"The Season"

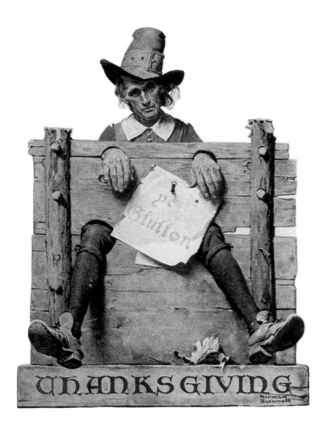

For the hay and the corn and the wheat that is
 reaped,
For the labor well done, and the barns that are
 heaped,
For the sun and the dew and the sweet honey-
 comb,
For the rose and the song, and the harvest
 brought home—
Thanksgiving! Thanksgiving!

 —ANONYMOUS

All over the land and far over the sea
 Our glad "gobble-gobble" is heard,
'Tis the national air of the brave and the free
 The Song of the Thanksgiving Bird!

 —*JOHN HOWARD JEWETT*
 "The Song of the Thanksgiving Bird"
 New Idea Woman's Magazine, 1906

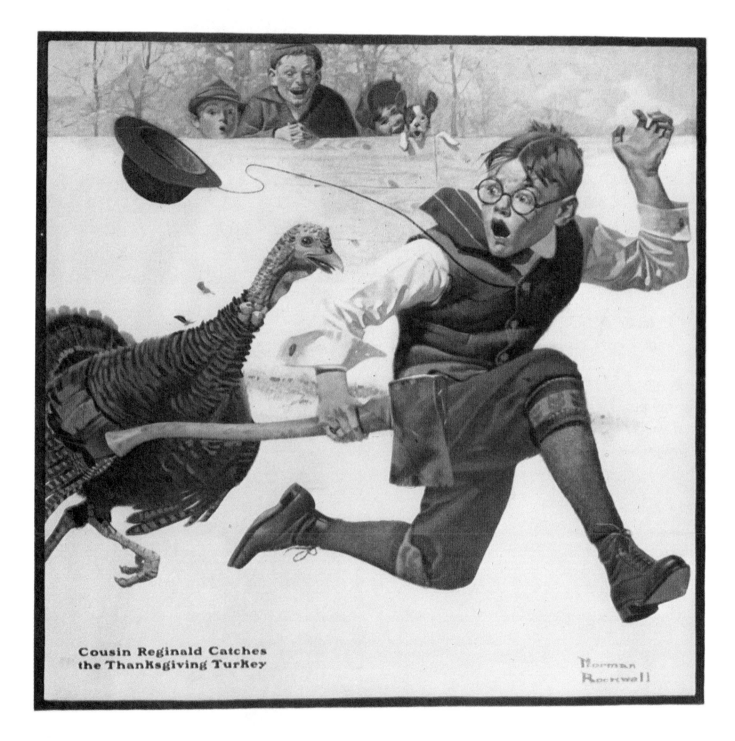

Cousin Reginald Catches
the Thanksgiving Turkey

Norman
Rockwell

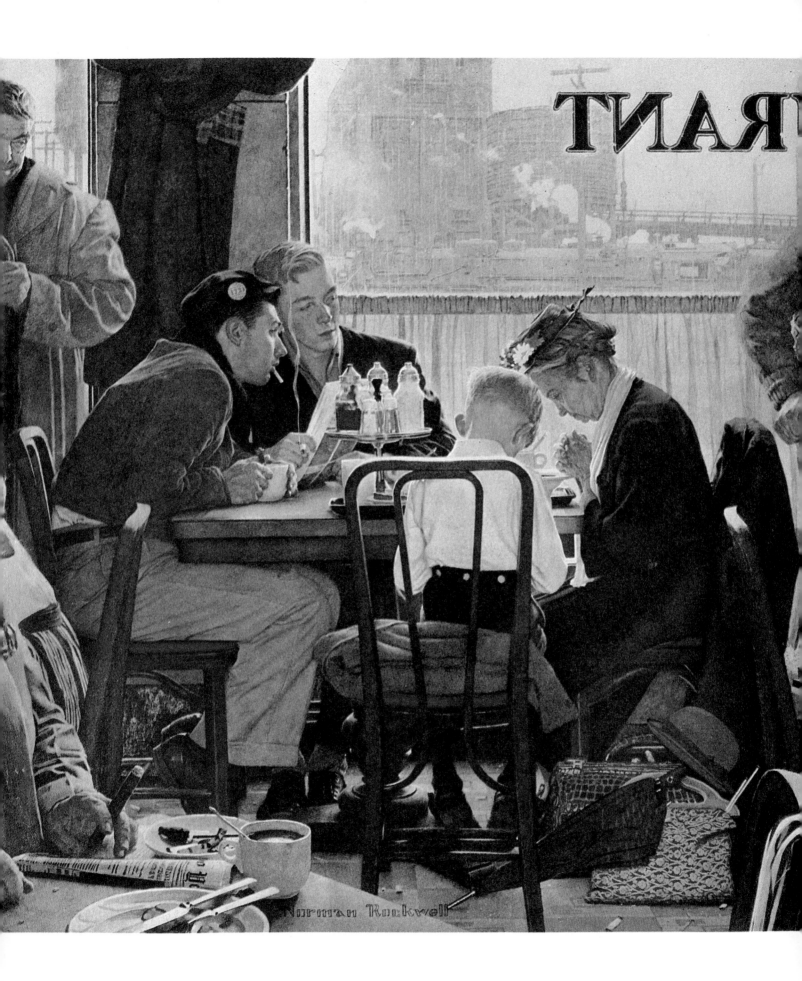

Proclamation

FOR THANKSGIVING AT PLYMOUTH IN THE BAY COLONY

NOVEMBER 24, 1623, A.D.

To All Ye Pilgrims

Inasmuch as the great Father has given us this year an abundant harvest of Indian corn, wheat, beans, squashes, and garden vegetables, and has made the forests to abound with game and the sea with fish and clams, and inasmuch as He has protected us from the ravages of the savages, has spared us from pestilence and disease, has granted us freedom to worship God according to the dictates of our own conscience; now, I, your magistrate, do proclaim that all ye Pilgrims, with your wives and little ones, do gather at ye meeting house, on ye hill, between the hours of 9 and 12 in the day time, on Thursday, November ye 29th of the year of our Lord one thousand six hundred and twenty three, and the third year since ye Pilgrims landed on ye Pilgrim Rock, there to listen to ye pastor, and render thanksgiving to ye Almighty God for all His blessings.

WILLIAM BRADFORD
Ye Govenor of Ye Colony

Ye Bill of Thanksgiving Fare

To Begin the Feast

Harlow House Mulled Cider
and
An Appetite Whetter

Fresh Fruits and Berries from the Harvest　　Fall Melon from the Patch　　The Shrimp from Plymouth Bay

And then a Soup

The Clam Chowder of New England　　　　An Herb Soupe of Creamed Artichoke

Followed by The Main Course

Roast Prime Sirloin of Beef, Yorkshire Pudding
Roasted Turkey with a Sauce of Cranberries and as ye may choose:
a dressing of chestnuts
A Young Duck with a sauce of Spiced Apples
and cut Kumquat

And from the Community Gardens

Sweet Potatoes that are Candied

Yellow Corn off the Hull

Small Onions in a Cream Sauce

A Salad of Fresh Greens with Woodland Herbs

Accompanyments from the Baking Ovens

An abundance of Rolls with Pecan meats

To Complete the Feaste

A Pie of Harvest Pumpkin
A Pie of Apples and Mincemeat

Coffee from the Indies　　　Tea from Auld England　　　Milk from the Colony's cows

THANKSGIVING TURKEY STUFFING

1½ lb. hamburger—bottom round
1 large chopped onion
¼ lb. butter
½ cup uncooked rice (then partly cook and strain well)
1 cup seedless raisins
½ cup pignolia nuts
1 lb. chestnuts (slit and broil until shells peel off easily)
½ tsp. ground cloves
1 tsp. cinnamon
1 cup almonds

Saute onions with butter and add salt and pepper to taste. When onion is browned, add each of the following and saute: rice, raisins, chestnuts, almonds, pignolia nuts and hamburger (break up meat well as it is sauteed). Then add cloves and cinnamon. Stir often during this process. Let cool. Stuff poultry with as much as it will take. When bird has been roasted, remove stuffing from poultry and put into roasting pan with the drippings. Add the leftover stuffing, mix well, and bake for about 30 minutes. Use same temperature as for roasting.

—THE STANFORD COURT HOTEL

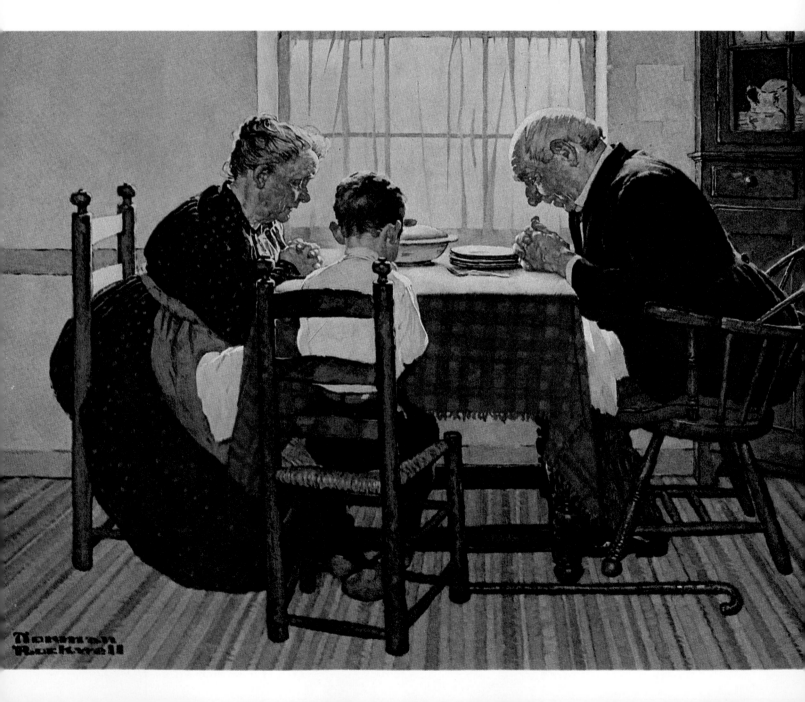

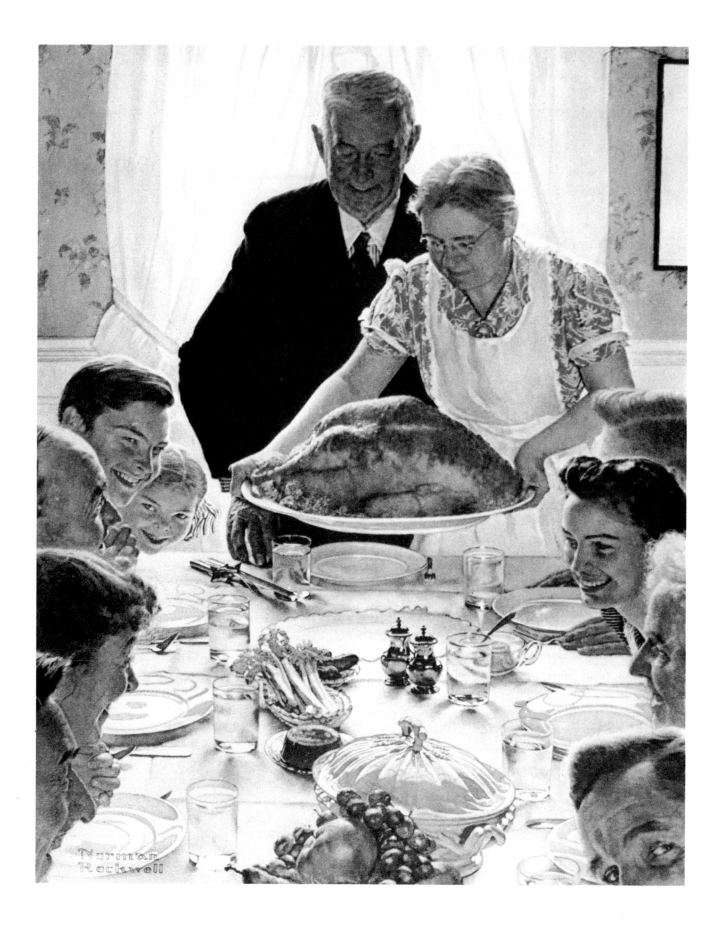

A MISERABLE, MERRY CHRISTMAS

MY FATHER'S BUSINESS seems to have been one of slow but steady growth. He and his local parner, Llewelen Tozer, had no vices. They were devoted to their families and to "the store," which grew with the town, which, in turn, grew and changed with the State from a gambling, mining, and ranching community to one of farming, fruit-raising, and building. Immigration poured in, not goldseekers now, but farmers, businessmen and home-builders, who settled, planted, reaped, and traded in the natural riches of the State, which prospered greatly, "making" the people who will tell you that they "made the State."

As the store made money and I was getting through the primary school, my father bought a lot uptown, at Sixteenth and K Streets, and built us a big house. It was off the line of the city's growth, but it was near a new grammar school for me and my sisters, who were coming along fast after me. This interested the family, not me. They were always talking about school; they had not had much of it themselves, and they thought they had missed something. My father used to write speeches, my mother verses, and their theory seems to have been that they had talents which a school would have brought to flower. They agreed, therefore, that their children's gifts should have all the schooling there was. My view, then, was that I had had a good deal of it already, and I was not interested at all. It interfered with my own business, with my own education.

And indeed I remember very little of the primary school. I learned to read, write, spell, and count, and reading was all right. I had a practical use for books, which I searched for ideas and parts to play with, characters to be, lives to live. The primary school was probably a good one, but I cannot remember learning anything except to read aloud "perfectly" from a teacher whom I adored and who was fond of me. She used to embrace me before the whole class and she favored me openly to the scandal of the other pupils, who called me "teacher's pet." Their scorn did not trouble me; I saw and I said that they envied me. I paid for her favor, however. When she married I had queer, unhappy feelings of resentment; I didn't want to meet her husband, and when I had to I wouldn't speak to him. He laughed, and she kissed me—happily for her, to me offensively. I never would see her again. Through with her, I fell in love immediately with Miss Kay, another grown young woman who wore glasses and had a fine, clear skin. I did not know her, I only saw her in the street, but once I followed her, found out where she lived, and used to pass her house, hoping to see her, and yet choking with embarrassment if I did. This fascination lasted for years; it was still a sort of super-romance to me when later I was "going with" another girl nearer my age.

What interested me in our new neighborhood was not the school, nor the room I was to have in the house all to myself, but the stable which was built back of the house. My father let me direct the making of a stall, a little smaller than the other stalls, for my pony, and I prayed and hoped and my sister Lou believed that that meant that I would get the pony, perhaps for Christmas. I pointed out to her that there were three other stalls and no horses at all. This I said in order that she should answer it. She could not. My father, sounded, said that some day we might have horses and a cow; meanwhile a stable added to the value of a house. "Some day" is a pain to a boy who lives in and knows only "now." My good little sisters, to comfort me, remarked that Christmas was coming, but Christmas was always coming and grown-ups were always talking about it, asking you what you wanted and then giving you what they wanted you to have. Though everybody knew what I wanted, I told them all again. My mother knew that I told God, too, every night. I wanted a pony, and to make sure that they understood, I declared that I wanted nothing else.

"Nothing but a pony?" my father asked.

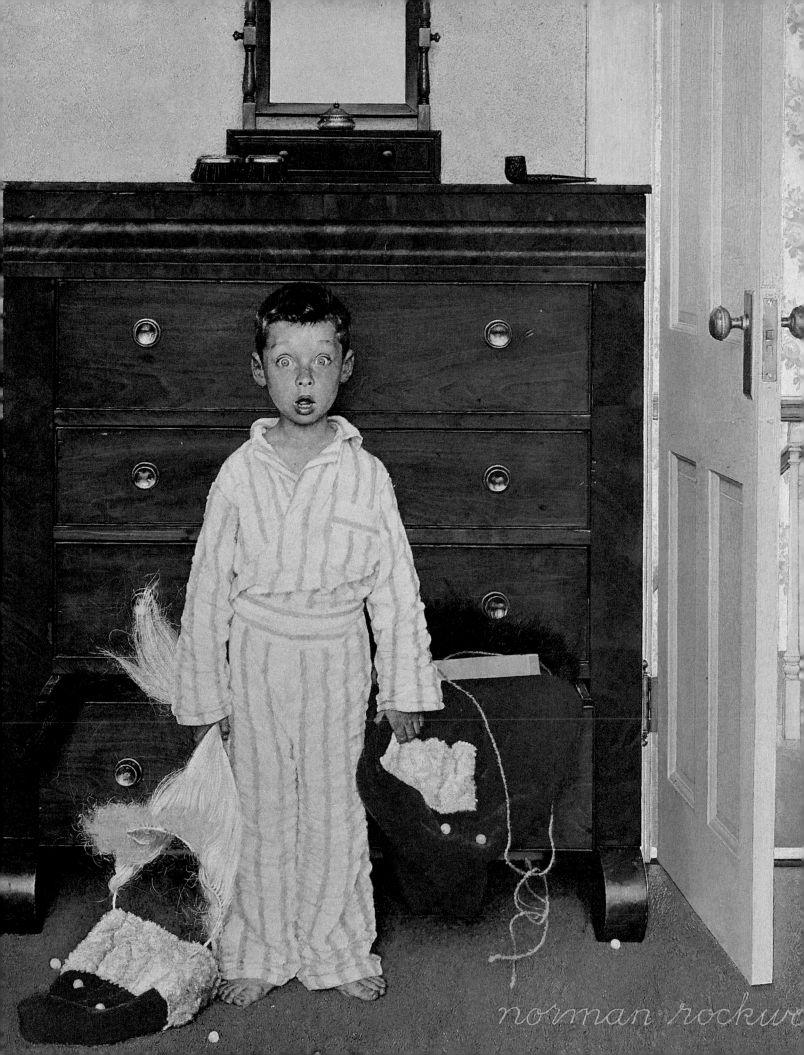

"Nothing," I said.

"Not even a pair of high boots?"

That was hard. I did want boots, but I stuck to the pony. "No, not even boots."

"Nor candy? There ought to be something to fill your stocking with, and Santa Claus can't put a pony into a stocking."

That was true, and he couldn't lead a pony down the chimney either. But no. "All I want is a pony," I said. "If I can't have a pony, give me nothing, nothing."

Now I had been looking myself for the pony I wanted, going to sales stables, inquiring of horsemen, and I had seen several that would do. My father let me "try" them. I tried so many ponies that I was learning fast to sit a horse. I chose several, but my father always found some fault with them. I was in despair. When Christmas was at hand I had given up all hope of a pony, and on Christmas Eve I hung up my stocking along with my sisters', of whom, by the way, I now had three. I haven't mentioned them or their coming because, you understand, they were girls, and girls, young girls, counted for nothing in my manly life. They did not mind me either; they were so happy that Christmas Eve that I caught some of their merriment. I speculated on what I'd get; I hung the biggest stocking I had, and we all went reluctantly to bed to wait till morning. Not to sleep; not right away. We were told that we must not only sleep promptly, we must not wake up till seven-thirty the next morning—or if we did, we must not go to the fireplace for our Christmas. Impossible.

We did sleep that night, but we woke up at six A.M. We lay in our beds and debated through the open doors whether to obey till, say half-past six. Then we bolted. I don't know who started it, but there was a rush. We all disobeyed; we raced to disobey and get first to the fireplace in the front room downstairs. And there they were, the gifts, all sorts of wonderful things, mixed-up piles of presents; only, as I disentangled the mess, I saw that my stocking was empty; it hung limp; not a thing in it; and under and around it—nothing. My sisters had knelt down, each by her pile of gifts; they were squealing with delight, till they looked up and saw me standing there in my nightgown with nothing. They left their piles to come to me and look with me at my empty place. Nothing. They felt my stocking; nothing.

I don't remember whether I cried at that moment, but my sisters did. They ran with me back to my bed, and there we all cried till I became indignant. That helped some. I got up, dressed, and driving my sisters away, I went alone out into the yard, down to the stable, and there, all by myself, I wept. My mother came out to me by and by; she found me in my pony stall, sobbing on the floor, and she tried to comfort me. But I heard my father outside; he had come part way with her, and she was having some sort of angry quarrel with him. She tried to comfort me, besought me to come to breakfast. She left me and went on into the house with sharp words for my father.

I don't know what kind of a breakfast the family had. My sisters said it was "awful." They were ashamed to enjoy their own toys. They came to me, and I was rude. I ran away from them. I went around to the front of the house, sat down on the steps, and, the crying over, I ached. I was wronged, I was hurt—I can feel now what I felt then, and I am sure that if one could see the wounds upon our hearts, there would be found still upon mine a scar from that terrible Christmas morning. And my father, the practical joker, he must have been hurt, too, a little. I saw him looking out of the window. He was watching me or something for an hour or two, drawing back the curtain ever so little lest I catch him, but I saw his face, and I think I can see now the anxiety upon it, the worried impatience.

After—I don't know how long—surely an hour or two—I was brought to the climax of my agony by the sight of a man riding a pony down the street, a pony and a brand-new saddle; the most beautiful saddle I ever saw, and it was a boy's saddle; the man's feet were not in the stirrups; his legs were too long. The outfit was perfect; it was the realization of all my dreams, the answer to all my prayers. A fine new bridle, with a light curb bit. And the pony! As he drew near, I saw that the pony was really a small horse, what we called an Indian pony, a bay, with black mane and tail, and one white foot and a white star on his forehead. For such a horse as that I would have given, I could have forgiven, anything.

But the man, a disheveled fellow with a black-

ened eye and a fresh-cut face, came alone, reading the numbers on the houses, and, as my hopes—my impossible hopes—rose, he looked at our door and passed by, he and the pony, and the saddle and the bridle. Too much. I fell upon the steps, and having wept before, I broke now into such a flood of tears that I was a floating wreck when I heard a voice.

"Say, kid," it said, "do you know a boy named Lennie Steffens?"

I looked up. It was the man on the pony, back again, at our horse block.

"Yes," I spluttered through my tears. "That's me."

"Well," he said, "then this is your horse. I've been looking all over for you and your house. Why don't you put your number where it can be seen?"

"Get down," I said, running out to him.

He went on saying something about "ought to have got here at seven o'clock; told me to bring the nag here and tie him to your post and leave him for you. But, hell, I got into a drunk—and a fight—and a hospital, and—"

"Get down," I said.

He got down, and he boosted me up to the saddle. He offered to fit the stirrups to me, but I didn't want him to. I wanted to ride.

"What's the matter with you?" he said, angrily. "What you crying for? Don't you like the horse? He's a dandy, this horse. I know him of old. He's fine at cattle; he'll drive 'em alone."

I hardly heard, I could scarcely wait, but he persisted. He adjusted the stirrups, and then, finally, off I rode, slowly, at a walk, so happy, so thrilled, that I did not know what I was doing. I did not look back at the house or the man, I rode off up the street, taking note of everything—of the reins, of the pony's long mane, of the carved leather saddle. I had never seen anything so beautiful. And mine! I was going to ride up past Miss Kay's house. But I noticed on the horn of the saddle some stains like rain-drops, so I turned and trotted home, not to the house but to the stable. There was the family, father, mother, sisters, all working for me, all happy. They had been putting in place the tools of my new business: blankets, curry-comb, brush, pitchfork—everything, and there was hay in the loft.

"What did you come back so soon for?" somebody asked. "Why didn't you go on riding?"

I pointed to the stains. "I wasn't going to get my new saddle rained on," I said. And my father laughed. "It isn't raining," he said. "Those are not rain-drops."

"They are tears," my mother gasped, and she gave my father a look which sent him off to the house. Worse still, my mother offered to wipe away the tears still running out of my eyes. I gave her such a look as she had given him, and she went off after my father, drying her own tears. My sisters remained and we all unsaddled the pony, put on his halter, led him to his stall, tied and fed him. It began really to rain; so all the rest of that memorable day we curried and combed that pony. The girls plaited his mane, forelock, and tail, while I pitchforked hay to him and curried and brushed, curried and brushed. For a change we brought him out to drink; we led him up and down, blanketed like a race-horse; we took turns at that. But the best, the most inexhaustible fun, was to clean him. When we went reluctantly to our midday Christmas dinner, we all smelt of horse, and my sisters had to wash their faces and hands. I was asked to, but I wouldn't till my mother bade me look in the mirror. Then I washed up—quick. My face was caked with the muddy lines of tears that had coursed over my cheeks to my mouth. Having washed away that shame, I ate my dinner, and as I ate I grew hungrier and hungrier. It was my first meal that day, and as I filled up on the turkey and the stuffing, the cranberries and the pies, the fruit and the nuts—as I swelled, I could laugh. My mother said I still choked and sobbed now and then, but I laughed, too; I saw and enjoyed my sisters' presents till—I had to go out and attend to my pony, who was there, really and truly there, the promise, the beginning, of a happy double life. And—I went and looked to make sure—there was the saddle, too, and the bridle.

But that Christmas, which my father had planned so carefully, was it the best or the worst I ever knew? He often asked me that; I never could answer as a boy. I think now that it was both. It covered the whole distance from broken-hearted misery to bursting happiness—too fast. A grown-up could hardly have stood it.

—LINCOLN STEFFENS

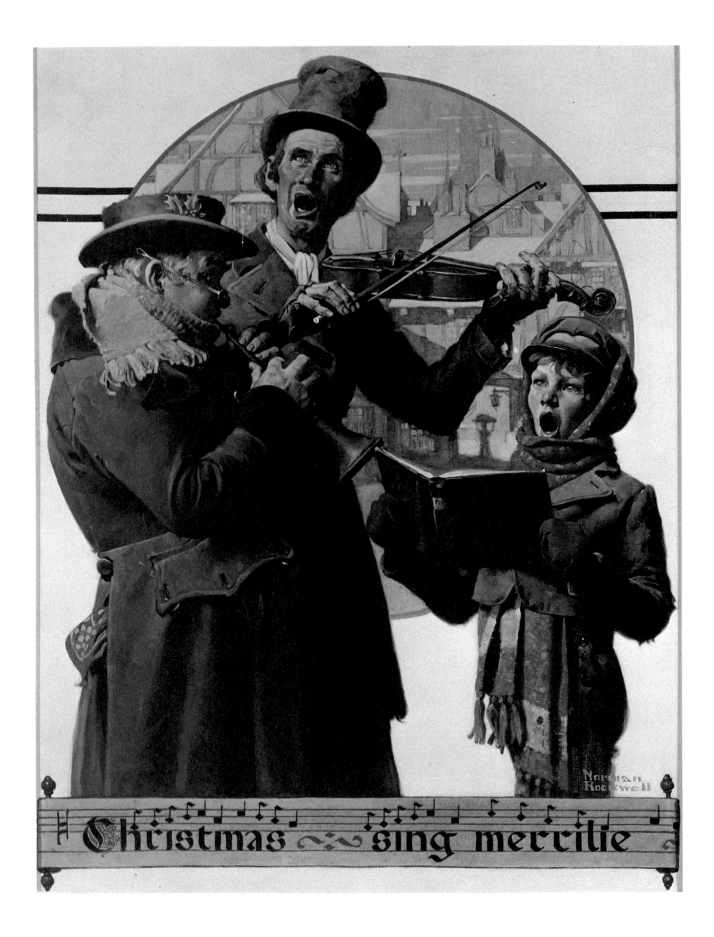

Sing hey! Sing hey!
For Christmas Day
Twine mistletoe and holly
For friendship glows
In winter snows,
And so let's all be jolly.

little tree
little silent Christmas tree
you are so little
you are more like a flower

who found you in the green forest
and were you very sorry to come away?
see i will comfort you
because you smell so sweetly

i will kiss your cool bark
and hug you safe and tight
just as your mother would,
only don't be afraid

look the spangles
that sleep all the year in a dark box
dreaming of being taken out and allowed to shine,
the balls the chains red and gold the fluffy threads,

put up your little arms
and i'll give them all to you to hold
every finger shall have its ring
and there won't be a single place dark or unhappy

then when you're quite dressed
you'll stand in the window for everyone to see
and how they'll stare!
oh but you'll be very proud

and my little sister and i will take hands
and looking up at our beautiful tree
we'll dance and sing
"Noel Noel"

—E. E. CUMMINGS

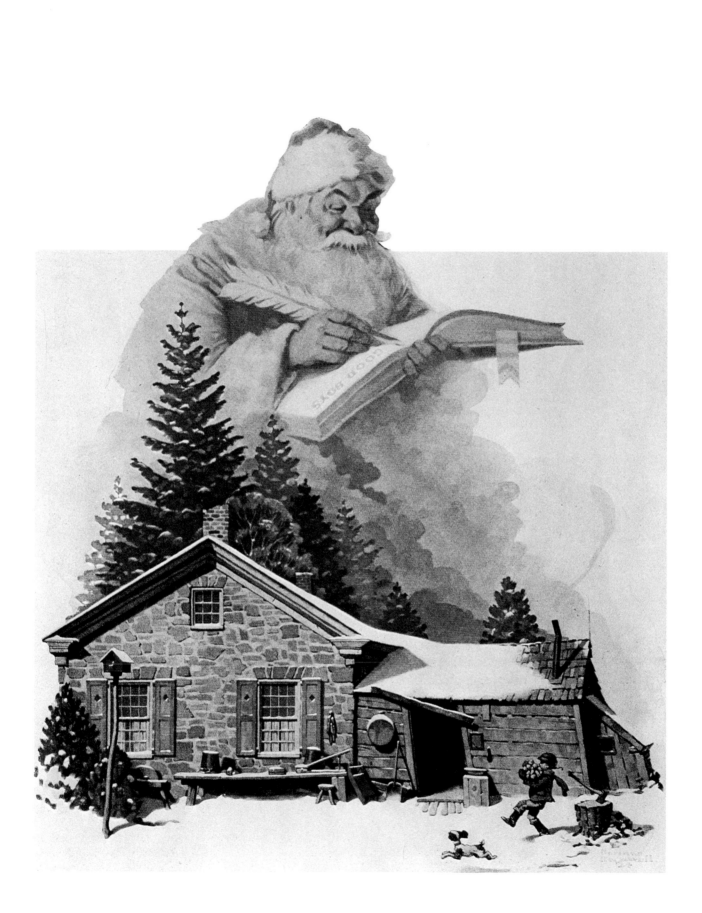

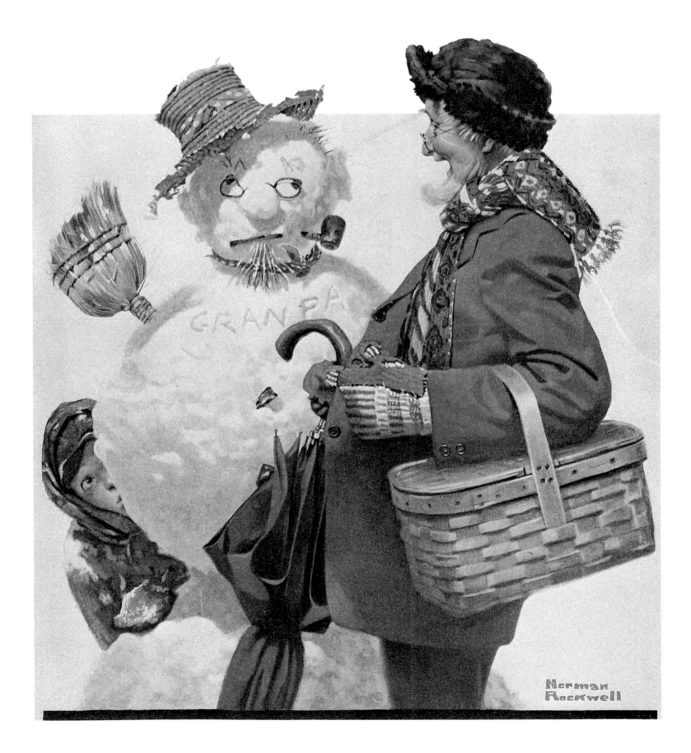

Blow, blow, thou winter wind,
Thou art not so unkind
　　As man's ingratitude;
Thy tooth is not so keen,
Because thou art not seen,
　　Although thy breath be rude.
Heigh-ho! sing, heigh-ho! unto the green holly:
Most friendship is feigning, most loving mere
　　folly.
　　　　Then heigh-ho! the holly!
　　　　This life is most jolly.

Freeze, freeze, thou bitter sky,
That dost not bite so nigh
　　As benefits forgot:
Though thou the waters warp,
Thy sting is not so sharp
　　As friend remember'd not.
Heigh-ho! sing, heigh-ho! unto the green holly:
Most friendship is feigning, most loving mere
　　folly.
　　　　Then heigh-ho! the holly!
　　　　This life is most jolly.

　　　　　　　　　—WILLIAM SHAKESPEARE

CHRISTMAS IN SAN FRANCISCO

IMAGINE ASKING your children to forsake their traditional Christmas tree at home and to spend their holidays in San Francisco. What cries, wails, and threats came from our children, Ashley and Ryan.

"What about all our presents?" bemoaned my son.

"And no tree with all our special ornaments!" chimed Ashley, her face telling a sudden story of despair.

But when we arrived at the hotel atop Nob Hill, the children could not believe their eyes. For there in the grand lobby stood a twenty-five-foot white fir, a fairy land Christmas tree spraying forth a million lights sparkling on boughs of frosted snow. And in a corner of the enormous room a giant gingerbread house made of real cake and jelly beans had its doors opened for every child's heart in the world.

In the children's eyes you could see their absolute lambent joy, their overwhelming delight.

"Wait until you see what's waiting for you upstairs!" I said, knowing that the hotel had promised to set up a Christmas tree in our tower suite overlooking both the Golden Gate and Bay bridges.

But when we got to our rooms, there was no tree, not even a piece of holly, or a Christmas wreath.

"Where's *our* tree?" said my wife, looking at me sternly.

Immediately I got on the phone and asked this person and that person about our tree. No one seemed to know exactly where our tree was, but everyone I spoke with knew about the existence of our Christmas tree.

So the search was on to find a certain tree decorated especially for Ashley and Ryan.

Days passed and no one could find our tree.

It wasn't in another suite. It wasn't in the hotel basement. It wasn't in the maintenance room. Where was our mystery tree?

Finally, two days before Christmas, the most beautiful Oregon spruce appeared at our suite, bulging with lights and tinsel and glittering ornaments hanging from soft, fresh boughs.

And when it was lighted how it shone like an angel high above all the Christmas lights glimmering below round the city's wharfs and streets.

Standing silently before their tree, Ashley and Ryan gazed upon all its magical powers for the longest time.

It was not hard to know what they were feeling during those moments of reflection.

As I went to the door with the maintenance man who had delivered the tree, I kept thanking him over and over again. "Thank goodness you found it!" I said, feeling a great swell of relief.

"Tell you the truth," he said, "that's a *new* tree. We never found your original tree."

"Guess that tree will always be a mystery," I said.

"Oh no, sir," he replied quickly. "We think someone lifted your tree. You just can't trust anyone anymore."

I said nothing. But in my heart I was glad someone had our first tree. Whoever had taken it, I reckoned, had wanted it very badly for someone they loved and who now was as fortunate as Ashley and Ryan.

This is how I will always remember our Christmas together in San Francisco.

—*GEORGE MENDOZA*

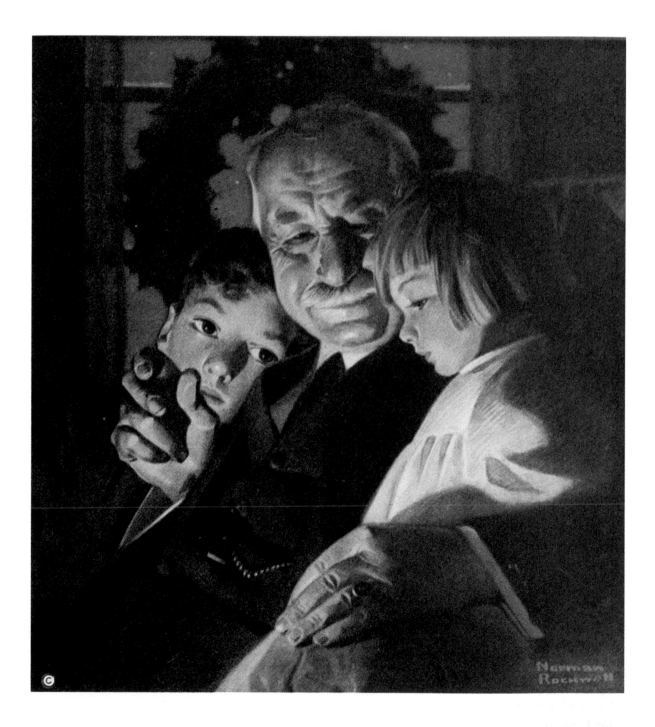

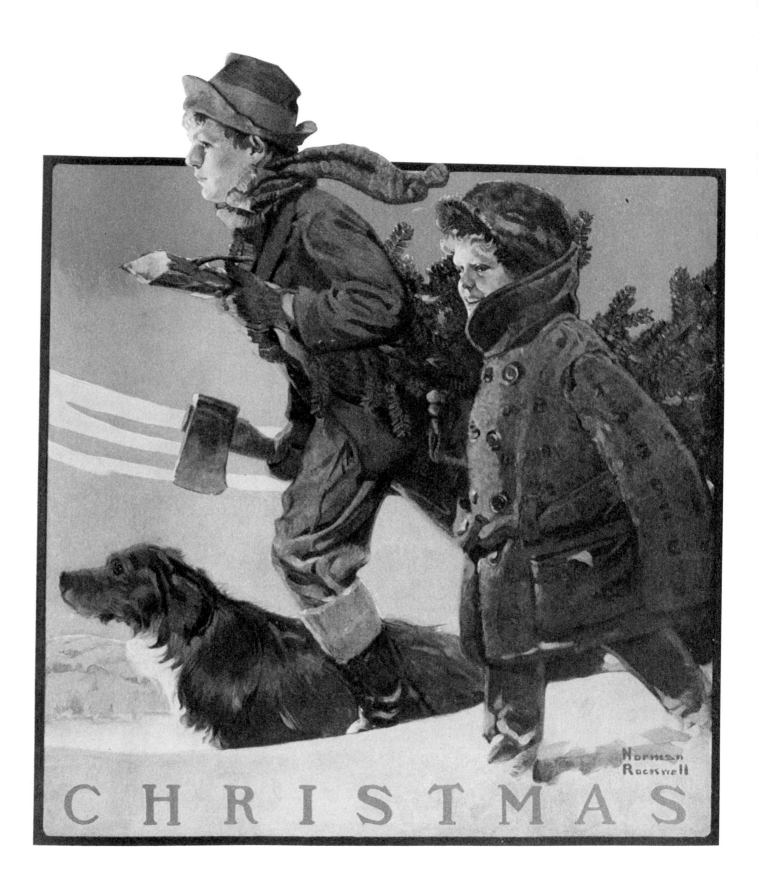

CHRISTMAS

I remember only one Christmas,
 one Christmas as a boy.
 The fields were heavy white,
the river ice-chunked, frozen.
The huge stone house buried in kingly trees
atop the hill high with gleaming snow dunes.
That snow-filled spruce we cut,
my father and I,
flickering through the wide window
so many lights and dancing colors
flying to eternity.
I don't remember the toys,
only the gladness of that evening
one Christmas as a boy.

—GEORGE MENDOZA

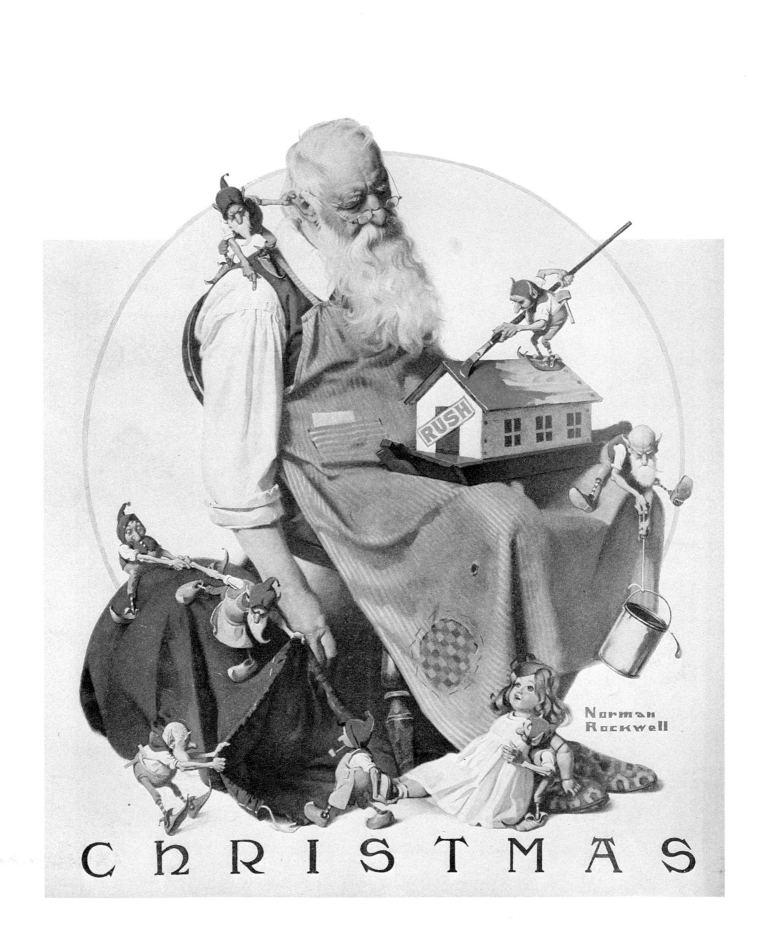

CHRISTMAS

SOME DAMNABLE ERRORS
ABOUT CHRISTMAS

THAT IT IS HUMAN to err is admitted by even the most positive of our thinkers. Here we have the great difference between latter-day thought and the thought of the past. If Euclid were alive to-day (and I daresay he is) he would not say, 'The angles at the base of an isosceles triangle are equal to one another.' He would say, 'To me (a very frail and fallible being, remember) it does somehow seem that these two angles have a mysterious and awful equality to one another.' The dislike of schoolboys for Euclid is unreasonable in many ways; but fundamentally it is entirely reasonable. Fundamentally it is the revolt from a man who was either fallible and therefore (in pretending to infallibility) an impostor, or infallible and therefore not human.

Now, since it is human to err, it is always in reference to those things which arouse in us the most human of all our emotions—I mean the emotion of love—that we conceive the deepest of our errors. Suppose we met Euclid on Westminster Bridge, and he took us aside and confessed to us that whilst he regarded parallelograms and rhomboids with an indifference bordering on contempt, for isosceles triangles he cherished a wild romantic devotion. Suppose he asked us to accompany him to the nearest music-shop, and there purchased a guitar in order that he might worthily sing to us the radiant beauty and the radiant goodness of isosceles triangles. As men we should, I hope, respect his enthusiasm, and encourage his enthusiasm, and catch his enthusiasm. But as seekers after truth we should be compelled to regard with a dark suspicion, and to check with the most anxious care, every fact that he told us about isosceles triangles. For adoration involves a glorious obliquity of vision. It involves more than that. We do not say of Love that he is short-sighted. We do not say of Love that he is myopic. We do not say of Love that he is astigmatic. We say quite simply, Love is blind. We might go further and say, Love is deaf. That would be a profound and obvious truth. We might go further still and say, Love is dumb. But that would be a profound and obvious lie. For love is always an extraordinarily fluent talker. Love is a wind-bag, filled with a gusty wind from Heaven.

It is always about the thing that we love most that we talk most. About this thing, therefore, our errors are something more than our deepest errors: they are our most frequent errors. That is why for nearly two thousand years mankind has been more glaringly wrong on the subject of Christmas than on any other subject. If mankind had hated Christmas, he would have understood it from the first. What would have happened then, it is impossible to say. For that which is hated, and therefore is persecuted, and therefore grows brave, lives on for ever, whilst that which is understood dies in the moment of our understanding of it—dies, as it were, in our awful grasp. Between the horns of this eternal dilemma shivers all the mystery of the jolly visible world, and of that still jollier world which is invisible. And it is because Mr. Shaw and the writers of his school cannot, with all their splendid sincerity and acumen, perceive that he and they and all of

us are impaled on those horns as certainly as the sausages I ate for breakfast this morning had been impaled on the cook's toasting-fork—it is for this reason, I say, that Mr. Shaw and his friends seem to me to miss the basic principle that lies at the root of all things human and divine. By the way, not all things that are divine are human. But all things that are human are divine. But to return to Christmas.

I select at random two of the more obvious fallacies that obtain. One is that Christmas should be observed as a time of jubilation. This is (I admit) quite a recent idea. It never entered into the tousled heads of the shepherds by night, when the light of the angel of the Lord shone about them and they arose and went to do homage to the Child. It never entered into the heads of the Three Wise Men. They did not bring their gifts as a joke, but as an awful oblation. It never entered into the heads of the saints and scholars, the poets and painters, of the Middle Ages. Looking back across the years, they saw in that dark and ungarnished manger only a shrinking woman, a brooding man, and a child born to sorrow. The philomaths of the eighteenth century, looking back, saw nothing at all. It is not the least of the glories of the Victorian Era that it rediscovered Christmas. It is not the least of the mistakes of the Victorian Era that it supposed Christmas to be a feast.

The splendour of the saying, 'I have piped unto you, and you have not danced; I have wept with you, and you have not mourned' lies in the fact that it might have been uttered with equal truth by any man who had ever piped or wept. There is in the human race some dark spirit of recalcitrance, always pulling us in the direction contrary to that in which we are reasonably expected to go. At a funeral, the slightest thing, not in the least ridiculous at any other time, will convulse us with internal laughter. At a wedding, we hover mysteriously on the brink of tears. So it is with the modern Christmas. I find myself in agreement with the cynics in so far that I admit that Christmas, as now observed, tends to create melancholy. But the reason for this lies solely in our own misconception. Christmas is essentially a *dies irae.* If the cynics will only make up their minds to treat it as such, even the saddest and most atrabilious of them will acknowledge that he has had a rollicking day.

This brings me to the second fallacy. I refer to the belief that 'Christmas comes but once a year.' Perhaps it does, according to the calendar—a quaint and interesting compilation, but of little or no practical value to anybody. It is not the calendar, but the Spirit of Man that regulates the recurrence of feasts and fasts. Spiritually, Christmas Day recurs exactly seven times a week. When we have frankly acknowledged this, and acted on this, we shall begin to realise the Day's mystical and terrific beauty. For it is only everyday things that reveal themselves to us in all their wonder and their splendour. A man who happens one day to be knocked down by a motor-bus merely utters a curse and instructs his solicitor; but a man who has been knocked down by a motor-bus every day of the year will have begun

to feel that he is taking part in an august and soul-cleansing ritual. He will await the diurnal stroke of fate with the same lowly and pious joy as animated the Hindoos awaiting Juggernaut. His bruises will be decorations, worn with the modest pride of the veteran. He will cry aloud, in the words of the late W. E. Henley, 'My head is bloody but unbowed.' He will add, 'My ribs are broken but unbent.'

I look for the time when we shall wish one another a Merry Christmas every morning; when roast turkey and plum-pudding shall be the staple of our daily dinner, and the holly shall never be taken down from the walls, and every one will always be kissing every one else under the mistletoe. And what is right as regards Christmas is right as regards all other so-called anniversaries.

The time will come when we shall dance round the Maypole every morning before breakfast—a meal at which hot-cross buns will be a standing dish—and shall make April fools of one another every day before noon. The profound significance of All Fools' Day—the glorious lesson that we are all fools—is too apt at present to be lost. Nor is justice done to the sublime symbolism of Shrove Tuesday—the day on which all sins are shriven. Every day pancakes shall be eaten either before or after the plum-pudding. They shall be eaten slowly and sacramentally. They shall be fried over fires tended and kept for ever bright by Vestals. They shall be tossed to the stars.

I shall return to the subject of Christmas next week.

—MAX BEERBOHM
"A Christmas Garland"

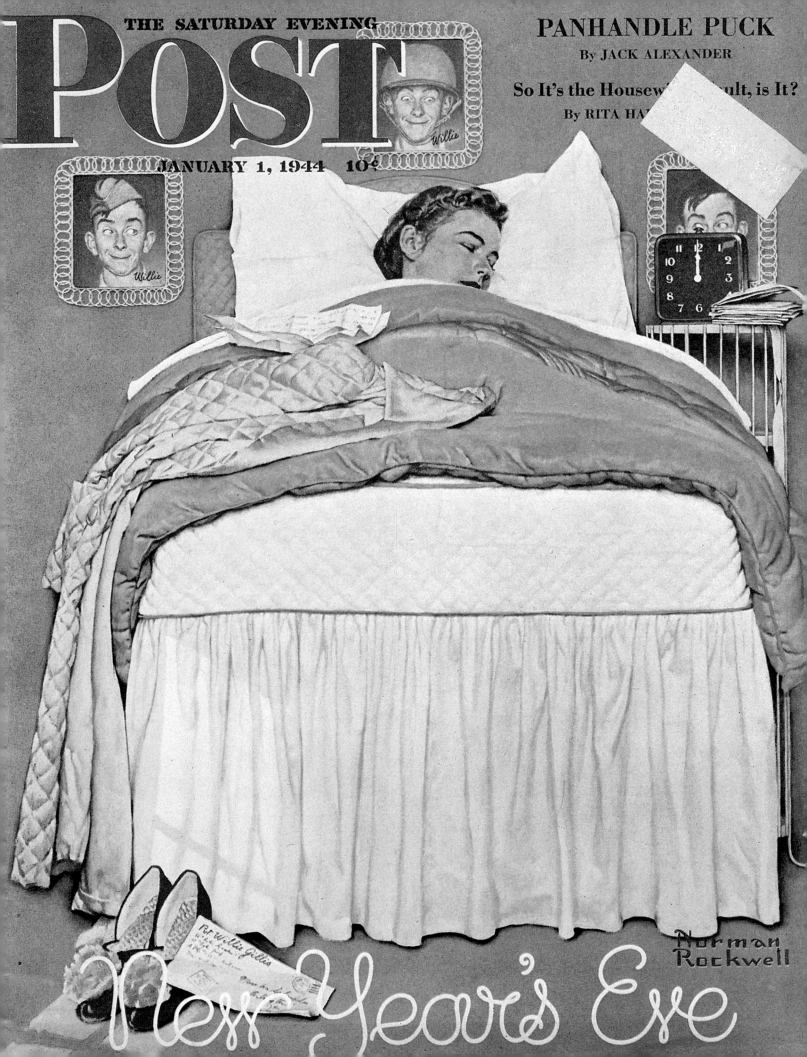

Hold fast to dreams
For if dreams die
Life is a broken-winged bird
That cannot fly.

Hold fast to dreams
For when dreams go
Life is a barren field
Frozen with snow.

—*LANGSTON HUGHES*
"Dreams"